£3.50 £1.75

MICHELANGELO
A Self-Portrait

Texts and Sources

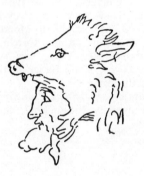

Edited with Commentaries and New Translations by
Robert J. Clements

New York: NEW YORK UNIVERSITY PRESS
London: UNIVERSITY OF LONDON PRESS LIMITED
1968

Other Books on Renaissance Literature or Aesthetics by
Robert J. Clements

Critical Theory and Practice of the Pléiade (Cambridge, USA, Harvard University Press, 1942; New York, Octagon Books, 1968)
Platonism in French Renaissance Literature, with Robert Valentine Merrill (New York, New York University Press, 1957)
The Peregrine Muse: Studies in Comparative Renaissance Literature (Chapel Hill, University of North Carolina Press, 1959)
Picta Poesis: Humanistic and Literary Theory in Renaissance Emblem Books (Rome, Edizioni di Storia e Letteratura, 1960)
Michelangelo's Theory of Art (Zurich, Buehler Buchdruck, 1961; New York, New York University Press, 1961; London, Routledge and Kegan Paul, 1962; New York, Gramercy Press, 1963)
La teorica di Michelangelo (Milan, Alberto Mondadori, 1964)
Michelangelo scultore, co-author (Rome, Curcio, 1963)
The Poetry of Michelangelo (New York, New York University Press, 1965; London, Peter Owen, 1966; Italian edition published by Alberto Mondadori, forthcoming)
American Critical Essays on the Divine Comedy, editor-author (New York, New York University Press, 1967; London, University of London Press, 1967)

FOR STERLING WARNER CLEMENTS

PREFACE

The character of Michelangelo was a complex amalgam which has fascinated historians and biographers. However, the biographers—especially those working in that dubious genre, the *biographie romancée*—have left us incomplete and even inaccurate portraits of the great artist. Partly to erase the impressions these fanciful portraitists have left, and more precisely to enable the modern reader to form an authentic picture of Michelangelo, we are making available in English a full collection of the master's own words, the most revealing and rewarding thoughts gleaned from his 495 letters, his 343 poems and poetic fragments, his conversations with friends, and even from sundry outbursts set down by contemporaries who understood their enduring value. If it is likely that truth is more provocative than fiction, it is equally true that Michelangelo's verbal testament is more important and fascinating than any words ever attributed to him by the wanton muse of the biographers.

Michelangelo's thoughts have also been frequently distorted by translators of his poetry bent upon rendering them in English and on retaining the meters and rhyme schemes of the Italian. With a view to preserving the original meaning intact, I have sorted through some 2000 translations of his poems into English (some of them done by my own graduate students). Where I have not been satisfied that available translations adhere closely enough to the meaning and spirit, I have made a literal translation myself. Whatever lyrical qualities they may lack, at least my versions do not stray from the original spirit and letter to meet the challenges of rhyme and meter. All translations which do not carry within parentheses the name of another translator were executed by myself, whether renditions from poetry or prose.

As luck would have it, a few of the best translations of Michelangelo's *Rime* were done by major literary figures. Thus, this volume boasts some fine translations, seldom found in print, by Henry Wadsworth Longfellow, Ralph Waldo Emerson, Robert Southey, William Wordsworth, Charles Eliot Norton, George Santayana, Nesca Robb, and others. The task of tracking down every English translation from Michelangelo's poetry which ever found its way into print could not have been achieved without the magnificent bibliographical researches of Miss Margaret Webb, Librarian of Queen's College, New York.

Permission has been granted to reprint translated materials from the following works: *Michael Angelo Buonarroti,* by Charles Holroyd (London: Duckworth, 1909); Ralph Waldo Emerson, *Journals* (Boston: Houghton Mifflin, 1914); Robert W. Carden, *Life of Michelangelo* (London: Constable and Company, 1913); S. Elizabeth Hall, *Sonnets of Michelangelo* (London: Routledge & Kegan Paul, Ltd., 1905); John Edward Taylor, *Michelangelo considered as a Philosophic Poet* (London: John Murray, 1852); Charles Speroni, "Letters

of Michelangelo," *Italian Quarterly* (Fall, 1960); Nesca Robb, *Neoplatonism of the Italian Renaissance* (London: George Allen & Unwin, 1935); George Santayana, *Interpretations of Poetry and Religion* (New York: Charles Scribner's & Sons, 1927). Passages from De Hollanda's *Dialogos em Roma* herein are translated either by Charles Holroyd or myself. All other translations used are now in the public domain under existing copyright laws of the United States and the United Kingdom.

I should like to acknowledge with appreciation the learned editorial assistance of Miss Hilary Dole, who is in large part responsible for the compilation of the primary source list and fully responsible for the collation, presented in the appendix, of the Milanesi dates for the letters with those proposed by E. H. Ramsden and by the continuators of the Poggi edition, Paola Barocchi and Renzo Ristori. Illustrations so credited are reproduced from Ludwig Goldscheider's *Michelangelo Drawings* (London: The Phaidon Press), copyright 1951 by Phaidon Press Ltd., by permission of the author and publisher.

<div align="right">R.J.C.</div>

CONTENTS

(Numbers accompanying chapter titles refer to pages; those accompanying subheadings refer to entries themselves.)

ILLUSTRATIONS

Michelangelo's Self-Portrait

INTRODUCTION TO REVISED EDITION

Con poche parole ti farò intendere l'animo mio.

With few words I shall make thee understand my
soul. —Michelangelo, 22 March, 1561

Michelangelo Buonarroti seems to have as many characters
and personalities as he has biographers, and these are legion. The really
accurate biography of the artist remains to be written, if indeed it ever
can be. As a recent reviewer put it, "through all the serious histories
and fervent romances the central personality of 'the Divine One' moves
in ghostly fashion."

Why is an accurate portrayal of Michelangelo such a will-of-the-wisp?
Certainly the facts of his life and his character are numerous and docu-
mented. When one considers that Michelangelo died the year Shakespeare
was born, the paucity of our information on the dramatist contrasts
strangely with the abundance of our information on the artist. The
sources are detailed and reliable, the foremost among these being Michel-
angelo's poems and poetic fragments and his many letters. For the
everyday information on his profession there are the *ricordi*, business
and financial records. If these are frequently the mere chronicle of
technical and economic concerns, a few of them are rich in meaning
for him who would read them carefully. Typical is the bitter entry in
which he agrees unwillingly to go ahead with the painting of the Sistine
Vault and signs himself "Michelangelo, sculptor." Other testimony set
down by his contemporaries is extremely helpful, but these records, as
we shall see shortly, are few and scattered.

One of the most obvious difficulties of filling in a portrait of Michel-
angelo is his unwillingness to reveal himself to others. In the first place,
he was embarrassed when people discussed him and his work. In the
transcript of the conversation with the Florentine exiles in the home of
Donato Giannotti we hear his efforts to turn the discussion away from
himself. "There is nothing which makes a modest person blush more
than praising him in his presence." Again, he pleads with Messer Donato
to stop praising him so fulsomely or he will be like "the crow in Aesop":
"so that if the legitimate owners of these ornaments with which you
have clothed me will come for them, I shall standing nude be the
laughing stock of all." At another moment he cries out in protest, "Just
leave me alone wrapped up in my shroud." Similarly, in the dialogues
recorded by his friend De Hollanda, Michelangelo seeks to avoid any
talk of himself or his art until his beloved hostess Vittoria Colonna un-
leashes his tongue.

Michelangelo's unwillingness to let the "hateful ego" intrude into

1

these discussions need not be attributed to modesty. Michelangelo's modesty was more social and more Christian than ingrained. He who cried on more than one occasion that "the world is blind" had little stomach for revealing himself to social groups. Like that Horace whom he could quote by memory, Michelangelo preferred to keep the ignorant throng at a distance. Even the learned humanist Varchi is included in this embracing category, and Michelangelo refuses to rise to the occasion when Varchi tries to involve several important artists and critics in a referendum on the Paragon (comparison) of painting and sculpture. Michelangelo jots down a hasty reply, with an incidental jab at Da Vinci as well as Varchi, and then grumbles that it is better to settle down to the creation of art than to waste time discussing it.

Michelangelo never set down a prose version of his life, or even the notes for one. He left this task to Giorgio Vasari and Ascanio Condivi, who assembled sketchy and anecdotal biographies of him. Wrote Vasari, "Michelangelo mistrusted his ability to express in writing what he would have liked, not being trained in discourse." Condivi echoed, "Nor does he think that he can express his fancy to the world in writing." Even in his most personal and sincere prose, to Tommaso Cavalieri, Michelangelo regrets that his "pen cannot even approach one's intent." Indeed, when composing a confessional sonnet to God himself, Michelangelo cries out in anguish that "the pen does not correspond to the workings of my spirit and makes the sheet a falsehood." Small wonder, then, that Michelangelo did not attempt an autobiography, even if moved to do so.

Yet the words "spiritual autobiography" are frequently applied to the sonnets, madrigals, canzoni, capitoli, quatrains, and fragments which make up the artist's poetry. These provide direct avenues to Michelangelo's thoughts, beliefs, and moods. We shall make frequent use of them, therefore, in the following pages. The poems are all the more personal and revealing since most of them were written without any intention of publication. True, the artist was flattered when Benedetto Varchi delivered a lecture on two of them to an academy or when an eminent composer like Jacob Arcadelt set one of them to music. Yet he managed to avoid publication of them during his lifetime. When Donato Giannotti and Luigi del Riccio started to prepare a group of them for the press in the mid-1540's, Michelangelo found his protests and disclaimers overruled for a time. Yet before the edition was completed he effected a rupture with Del Riccio, probably over the printing of his 50 or 51 poems to the fifteen-year-old Cecchino Bracci. Del Riccio died suddenly, and Michelangelo's poems were not printed until 1623. Thus, the poems remained for the artist a sort of intimate journal in which he could confide his most personal thoughts, occasionally to be shared with a good friend, with Christ, or with God the Father. The poems consider love, religion, politics, and so many other topics that we shall be able to use their testimony throughout the present volume.

Letter writing in the Italian Renaissance has been called "the most genteel art" of the time. Most Renaissance composers of social letters wrote not only for the actual recipient himself, but with a wide circle of eventual readers in view. If necessary, Michelangelo was capable of composing a letter of exquisite gentility destined to be read by many, such as his gracious refusal to undertake a commission from King Francis I of France. The vast majority of his letters, however, were never intended as models of the current epistolary art. If they were rather meant to be read by one person alone, Michelangelo was too famous a person to have his letters vanish into oblivion. No complete edition of them appeared until 1875, but a few of them, such as his criticism of Sangallo's model for St. Peter's or his tongue-in-cheek rebuttal to Aretino were widely read by his contemporaries. In any case, the span of letters was a tremendous one, from his first note to his brother Buonarroto from Rome in 1497 until the last letter to his nephew Lionardo in 1562. Sometimes the entire letter is reproduced below to make a point fully. At other times, a single thought shining forth like a gem in the middle of a letter serves by itself, enclosing dense meaning in an aphorism. In the letters, and sometimes even in the *Rime,* the important thought or series of thoughts may be embedded in an irrelevant context of little or no interest to us. Thus, these passages are "taken out of context" much as the sculptor Michelangelo removed the *soverchio* (superfluous stone) to get down to the autonomous "concept" contained within.

In explaining the actual words of Michelangelo himself on life and art we make use of the fascinating *Dialogues in Rome* of the Portuguese miniature painter Francisco de Hollanda. Fortunately, this admirer of Buonarroti attended three conversations occurring in October, 1536, at which his idol was present. These colloquies were presided over by Vittoria Colonna, who spent a great deal of time at the convent on San Silvestro—not a far walk, if uphill, from Michelangelo's studio on the Macel de' Corvi. The presence of the beloved Marchioness stirred Michelangelo to unwonted loquacity and the precious record of his remarks on these occasions was dutifully set down by the Portuguese humanist. Despite an occasional debate over the authenticity of De Hollanda's report, the dialogues are now widely accepted by such eminent scholars as Sánchez Cantón, Rezio Buscaroli, Menéndez y Pelayo, and Valerio Mariani as a true, accurate transcript with occasional polemic accentuation. Redig de Campos even likens him (and Giannotti) to Goethe's Eckermann. To dismiss De Hollanda as "an inferior painter living in still medieval Portugal," as has James Ackerman, is as misleading and irrelevant as to dismiss Michelangelo as a "would-be poet from provincial Caprese who never completed grammar school." De Hollanda received the typical humanists's training, including Greek and Latin, and spent over a decade in the humanistic circles of Italy. One must read his *Da*

pintura antigua (it exists only in Portuguese) to appreciate the breadth of his erudition. The *Dialogos* are unique in presenting Michelangelo's persuasions on the socio-political values of the fine arts and for his assessment of the art centers of Western Europe. No less a personage than the Portuguese ambassador Mascarenhas was invoked as witness before João III of Portugal to the length and frequency of conversations about art (other than the three recorded *Dialogos em Roma*) between Michelangelo and De Hollanda.

Another learned contemporary who was aware of the utility of recording Michelangelo's actual statements was the Florentine humanist and exile Donato Giannotti. In the early 1540's Giannotti was one of Michelangelo's two or three closest friends, and Michelangelo did his bust of *Brutus* with the intention of presenting it to him. After an evening with the artist, along with Luigi del Riccio, Antonio Petreo, and Francesco Priscianese, the sagacious Messer Donato recorded the conversation in his *Two Dialogues on the Days Which Dante Consumed in Seeking Hell and Purgatory*. This precious report has never been translated into English, the present volume providing more pages of it in English than any heretofore. If much of the conversation we have translated hinged upon details of the nature and timing of Dante's itinerary through inferno and purgatory (precisely the two books of Dante featured in Michelangelo's two sonnets on the Trecento poet), other topics intrude. Thus, we are afforded a glimpse of Michelangelo's opinions on tyrannicide, a theme certain to beguile a group of Florentine exiles sitting it out in Rome while Dukes Alessandro and Cosimo de' Medici rule Tuscany like tyrants.

These four sources, the *Rime,* the letters, the *Dialogues in Rome,* and Donato's conversations are combined with the "official" biographies of Vasari and Condivi to supply us with the bulk of direct quotations by the artist which comprise this anthology. During twenty years of Michelangelo study, I have looked into hundreds of Renaissance source materials, including unknown or unexploited sources from as far away as Spain. From these investigations have come many quotations which appear in English for the first time.

These precious words of Michelangelo, spoken by him or written, are arranged in the following pages topically and ideologically, not by chronology or source. Out of them the reader may construct his own "romance of Michelangelo," for as editor I have supplied only introductions, captions, and minimal sentences of presentation. I have resisted the temptation of extensive editing and footnoting. In this book Michelangelo holds the floor. For those who would explore Michelangelo's thoughts further or place them into the full context of his philosophy or aesthetics, I can suggest the reading of several recent volumes, including my own *Michelangelo's Theory of Art* (New York, 1961, London, 1963, and Milan, 1964), which gives full bibliographical

information and pagination of most of the sources used below, and *The Poetry of Michelangelo* (Milan and New York, 1964). Extremely important English-language sources of the artist's life and thought are Charles de Tolnay's magistral six-volume study, *Michelangelo* (Princeton, 1947–), John Addington Symonds's pioneering *Life of Michel-Angelo* (London, 1893), Giovanni Papini's understanding *Life of Michelangelo* (New York, 1952), and Charles Morgan's well-balanced, authoritative biography of the artist (New York, 1960).

In a strictly ideological disposition of Michelangelo's statements, dates cannot of course determine the over-all ordering of the texts. As stated above, materials cannot be presented by chronology or source—an arrangement which might allow one to note more easily occasional evolutions or revisions in the artist's thinking. Within chapters it has in a few cases been possible to present the texts chronologically, such as the series of counsels to young Lionardo about the selection of a wife, of poems addressed to young men, and of complaints on his successive illnesses. However, if chronological must generally give way to ideological ordering, this is less important in the case of Michelangelo than with a more changeable artist. Michelangelo prided himself on the stability and immutability of his thinking. See such claims below as "I am firm in my opinion," "I don't contradict myself," and "I'll abide by my original opinion."

However, the means are provided for the interested reader to place Michelangelo's statements in chronological sequence. Dates are attached to all the letters, even when they are the tentative dates established by Milanesi and others. Dates or at least general chronological attributions accompany the poems, thanks to Enzo Noè Girardi's researches on the chronology of the *Rime*. However, as Girardi is the first to admit, dates proposed for most of the poems inevitably remain tentative and unconfirmable. If the reader will remember further that quotations identified as from De Hollanda date from October, 1538, and those from Giannotti from January-March, 1546 (the period established by Redig de Campos), he will have at his disposal the dates for the vast majority of sources. A completely chronological presentation would moreover have been impossible, since not enough is known to date Michelangelo's quotations set down by such disparate writers or witnesses as Anton Francesco Doni, Niccolò Franco, Giraldi Cinzio, and others. In view of the variety of stylings of the letters, accompanying dates may or may not include commas before the year; tentative years assigned to letters are bracketed.

The topics of the sections below were of course determined by the quantity and distribution of the materials at hand. Thus, there is a variety of subject and tone about them. Some deal with thoughts, some with opinions, some with emotions, and one group is integrated by nothing more encompassing than an ironical sense of humor. The levels represented run the gamut from lofty Platonic thoughts about the

winged soul to clinical observations about his wasted body. Thus, Michelangelo stands revealed in all his complexity and indeed his contradictions. Certain new facets of the man emerge: his guilt-ridden homosexuality, his passion for maxims or aphorisms, his propensity for visions, and especially the anger which most of his biographers tend to gloss over complacently. (One recent novelist-biographer even claims that young Pietro Torrigiani broke Michelangelo's nose without provocation.)

Perhaps the greatest contribution of these pages is to offer the reader a deeper understanding of Michelangelo's art. The essential unity of Michelangelo's thought and taste marks his writing, his conversations, and his art: what the Roman critic Eugenio Battisti has called "the indissoluble unity in Michelangelo's art, poetry, and culture." The two prayers probably composed by Michelangelo or such a poem as "The blessed spirits were no less happy than disturbed and sad," illuminate his Pietàs and Depositions. The jeremiads in his poetry explain his choice of Jeremiah among the Biblical prophets to adorn the Sistine Ceiling. His self-debasing letters to Tommaso Cavalieri reveal the meaning of the *Tityus* he drew for this young Roman nobleman, or of the *Victory*. The continual references to the artist's body as pelt, leather, bark, and so on, are a clue to his self-portrait as the leathery cadaver in the grip of St. Bartholomew on the wall of the *Last Judgment*. These continuous analogies demonstrate the value of a record of the artist's actual words.

One section, "The Interpreter of His Own Art Works" correlates Michelangelo's thoughts to his artistic production more directly or pointedly than the others. Here is the extended sonnet describing the physical ordeal of painting the vast expanse of the Sistine Ceiling. Here, too, are such indirect exegeses as his sonnets explaining the different meanings which the concept of Night held for the artist. Even the mocking self-portrait of the artist coifed with a boar's head, used on our title page, corresponds to the Bernesque and ironic note of poems and postscripts in which Michelangelo refers to himself.

Thus it is anticipated that the reader who has read through the profusion of affirmation and confession in this book will have gained not only a truer picture of the man himself, but a deeper understanding of his masterworks.

A few words of explanation are in order concerning the editing and styling of materials. Names of translators are appended within parentheses after the selection. When no name appears, the translation is my own. Names of contemporary sources for the passages are in brackets. The letters carry either the date of composition as provided in Milanesi's definitive *Le Lettere di Michelangelo Buonarroti* (Florence, 1875) or Milanesi's number in capital Roman numerals. Poems are accompanied by precise or approximate dates. When the incipit verse of the poem is included in the quotation, this verse is given in the Italian. When the

incipit is not used, then the passage carries the poem number (G) assigned to it in Girardi's *Rime di Michelàngiolo Buonarroti* (Bari, 1960). These poem numbers from Girardi may appear within parentheses or brackets, depending on the subsection. In a few cases small Roman numerals refer the reader to the version of the poem found in Carl Frey (F), *Dichtungen des Michelangiolo Buonarroti* (Berlin, 1897).

To make the present revision a more informative source book, an appendix of primary sources for each of the 622 entries has been added to the rear indices on page 181. There is also included a list of new dates proposed in *The Letters of Michelangelo,* edited by E. H. Ramsden (Stanford, 1963), and in the first two volumes of *Il Carteggio di Michelangelo,* still in progress, edited by Paola Barocchi and Renzo Ristori (Firenze, 1965, 1967), wherever these dates differ from or are more precise than the Milanesi.

I. ART AND LETTERS

Consistent with his repeated assertions that the artist's role is to create works of art and not to waste time in mouthings (abbocca-menti) about his craft, Michelangelo was known among his contemporaries for his reticence to talk about the three major fine arts he exercised so brilliantly. Nevertheless, one of the chief characteristics of the High Renaissance was precisely the professional self-consciousness sensed by the artist which led to his being both practitioner and theorist. Not only did Michelangelo respond occasionally to the unremitting curiosity of his fellows about his views on art—and indeed on other artists—but his immersion in art made it impossible for him to avoid the role of practitioner-theorist. Among other motives which led him to become a theorist and critic in spite of himself were the needs to plead his case over his rival artists', to clarify his demands on successive patrons, to distinguish his role from that of his assistants, but especially to speak up for the arts when they were evolving from a trade to a profession. It is not then surprising that the largest group of quotations in this collection is this first chapter on arts and letters. We group these creative categories together, since Michelangelo's long activity as poet (circa 1503-1561) won him the title, among his contemporaries, of Apollo-Apelles, the precise title with which he was hailed by Bembo, Berni, and Varchi. Indeed, despite his modest disclaimers about his poetic "jumble-cakes" Michelangelo has finally won a niche as one of Italy's foremost Cinquecento poets. His thoughts on literature interest us not only in themselves, but as they touch upon the Paragon of arts and letters, widely preached and approved by the humanist who evoked Simonides' famous analogy between painting and poetry.

THE THEORIST ON ART

1. *Asked to join a referendum on the Paragon, that is, the comparison of painting and sculpture, Michelangelo impatiently decrees that each is part of the same artistic process. His letter was published by Varchi in 1549 and dates from March/April, 1547 (Ramsden).*

. . . In my opinion painting should be considered excellent in proportion as it approaches the effect of relief, while relief should be considered bad in proportion as it approaches the effect of painting. I used

to consider that sculpture was the lantern of painting and that between the two things there was the same difference as that between the sun and the moon. But now that I have read your book, in which, speaking as a philosopher, you say that things which have the same purpose are themselves the same, I have changed my opinion; and I now consider that painting and sculpture are one and the same thing, unless greater nobility be imparted by the necessity for a keener judgment, greater difficulties of execution, stricter limitations, and harder work. And if this be the case no painter ought to think less of sculpture than of painting and no sculptor less of painting than of sculpture. By sculpture I· mean the sort that is executed by cutting away from the block: the sort that is executed by building up resembles painting. This is enough, for as one and the other, that is to say both painting and sculpture, proceed from the same faculty, it would be an easy matter to establish harmony between them and to let such disputes alone, for they occupy more time than the execution of the figures themselves. As to that man who wrote saying that painting was more noble than sculpture, as though he knew as much about it as he did of the other subjects on which he has written, why, my serving-maid would have written better! . . . An infinite number of things still remain unsaid which might be urged in favor of these arts, but, as I have already said, they would take up too much time and I have very little to spare seeing that I am old and almost fitted to be numbered among the dead. For this reason I beg of you to excuse me. . . . (Carden)

2. The more relief a painting shows, the more it approaches and as-sumes lifelike quality. [Lomazzo]

3. There is as much difference between painting and sculpture as be-tween shadow and truth. [Doni]

4. *The following words of Michelangelo were recorded by Armenini and explain the frequent "sculptural" quality of the artist's painting:*

This must be kept in mind, that the closer you see paintings approach good sculpture, the better they will be; and the more sculptures will approach paintings, the worse you will hold them to be. Thence it is to be understood that good paintings consist essentially of much relief [roundness] accompanied by a good style. Let it be understood also that sculptures and reliefs, which perfect paintings must resemble, are of course not only those of marble or bronze, but even more, living sculp-tures, like a handsome man, a beautiful woman, a fine horse, and other similar things. [Armenini]

5. *This basic belief in the unity of art was expressed by the usually taciturn Michelangelo to the group in the convent courtyard of San Silvestro, Rome:*

I wish now to state my views about the noble art of painting. Let every man who is here understand this well: design, which by another name is called drawing, and consists of it, is the fount and body of painting and sculpture and architecture and of every other kind of painting, and the root of all sciences. Let whoever may have attained to so much as to have the power of drawing know that he holds a great treasure; he will be able to make figures higher than any tower, either in colors or carved from the block, and he will not be able to find a well or enclosure which does not appear circumscribed and small to his brave imagination. And he will be able to paint in fresco in the manner of old Italy, with all the mixtures and varieties of color usually employed in it. He will be able to paint in oils very suavely with more knowledge, daring, and patience than painters. And, finally, on a small piece of parchment he will be most perfect and great, thanks to his power of design and drawing. . . . [De Hollanda] (Holroyd)

6. *Michelangelo thus viewed design (which he sometimes equated with painting) as the fountainhead of all artistic endeavor:*

But I say, Senhor Lactancio, that the painter must be instructed not only in liberal arts and other sciences such as architecture and sculpture, which are his own province, but also in all other manual crafts which are practiced throughout the world; should he wish, he will do them with more art than the actual masters of them. However that may be, I sometimes set myself thinking and imagining that I find among men but one single art or science, and that is drawing or painting, all others being members proceeding therefrom; for if you carefully consider all that is being done in this life you will find that each person is, without knowing it, painting this world, creating and producing new forms and figures here, in dress and the various garbs, in building and occupying spaces with painted buildings and houses, in cultivating the fields and ploughing the land into pictures and sketches, in navigating the seas with sails, in fighting and dividing the spoil, and finally in buttresses, in burials and in all other operations, movements, and actions. I leave out all the handcrafts and arts, of which painting is the principal fount, of which some are rivers which spring from it, such as sculpture and architecture; some are brooks, such as mechanical trades; and some are stagnant ponds, which do not flow (such as useless handicrafts like cutting out with scissors and such like), formed from the waters of the flood when drawing overflowed its banks in old time and inundated everything under its dominion and empire, as one sees in the works of the

Romans, all done in the manner of painting. In all their painted buildings and fabrics, in all works of gold, silver, or in metals, in all their vases and ornaments, and even in the elegance of their coins, and in their dress and armor, in their triumphs as well as in all their other operations and works, one easily recognizes how, in the time when they held sway over all the earth, my lady Painting was the universal sovereign and mistress of all their deeds and trades and sciences, extending herself even to writing, and composing or writing histories. So that whosoever well considers and understands human works, will find without doubt that they are all either painting itself or some part of painting; and although the painter be capable of inventing what has not as yet been found, and of doing all the handicrafts of the others with much more grace and elegance than their own professors, yet no one but he can be a true painter or draughtsman.

[De Hollanda] (Holroyd)

7. *The sculptor is not an originator, but rather the executor who draws forth from rock the art-forms which God has designed and enclosed within:*

SE BEN CONCETTO . . .

When godlike art has, with superior thought,
The limbs and motions in idea conceived,
A simple form, in humble clay achieved,
Is the first offering into being brought:
Then stroke on stroke from out the living rock
Its promised work the practised chisel brings,
And into life a form so graceful springs,
That none can fear for it time's rudest shock.

(1545/46) (Fanny Bunnett)

8. *The following celebrated quatrain of one of Michelangelo's sonnets constitutes the most compact statement of his basic view of art as God-implanted form to be discerned by chosen intellects and released by trained hands:*

NON HA L'OTTIMO ARTISTA . . .

Nothing the greatest artist can conceive
That every marble block doth not confine
Within itself; and only its design
The hand that follows intellect can achieve.

(1538/44) (H. W. Longfellow)

9. *Whatever the subject chosen by the artist, he is at best an imitator of the beautiful forms conceived by God:*

Painting is not such a great work as any of those which you have mentioned, sir, only the painting which I so much vaunt and praise will be the imitation of some single thing among those which immortal God made with great care and knowledge and which He invented and painted, like a Master: and so downward, whether animals or birds, dispensing perfection according as each merits it. And in my judgment that is the excellent and divine painting which is most like and best imitates any work of immortal God, whether a human figure, or a wild and strange animal, or a simple and easy fish, or a bird of the air, or any other creature. And this neither with gold nor silver nor with very fine tints, but drawn with a pen or pencil, or with a brush in black and white. To imitate perfectly each of these things in its species seems to me to be nothing else but to desire to imitate the work of immortal God. And yet that thing will be the most noble and perfect in the works of painting which in itself reproduced the subject which is most noble and of the greatest delicacy and knowledge. And what barbarous judge is there who cannot understand that the foot of a man is more noble than his shoe? His skin than that of the sheep from which his clothes are made? And who from this will proceed to find the merit and degree in everything? But I do not mean that, because a cat or a wolf is humble, the man who paints them skillfully has not as much merit as one who paints a horse, or the body of a lion, since even (as I have said above) in the simple shape of a fish there is the same perfection and proportion as in the form of man, and I may say the same of all the world itself with all its cities. But all must be ranked according to the work and study which one demands more than another, and this should be taught to some ignorant persons who have said that some painters painted faces well but that they could not paint anything else. Others have said that in Flanders they painted clothes and trees extremely well, and some have maintained that in Italy they paint the nude and symmetry or proportions better. And of others they say other things. But my opinion is that he who knows how to draw well and does merely a foot or a hand or a neck, can paint everything created in the world; and yet there are painters who paint everything there is in the world so imperfectly and so much without worth that it would be better not to do it at all. One recognizes the knowledge of a great man in the increasing fear with which he does a thing the more he understands it. And on the contrary, the ignorance of others in the foolhardy daring with which they fill pictures with what they know nothing about. There may be an excellent master who has never painted more than a single figure, and without painting anything more deserves more renown and honor than those who have painted a thousand pictures: he knows better

Goldscheider

Block of Marble Bearing Michelangelo's Symbol: An M
with Interwoven Circles (Florence, Archivio Buonarroti)

Nothing the greatest artist can conceive
That every marble block doth not confine
Within itself . . . (*see page 11*)

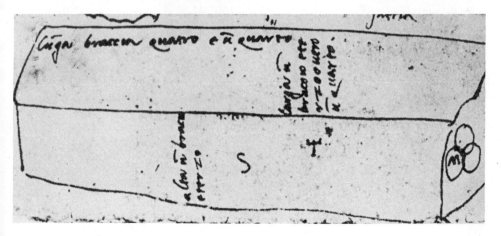

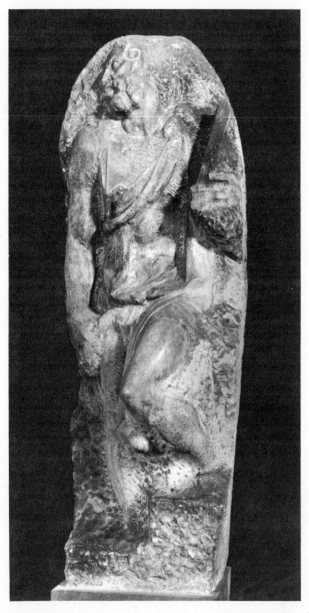

Brogi

Saint Matthew (Florence, Accademia delle Belle Arti)
Then stroke on stroke from out the living rock
Its promised work the practised chisel brings . . .
(*see page 11*)

Sketch of Bronze David with Study of Right Arm of
Marble David (Paris, Louvre)

David with the sling
and I with the bow
 Michelangelo (*see page 46*)

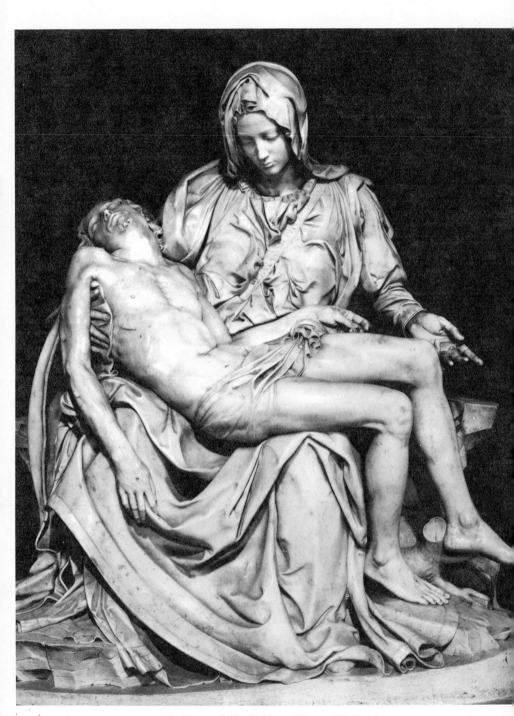

Madonna della Febbre (Rome, Vatican)

. . . For these reasons I have represented the Very Holy Virgin, the Mother of God, much younger than her years . . . (*see page 47*)

how to do what he has not done than the others know what they do.

And not only is this as I tell you, but there is another wonder which seems greater, namely, that if a capable man merely makes a simple outline, like a person about to begin something, he will at once be known by it—if Apelles, as Apelles; if an ignorant painter, as an ignorant painter. And there is no necessity for more, neither more time, nor more experience, nor examination, for eyes which understood it and for those who know that by a single straight line Apelles was distinguished from Protogenes, immortal Greek painters. [De Hollanda] (Holroyd)

10. *To Niccolò Franco on nobility of subject:*

And who does not know that a noble and sublime subject gives greatness to our souls and lends wings to the most humble and modest intellect?

11. *The welter of subjects:*

> PASSA PER GLI OCCHI . . .
>
> In one instant there passes through the eyes to the heart
> Every sort of beautiful object which exists,
> On such a vast and capacious field of vision
> That a hundred, nay a thousand, are caught up,
> Of every age, of each sex, whereat I am bewildered. . . .
> (1547/50)

12. *Just as living rock is perfected through the medium of art, so is the poet made better through the perfecting grace of love:*

> SICCOME PER LEVAR . . .
>
> As when, O lady mine,
> With chisell'd touch
> The stone unhewn and cold
> Becomes a living mold,
> The more the marble wastes,
> The more the statue grows;
> So, if the working of my soul be such
> That good is but evolved
> By Time's dread blows,
> The vile shell, day by day,
> Falls like superfluous flesh away.
> Oh! take whatever bonds my spirit knows,
> For will and power inert within me stay.
> (1538/44) (Mrs. Henry Roscoe)

13. *As a Platonist Michelangelo knows that the Idea of beauty outlives the ravages of time:*

MOLTO DILETTA AL GUSTO INTERO . . .

With deep delight may sound, sane taste behold
That work of highest art, complete and rare,
Which shows the face with movements apt and fair,
With wax, or clay, or stone, in human mold.

But if injurious time too rough or bold,
Shall shatter or distort those limbs, or tear,
Then not in vain the beauty lingering there
Recalls in thought what was so fair of old.

So does thy own great loveliness allow
To see His work who did the Heavens adorn,
Th' Eternal Artist unto whom we bow.

Time passes, comes old age. ₁nd still more thou
Comest as each thought of that fair past is born
Unchanged, unchilled by passing winter now.
 (1545/46) (G. Grinnell-Milne)

14. *In a letter apparently to Cardinal Rodolfo Pio dei Carpi, discussing St. Peter's, Michelangelo proves himself a good disciple of Vitruvius, the Roman theorist who anthropomorphically compared architecture to human anatomy:*

[Undated; 1550–1560]

When a plan includes several parts, all those which are of the same qualitative and quantitative kind are to be decorated in the same mode and manner, as must the parts paired with them. But when the plan is radically changed, it is not only permissible but necessary to change the decoration of the corresponding parts. What is in the very center is always as free as you like, just as the nose, which is in the middle of the face, need not conform to either one or the other eye. But one hand is quite obliged to be like the other, and one eye like the other with regard to position and correspondence. For it is an established fact that the members of architecture resemble the members of man. Whoever neither has been nor is a master at figures, and especially at anatomy, cannot really understand architecture.

15. Ha! To change all these trifles [in an architectural plan], major changes become necessary, and to accomplish that you must imitate a man who has to pass a ditch too wide for him to jump to the other side,

too wide by several palms. In such a case he must retreat in order to be able to leap forward. [Bernini]

16. *Michelangelo the artist makes Art, here allegorized as a woman, seem even more beautiful than Nature:*

COSTEI PUR SI DELIBRA . . .

Thus, she decides,
Untamed and savage woman,
That I should burn, die, and fall,
Seeking a favor weighing not even an ounce,
While she drains my blood
Pound by pound from my veins and fibers,
And disarranges my soul and body.
There she enjoys herself and primps
At her trusty looking-glass,
In which she sees herself equal to paradise.
Then, turning to me, she settles me properly,
For beyond being old, my aged face
Makes her mirrored face more comely,
Whence I am all the more derided
For my ugliness: and yet it is a boon to me,
If in making her beautiful, I am defeating nature.

(1541/44)

17. *Michelangelo points up the primacy of arts over crafts:*

If a room were adorned with tapestries woven with gold, and in another room there were only one beautiful statue, the latter room would appear to be adorned royally and would make the first look like a nun's cell. [Bernini]

18. *What determines the price and value of art?*

What do you call valuing? Do you wish the painting which we are discussing to be paid for according to a valuation, or do you think that anyone knows how to value it? For I consider that work to be worth a great price which has been done by the hand of a very capable man, even though in a short time; if it were done in a very long time who will know how to value it? And I hold that to be of very little value which has been painted over many years by a person who does not know how to paint, although he be called a painter; for works ought not to be esteemed because of the amount of time employed and lost in the labor, but because of the merit of the knowledge and of the hand which did them; for if it were not so, they would not pay more

to a lawyer for an hour's examination of an important case, than to a weaver for as much cloth as he may weave during the course of his whole life, or to a ditch digger who is bathed in sweat the whole day by his work. By such variation nature is beautiful, and that valuation is very foolish which is made by one who does not understand the good or the bad in the work: some paintings worth little are valued highly, and others, which are worth more, do not even pay for the care with which they are done or for the discomfort that the painter himself experiences when he knows that such persons have to value his work, or for the exceeding disgust he feels asking for payment from an unappreciative treasurer.

It does not seem to me that the ancient painters were content with your Spanish payments and valuations; and I certainly think they were not, for we find that some were so magnificently liberal that, knowing that there was not sufficient money in the country to pay for their works, they presented them liberally for nothing, having spent on such work labor of their mind, time, and money. Such were Zeuxis, Heracleotes, and Polygnotus Thasius and others. And there were others of a more impatient nature who used to waste and break up the works that they had done with so much trouble and study, on seeing that they were not paid for as they deserved; like the painter who was commanded by Caesar to paint a picture, and having asked a sum of money for it that Caesar would not give, perhaps in order to effect his intention the better, the painter took the picture and was about to break it up, his wife and children around him bemoaning such great loss; but Caesar then delighted him, in a manner proper to a Caesar, giving him double the sum which he had previously asked, telling him that he was a fool if he expected to vanquish Caesar. [De Hollanda] (Holroyd)

19. *The artist's innate sense of proportion:*

It is necessary to keep one's compass in one's eyes and not in the hand, for the hands execute, but the eye judges. [Vasari]

20. Modern sculptors and painters ought to have proportion and measures right in their eyes, in order to put them into execution. This science has been lost among the moderns, if compared to those marvelous statues of the classic artists, such as those of Phidias and Praxiteles located here in Rome. [Lomazzo, *Trattato*]

21. Among men all the proportions of geometry and arithmetic or examples of perspective are of no avail without the eye, that is, without exercising the eye to learn how to see. [Lomazzo, *Trattato*]

22. Proportion should be in men's eyes so that they might know directly how to judge what they see. [Lomazzo, *Idea*]

23. The ancients possessed the true science of knowing how to view statues from both near and far. [Lomazzo, *Trattato*]

24. *The Ideal Composition: Advice to Marco da Siena*

You should always make a figure pyramidal, serpentine-formed, and multiplied by one, two, and three. [That is, ankle = 1, calf = 2, thigh = 3.]

25. *Like Leonardo da Vinci, Michelangelo liked to stress that painting is a matter of the head as well as the hand:*

In many places there are painters who are not painters, but as the majority of people are without sense and always love that which they ought to abhor, and blame that which deserves most praise, it is not very surprising that they are so constantly mistaken about painting, an art worthy only of great understandings, because without any discretion or reason, and without making any distinction, they call a "painter" both the person who has nothing more than the oils and brushes of painting and the illustrious painter born only in the course of many years (which I consider to be a very great event); and as there are some who are called painters and are not painters, so there is also painting which is not painting, for they do it. And what is marvelous is that a bad painter neither can nor knows how to imagine, nor does he even desire to do good painting; his work mostly differs but little from his imagination, which is generally somewhat worse; for if he knew how to imagine well or in a masterly manner in his fantasy, he could not have a hand so corrupt as not to show some part or indication of his good will. But no one has ever known how to aspire well in this science, except the mind which understands what good work is, and what he can make of it. It is a serious thing, this distance and difference which exist between the high and the low understanding in painting.

[De Hollanda] (Holroyd)

26. *Michelangelo preferred to think that the artist of genius can execute with speed and a minimum of effort. Indeed, he was reputed to work this way himself, both as sculptor and painter. However, such rapidity should be attempted by only those craftsmen of sound judgment and long training:*

I will tell you: to do anything quickly and swiftly is very, profitable and good, and it is a gift received from the immortal God to do in a few hours what another is painting during many days; for if it were not so Pausias of Sicyon would not have worked so hard in order to paint in one day the perfection of a child in a picture. If he who paints quickly

does not on that account paint worse than one who paints slowly, he deserves therefore much greater praise. But should he through the hurry of his hand pass the limits which it is not right to overstep in art, he ought rather to paint more slowly and studiously; for an excellent and skillful man is not entitled to allow his taste to err through haste when thereby some part is forgotten or neglected of the great goal perfection, which must be always sought; hence it is not a vice to work a little slowly or even to be very slow, nor to spend much time and care on works, if this be done for more perfection; only the want of knowledge is a defect.

And I wish to tell you, Francisco De Hollanda, of an exceedingly great beauty in this science of ours, of which perhaps you are aware, and which I think you consider the highest, namely, that what one has most to strive for in painting is to do the work with a great amount of labor and study in such a way that it may afterward appear, however much it was labored, to have been done almost quickly and almost without any labor, and very easily, although it was not. And this is a very excellent beauty! At times some things are done with little work in the way I have said, but very seldom: most are done by dint of hard work and appear to have been done very quickly.

Plutarch says in his book *De Liberis educandis,* that a poor painter showed Apelles what he was doing, telling him: "This painting has just this moment been done by my hand." Apelles answered: "Even if you had not said so I should have known that it was by your hand and that it was done quickly, and I am surprised that you do not do many of them every day."

However I should prefer (if one had either to err or be correct) to err or be correct quickly rather than slowly, and that my painter should rather paint diligently and a little less well than one who is very slow, painting better, but not much better. [De Hollanda] (Holroyd)

27. *To learners, however, Michelangelo advises against haste:*

Hurry does not pay, in any case, except in knowing how to seize an occasion which offers itself at a given moment, and at that moment escapes him who does not recognize it. But in matters of art, this hurry lacks judgment and may therefore be said to be blind. Whereas Art, which is imitative of Nature (if it wishes to be praised for its function) should not depart from that very method which Nature uses in the generation of animals: the longer the life that these animals are to have, the more time Nature spends in producing them.

[Giraldi Cinzio, *Hecatommithi*]

28. *Michelangelo expresses the Renaissance ideal of* sprezzatura, *apparent effortlessness:*

Only those figures are well-executed which the artist has eliminated effort, that is, executed with such skill that they appear things done naturally and not by artifice. [G.-B. Gelli]

29. *Michelangelo's rejoinder to those who complained that his portrayal of Lorenzo and Giuliano de' Medici was not lifelike:*

A thousand years from now no one could judge that they looked otherwise! [Niccolò Martelli]

30. *On decoration and ornament:*

The human figure is the ideal ornament for the niche.
 [Bernini; also Vasari]

THE CRAFTSMAN

20 January, 1542
31. I am a poor man of little value, who keeps striving in that art which God has given me, to lengthen my life as much as I can.

October, 1542
32. I cannot live under pressures from patrons, far less paint.

33. *Discussing the settlement of claims against the artist by the heirs of Julius II, Michelangelo reveals his compulsion to work:*

19 April 1525
. . . And as soon as it is cleared up what I am to pay back, I'll decide which of my possessions I shall sell, and arrange repayment, and then attend to the Pope's commission and get to work: for as things stand I cannot live unless I am working.

34. *Michelangelo's unwillingness to accept the Herculean assignment of painting the Sistine Ceiling in a medium unfamiliar to him is apparent even in the receipt which he signed on 10 May, 1508:*

I, Michelangelo Buonarroti, *sculptor,* have received from his Holiness 500 ducats of the Camara, on account, for the *paintings* of the vault of the Chapel of Pope Sixtus.

35. *To Julius II:*

And yet I told your Holiness that I was no painter. [Condivi]

36. *After working for over a year on the Sistine Ceiling, Michelangelo wrote to his father one of his many subsequent admissions that he was no painter:*

27 January 1509

. . . I'm still in quite a terrible dither, for it's now more than a year that I've not received a grosso from this Pope, and I don't ask for any, because the work isn't advancing in a way that seems to me worthy of payment. The thing that's difficult about this work is that it still just isn't my profession. And so I go on wasting my time fruitlessly. May God help me!

37. *Michelangelo's arms as he hammers and chisels are sustained by God himself, just as God has informed his Intellect:*

SE 'L MIO ROZZO MARTELLO . . .

If my rude hammer the unwilling stone
To human form and attitude doth mold,
It moves with him, who doth it guide and hold,
His will and impulse taking for its own.
But one diviner doth in heaven abide,
Which shapeth beauty with no hand to aid;
No hammer is, save by another, made,
Then doth th' eternal one make all beside.
And as the hammer that is raised on high,
With greater force doth on the forge descend,
So that, to mold my own, to heaven is gone.
Whence mine unperfected must useless lie,
Unless that instrument divine shall lend
Its aid in heaven, which here availed alone.

(1534/36) (Elizabeth Hall)

38. *Michelangelo's definition of sculpture:*

That art which God has given me. [Niccolò Martelli]

39. *Of painting:*

This most noble science belongs to no single country, for it comes from heaven. . . . [De Hollanda]

40. *Of painting rapidly:*

A gift received from the immortal God. [De Hollanda]

41.

COLUI CHE 'L TUTTO FE . . .

He who made the whole made every part,
And then from the whole chose the most beautiful part,
To exhibit here below his most lofty creations,
As he has now done with his divine art.

(1504/11)

42. *On the beauty of Cecchino de' Bracci:*

With his face God wished to correct nature. (G 213)

43. *The aged Michelangelo's reply to Cardinal Farnese, who inquired why he was headed for the Colosseum in such inclement weather:*

I'm still going to school to learn. [Lomazzo, *Idea*]

44. *On his deathbed Michelangelo confessed to Cardinal Salviati:*

I regret that I have not done enough for the salvation of my soul and that I am dying just as I am beginning to learn the alphabet of my profession. [Bernini]

45. *A complaint registered with Clement VII in 1524:*

. . . Now I see that the matter is dragging along, nor can I know how it is really progressing. I apologize therefore to your Holiness, but if what has happened does not please you, since I have no authority in the matter, it doesn't seem to me that I'm in the wrong. And I pray you, that in wishing me to do something, do not give me in the exercise of my art men over my head, and have trust in me, and give me free commission; then you will see what I can do, and what an accounting of myself I shall render to your Holiness.

46. *The artist's first known letter from Rome to his father, 1 July 1497, is a commentary on the patronage system:*

Most reverend and dear father.—Do not be surprised that I'm not returning, because I haven't yet been able to settle my affairs with the Cardinal. I won't leave if first I'm not satisfied and repaid for my labors. But with these bigwigs one has to go slow, because they won't be coerced. . . .

30 July 1513

47. I am solicited so much that I can't take time out to eat.

48. Poor, old, and a slave in the power of others. [G 267]

24 October 1525

49. They haven't let me do anything I want for several months now, for one cannot work at one thing with the hands and another with the brain, especially working in marble. Here in Florence people are saying that these things are done to spur me on. I tell you that those are poor spurs which make one turn backward.

50. *When the churchman Marcello Cervini asked the aged artist to account for his stewardship of the workshop at St. Peter's, Michelangelo retorted bitterly—hardly suspecting that his inquisitor was shortly to become Pope Marcellus II:*

I am not obliged to tell you, nor even less do I wish to, either to your Lordship, or anyone, what I must do and what I intend to do. Your job is to keep the money rolling in and out of the hands of thieves. As for the planning of the building, just you leave that to me!

51. *Michelangelo's projected façade for the Church of San Lorenzo in Florence never was executed in his lifetime, and is even today unfinished. Again the hopes of the artist are dashed by his patrons:*

[From Carrara, 2 May, 1517]

Messer Domenico,—Since I wrote to you lately, I had no time to spare for making models as I said I intended, but the reason would take too long to write. I had already roughed out a smallish one of clay, sufficient for my purpose here, and although it is as twisted as a shaving I intend to send it to you, come what may, lest this business may appear to be a fraud.

I have many things to tell you, so I beg of you to read on for a while with patience, as it is a matter of importance. Well then, I feel myself capable of carrying out this façade for San Lorenzo in such a way that it shall be a mirror of architecture and sculpture for all Italy; but the Pope and the Cardinal must make up their minds quickly whether they want me to do it or not. If they wish me to do it, they must come to some arrangement, either giving me a contract for the whole work and entrusting everything to my care, or adopting any other plan they may have in mind of which I know nothing. You will understand my reason for this.

As I have already told you, and again since I wrote last, I have placed orders for much of the marble, and have paid out money here and there, setting the men to digging in various places. Some of the places

on which I have spent money have failed to yield suitable marble, because the quarries have faults, this being especially the case with the large blocks I require, which must come up to my standard of excellence. One block which I had already begun to excavate proved to be faulty at the further end, a circumstance which could not possibly have been foreseen, with the result that the two columns I hoped to cut from it are of no use and half the money is wasted. The consequence of these misfortunes is that out of all this marble I have only been able to retain a few hundred ducats' worth: and as I don't know how to keep accounts, I shall in the end only be able to prove that I have spent so much money as is represented by the quantity of marble I shall ultimately consign to Florence. I only wish I could give free service as Maestro Pier Fantini [a generous doctor] used to do, but I have not enough ointment. Besides, I am an old man, and I do not think it worth while to save the Pope 200 or 300 ducats at the loss of so much time, and seeing that I am being pressed to return to my work [on Julius's tomb] in Rome, I now have to decide what I intend to do.

And this is my decision. Knowing that I have to do the work and arrange the price, I should not hesitate about throwing away 400 ducats, as I have no account to render: I should take three or four of the best men obtainable and make them responsible for all the marble, stipulating that it is to be of the same quality as that I have already quarried—which is excellent, though small in quantity. For this marble and for the money advanced I should obtain good security in Lucca: I should give orders that the marble already quarried is to be taken to Florence, and I should go there to work both for the Pope and for myself. If the above-mentioned arrangement with the Pope is not ratified it will make little difference to me; for I could not, even if I wished, have all the marble for my work sent to Florence if I have to take it on again to Rome. But I am obliged to hurry to Rome to get on with my work there, because, as I have already said, I have been urged to do so.

The cost of the façade, according to the way I want to carry it out—including everything, so that the Pope may have nothing further to provide for—cannot, according to my estimate, be less than 35,000 ducats of gold. I would undertake to finish it for this sum within six years, with this condition, that within six months I should be given at least another thousand ducats on account for the marble. Should the Pope not approve of this, one of two things will be necessary: either the expenses I have already begun to incur for the aforesaid work must be charged to my account and I must bear the loss, or else I shall have to restore the thousand ducats to the Pope so that he may appoint someone else to carry on the facade, as at any cost I wish to get away from here, for several reasons.

With regard to the price mentioned, I wish the Pope and the Cardinal so well that as soon as the work is begun, if I were to find that it could

be done for less, I would inform them of the fact even more willingly than if I were paying for it myself: indeed, I intend to do the work in such a way that it will cost me more than I am asking for it.

Messer Domenico, I beg of you to let me know definitely what the Pope and the Cardinal wish to do: this would be a very great kindness, greater than all the others I have received at your hands. . . . (Carden)

52. *John Addington Symonds rightly calls the following letter, concerning the "tragedy of the tomb" of Julius II, "one of the most weighty autobiographical documents from the hand of Michelangelo in our possession."*

October, 1542

Monsignore. Your Lordship has word sent to me that I am to paint and not have doubts about anything. I reply that one paints with the brain and not with the hands; and that he who cannot have his brain about him does himself a disservice; so until my affairs are arranged, I shall not do anything good. The rectification of the last contract has not come; so long as the previous agreement is operative, drawn up under Clement, I am stoned every day as though I had crucified Christ. I tell you that it was not my understanding that the aforesaid contract had the approval of Pope Clement. I say that the contract which I heard read before Pope Clement was not like the copy I afterward received, and the reason was as follows: I was sent off the very same day by Clement to Florence: Gianmaria of Modena, the agent, was with the notary, and made him draw it up in his own way, so that when I returned home and verified it I found a thousand more ducats had been put down as paid to me than was really the case; I found the house in which I live had been put down against me, and several other things which would nearly ruin me; Clement would never have allowed it, and Fra Sebastiano [del Piombo] begs me to let the Pope know of this and have the notary hanged, but I do not wish it, because I do not consider myself bound by a contract which I should not have agreed to had I been consulted. I pledge my word that I am not aware of ever having had the money of which the said contract speaks, and which Gianmaria says he finds I have received.

But let us suppose I have received them because I have acknowledged it, and cannot get out of the contract; and not only that sum, but other money as well, if other can be found, and total it and see all I have done for Pope Julius in Bologna, Florence, and Rome, in bronze, marble, and on canvas, and see what I deserve. I say, with a clear conscience and according to what Pope Paul allows me, that I ought to receive 5000 *scudi* from the heirs of Pope Julius.

I also say that I have had such paltry rewards for my labors from Pope Julius, partly through my own fault for not being able to manage

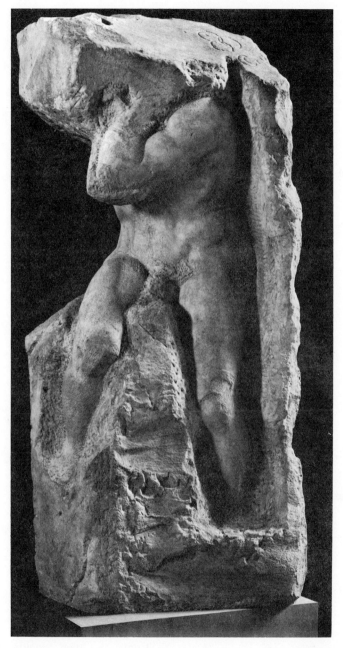

Slave ("Atlas") for the Tomb of Julius II (Florence, Accademia delle Belle Arti)

I am of old thy faithful servitor [*servo:* slave] (*Early verse epistle to Pope Julius II, see pages 27 and 50*)

Manuscript, with Accompanying Self-Portrait, of Extended
Sonnet on Painting the Sistine Ceiling
 In this hard task I've such a goiter grown . . . (*see*
page 51)

myself. If it had not been for what Pope Paul has done for me, I should today be dying of hunger; but, according to the agent, it appears as if I have become a rich man, and even gone so far as to rob the church; they make a great ruckus over it, and I might, I daresay, find means to hush them, but I am not equal to it. After the contract before Clement was made, and I had returned from Florence and commenced work on the sepulcher of Julius, Gianmaria, agent to the old Duke [of Urbino] told me that if I wished to give the Duke great pleasure I should go about my business, that he did not care anything about the tomb, but my serving Pope Paul vexed him sorely. Then I began to see why my house had been put into the contract, to make me go away, and let them lay hold of it with all their strength; one can easily see what they are wishing for, and even those who are not friends of their master's would be ashamed of them. . . .

I find myself having lost my youth and manhood, tied down to this tomb, which I defended as much as possible with Popes Leo and Clement; and my excessive loyalty which no one consented to acknowledge has ruined me. Thus my destiny wishes it! I see many men with incomes of 2000 or 3000 crowns lying in bed, while I with my very great efforts manage to grow poorer.

But to return to painting, I do not wish to deny anything to Pope Paul: I shall paint unhappy and shall paint unhappy things. I have written this to your lordship, for whatever happens you can explain the truth better to the Pope. And I should even be grateful if the Pope should hear my story, to know just how this war is made up which is being waged against me. Let him understand who should understand. . . .

There still occurs to me something else to be said. This ambassador stated that I have lent at usury monies of Pope Julius, and that I became rich from them: as if Pope Julius had ever advanced me 8000 ducats. The monies which I received for the sepulcher means the monies I paid out at that time on the tomb; it will be seen that they were close to the total specified in the contract made out in Clement's time. In his first year in office, Pope Julius commissioned me to make his tomb, and I stayed eight months at Carrara excavating marbles and sending them to the Piazza of St. Peter's where I had my lodgings behind Santa Caterina; then Pope Julius decided not to build his tomb during his lifetime, and set me to painting. Then he kept me in Bologna for two years doing his statue in bronze that was melted down later; then I returned to Rome and I stayed with him until his death, keeping my house always open, without provision or payment, continually living on the money for the tomb, since I had no other income. After the aforementioned death of Julius, Aginensis wanted me to keep on with the tomb, on an even grander scale; so I brought the marbles to the Macello de' Corvi [Michelangelo's later studio] and had that part of the project

done which is walled in at San Pietro in Vincoli, and I completed the figures which I have at home. At that time, Pope Leo, not wanting me to work on that tomb, pretended that he wished to complete the Façade of San Lorenzo in Florence and asked Aginensis for me. He therefore permitted me nevertheless to work on the sepulcher of Pope Julius at Florence. . . .

I beg your Lordship, when you have time, to read this account, and to use it to my benefit, and to know that there are still witnesses to many of the things herein written. I should even be gratified if the Pope were to see it and if everyone were to see it, because I write the truth and indeed understate, and I am neither usurer nor thief, but a Florentine citizen, noble and son of a gentleman, and not a nobody. . . .

To continue my history of the tomb of Julius, let me say that when he changed his mind about having it built during his lifetime, certain shiploads of marble arrived at the Ripa [dock] which I had meanwhile ordered at Carrara. Unable to get the cost of lading from the Pope, he having repented of the enterprise, I had to borrow to defray the cost of either 150 or 200 ducats, lent me by Baldassare Balducci, that is, by the bank of Messer Jacopo Gallo. At that time workmen came from Florence, some of whom are living today, and I furnished with beds and furniture the house which Julius gave me behind Santa Caterina, and with other things for the aforementioned tomb. All of this being accomplished without receiving money, I was greatly embarrassed. And as I was pressing the Pope as hard as I could to get on with the project, one morning when I was there to talk to him about finances, he had me dismissed by a lackey. As a bishop from Lucca who was witness to the incident said to the lackey:

"Don't you recognize this man?"

The lackey said to me,

"Pardon me, sire, but I am ordered to act thus."

I returned home and wrote as follows to the Pope:

"Most Blessed Father, I have this morning been expelled from the Palace on orders from your Holiness; therefore I am advising you that from now on, if you wish me, you will seek for me elsewhere than in Rome."

I sent this letter to Messer Agostino, the steward, to be given to the Pope; and at home I called in Cosimo the carpenter, who was staying with me furnishing my home, and a stone mason, still alive today, who was staying with me and I said to them:

"Go to a Jew's, and sell what's in this house, and then come up to Florence."

I went off and took a seat in the post carriage and went off toward Florence. The Pope having received my note, sent five horsemen in pursuit, who caught up with me at Poggi Bonsi at about three hours after dark and handed me a letter from the Pope which read, "Once you

have seen this letter, under pain of our displeasure, return to Rome."
The horsemen wanted me to answer, to prove that they had found me.
I replied to the Pope that whenever he observed those courtesies which
were his obligation, I should return. Otherwise, he should not expect
ever to have me again. And during my stay afterward in Florence, Julius
sent three briefs to the Signory. At the last one, Soderini the chief coun-
cilor, summoned me and said, "We don't wish to go to war with Pope
Julius because of you. You must return, and if you consent, we shall
write you letters of such authority that if he harms you, he will be
harming the Signory." So I took the letters and went back to the Pope.
What happened afterward would take a long time to tell. Suffice it to
say that this business cost me more than a thousand crowns, because
when I had fled from Rome, there was a lot of talk to the disparagement
of the Pope; and almost all the marbles which I had on St. Peter's
Square were sacked, especially small ones. I had therefore to start over
anew. So that I say and claim that I ought to receive as damages or
interest from the heirs of Julius II 5000 ducats; and he who took from
me my youth and honor and possessions now calls me a thief. . . .

I beg your Lordship, for the love of God and Truth, when you have
time, straighten up these matters, so that whatever happens I may de-
fend myself to the Pope against those who speak ill of me, without any
of the true facts, and who have with false information given the Duke
a picture of me as a great scoundrel. All the discords between Pope
Julius and me grew out of the envy of Bramante and Raffaello da
Urbino; and that was the reason for his not finishing the tomb in his
lifetime. By this they hoped to ruin me, and Raffaello had indeed good
reason to, for all that he had of art he got from me.

53. *Michelangelo's bitterness over the slights, "Canossas," and ill treat-
ment inflicted upon him by his early patron, Julius II, informs a sonnet
which probably was never shown to the Pope:*

SIGNOR, SE VERO È' . . .

If truth in any ancient saw there be,
'Tis here, "Who can, he never hath the will":
To tales and foolish talk thou listenest still,
Rewarding him who is truth's enemy.
I am of old thy faithful servitor,
To thee belong as to the sun its rays:
But thou, unrecking of my wasted days,
Art more displeased, as I toil the more.
I trusted thy greatness to ascend:
Need is of sword and scales to shield the weak,
Not empty words by Echo uttered.

In scorn it is that heaven doth virtue send
To dwell on earth, who mocking bids it seek
Fruit of its labor from a tree that's dead.

(1511) (Elizabeth Hall)

54. *In the following madrigal Michelangelo expresses the conviction
that perfection in art arrives late and then builds a love poem upon it.*

NEGLI ANNI MOLTI . . .

That wise man, who through labors manifold
And length of years, toils at the rebel stone
Shall see one form alone
Perfect, in living grace, before he die;
Since to high things untold
Late we attain, and soon must bid goodby.
If nature equally
From age to age devising many a face
Have beauty's absolute created here
In yours most fair, she's old and must decay;
And therefore does your grace
Combine with potent fear
With strangest food my soul to stay
Nor can I deem or say
Beholding you, which most shall harm or bless
Creation's end, or so great happiness.

(1542/44) (Robb)

55.

One does not have entire mastery
Until the very end of art and life. [G 241]

56. *The artist bestows eternity upon those beloved friends whom he
portrays, and their beauty will thus be preserved after his death and
theirs:*

COM' ESSER, DONNA, PUÓ . . .

Lady, how can that be, which each discerns,
As slowly passing years the truth make known
That longer lives the image carved in stone,
Than he, the maker, who to dust returns?
To the effect doth yield, surpassed, the cause,
And art of man doth nature's self subdue;

I know, who in fair sculpture prove it true,
Which still of time and death defies the laws.
Thus I to both us twain long life can give,
In paint or marble, as my wish may be
The semblance of thy face and mine to show.
And ages after we have ceased to live,
How fair thou wert, and I how sad, they'll see;
And that I was no fool to love thee so.

(1545/46) (Elizabeth Hall)

57. *Three comments on imitation:*

He who goes along behind others never passes ahead of them, and he who cannot do well by himself cannot utilize well the works of others.

[Armenini; also Vasari]

The artist can be surpassed only by himself. [Vasari]

For he who would without wings
Follow an angel, in vain he casts
Seed on rocks, words on wind, and intellect to God.

(G 80)

58. *On artists copying figures in the Sistine Chapel:*

This manner of mine will make many into clumsy artists! [Baldinucci]

59. Oh how many there are who want to make something clumsy of this work of mine. [Armenini]

60. *On studying from models:*

Studying from models is bad for beginners. [Armenini]

61. *Typical of Michelangelo's complaints about his assistants is the following passage in a letter from Rome to his brother Buonarroti, 1 August 1515:*

. . . Enclosed in this will be a letter for Michele, which is to be given to him. I do not write to him because I know he is crazy, but because I am in need of a certain quantity of marble, and I do not know how else to obtain it. I do not wish to go to Carrara myself, for I cannot, and I am not able to send anyone else who would be suitable, for if they are not madmen they are traitors and rogues—like that scoundrel Bernardino who at the end of his stay here left me a hundred ducats worse off than I was before, not to mention his going about gossiping and complaining about me all over Rome. I have learned

this only since I have been back here. He is a villainous scoundrel: avoid him as you would avoid fire, and do not allow him to enter the house under any pretext.

62. *From the quarries of Serravezza the poor sculptor sent back the following complaint to his brother in Florence (September 2, 1518):*

. . . Sandro has skipped off. He stayed around here several months with a pair of mules putting on airs, busy fishing and making love. He's thrown away a hundred ducats of my money; he's left here behind him a certain quantity of marbles with documents that I am to take what is suitable to my needs. I cannot even find twenty-five ducats' worth in the entire lot, and the whole business is a fraud. Either through malice or ignorance he has treated me very shabbily. When I get back there to Florence, I intend to have satisfaction at all costs. Nothing more.

63. These stonecutters whom I brought here don't understand anything in the world either about quarries or marbles. They are already costing me 130 ducats and they haven't yet quarried a flake of marble which is any good. (CXVI)

64. [The goldsmith] Messer Bernardino has really failed, to my damage as well as to his, for he has disgraced himself to such an extent that he no longer dares raise his eyes throughout Bologna. (LXIII)

65. [My new assistant] isn't worth a quattrino and makes me strain like a beast and my other *garzone* isn't out of bed yet. (XIX)

Rome, November, 1561
66. To the Deputies of the Workshop of Saint Peter's.—Since I am old and observe that Cesare [da Castel Durante] is so busy in his office with workshop affairs that the men often remain without a boss, it has seemed necessary to me to give to Cesare as a co-director Pierluigi [Gaeta], whom I know as an honorable person most valuable to the workshop. . . .
(Before the end of the following month, Pierluigi was imprisoned as a suspected thief.)

From Bologna, 8 February, 1507
67. Most Revered Father,—I have today received a letter from you, from which I learn that Lapo and Lodovico have been talking to you. I am content that you should rebuke me, because I deserved to be rebuked as a wretch and a transgressor quite as much as anyone else, and perhaps more. But you must understand that I have not transgressed in any wise in the matter for which you rebuke me, either against them or against anyone else, unless it be that I have done more than I ought. All the

men with whom I have ever had dealings know very well what I give them; and if anyone knows it, Lapo and Lodovico are the two who know it best of all, for in a month and a half one of them has had twenty-seven broad ducats and the other eighteen broad ducats, each with their expenses. Therefore I beg of you not to be carried away by their story. When they complained about me you ought to have asked how long they were with me and how much they had received from me: then you would have had to ask them what cause they had for complaint. But the reason of their great anger, particularly of that rascal Lapo, is this: they had given it out on all sides that they were the men who were doing this work, or rather, that they were in partnership with me; and they never realized—Lapo in particular—that he was not the boss until I sent him off. Only then did he understand that he was in my service; and having already given a great deal of trouble and caused the Pope's favor to show signs of declining, it appeared a strange thing to him that I should drive him away like a beast. I am sorry that he should still have seven ducats of mine, but when I return to Florence he shall most assuredly pay me back, though if he has any conscience he would also feel obliged to give me back the other money he has received. But enough. I shall say no more about it as I have written a sufficiently full account of their performances to Messer Agniolo [the herald]. I beg you to go to him, and if you can take Granaccio with you, do so, and let him read the letter I have written so that he may understand what abject creatures they are. But I beg of you to keep silent as to what I have written about Lodovico, for if I cannot find anyone else to come here and cast the metal I shall endeavor to get him back, because as a matter of fact I have not dismissed him; only Lapo, who received more blame than he cared to support alone, lightened his own load by corrupting Lodovico. You will learn the whole matter from the herald, and also how you are to act. Do not have any dealings with Lapo, for he is too great a scoundrel, and have nothing to do with either of them.

With reference to Giovansimone, it does not seem to me advisable that he should come here, as the Pope is leaving during Carnival; I believe he will visit Florence on the way, and he does not leave affairs here in good order. According to rumor, there is a want of confidence prevalent here which it is wise neither to inquire into nor to write about: but enough that, even if nothing were to happen—and I believe nothing will—I don't want to have the care of brothers on my shoulders. Do not be surprised at this and do not breathe a word of it to anyone, because I have need of assistants, and I should find none willing to come if this were known. And besides, I still think things may turn out well. I shall soon be back in Florence and I will behave in such a manner as to satisfy Giovansimone and the others, if it please God! Tomorrow I will write you another letter with reference to certain

monies I wish to send to Florence, telling you what to do with them. I understand about Piero: he will answer on my behalf, for he is a good fellow, as he has always been.

<div align="right">Your Michelangelo,</div>

P.S. I have something else to add in reply to the curious behavior Lapo attributes to me, and it is this. I bought seven hundred and twenty pounds of wax, and before I bought it I told Lapo to find out where it could be got, and to settle the price, saying that I would give him the money so that he could buy it. Lapo went, and came back again, and told me that it could not be got for a farthing less than nine broad ducats and twenty *bolognini* the hundred [pounds], which is equal to nine ducats forty *soldi*. He added that I ought to take the opportunity without delay because I was very fortunate. I replied that he was to go and find out whether he could get the odd forty *soldi* per hundred knocked off and that I would then buy it. He answered that the Bolognesi were of such a nature that they could not abate one farthing of the price they had asked. This raised my suspicions, and I let the matter drop. Later in the same day I called Piero aside and told him secretly to go and ask the price of the wax per hundred. Piero went to the same man as Lapo and bargained with him for eight and a half ducats, to which price I agreed, and afterward I sent Piero to receive his commission, and he got that also. This is one of my strange performances. Of a truth I know it seemed strange to him that I was able to see through his deceit. It was not enough for him to receive eight broad ducats a month and his expenses, but in addition he tried to swindle me; and he may have swindled me on many occasions of which I know nothing, for I trusted him. I have never met a man who appears more honest, so I suppose his straightforward look must have misled many another person. Therefore do not trust him in anything, and pretend not to see him.

<div align="right">(Carden)</div>

68. *Michelangelo, who complained of being called a cheat and usurer, was nevertheless quick to accuse others of skullduggery:*

<div align="right">Rome [1560]</div>

To the supervisors of the Workshop of St. Peter's:

You know that I told Balduccio not to send his lime if it was not good. Now that he has sent us a bad lot, doubtless to have to take it back, one may suppose that he connived with whoever accepted it. This is a great consolation to those whom I have chased out of the fabric for similar reasons. He who accepts bad materials as necessary to the work of the fabric, despite my having prohibited them, merely makes himself a friend to those whom I have made enemies. I think that there will be a new gang of them. Promises, bribes, and gifts corrupt justice. So I

beg of you from now on, with that authority which I have from the Pope, do not accept anything which is not suitable, even if it came from Heaven—so that I may not appear, as I am not, partial.

Your Michelangiolo

69. *Reminiscent of Petrarch's line "Broken is the lofty column," jotted by Michelangelo on a work sheet, is the following disastrous accident reported to the artist's assistant Pietro Urbano:*

From Serravezza, 20 April 1519

To Pietro Urbano, at the sculptor Michelangelo's house in Florence.

Matters have gone exceedingly ill. This morning I was about to lower a column with the utmost care, and had provided for every emergency: but when I had let it down about 50 *braccia* one of the rings of the lewis bolt holding the column gave way, with the result that it fell into the river and broke into a hundred pieces. Donato had entrusted the making of the ring in question to the smith Lazzero, a friend of his; and as to its being sufficiently strong, to judge from external appearances it seemed strong enough to lift four columns, as it undoubtedly would have been if it had been properly made. But when it broke the rascally trick played upon us became apparent, for the ring was nowhere solid, and there was not so much metal in it as would have sufficed in thickness for the ring of a knife handle, so that I marvel it held as long as it did. All who were on the spot had the narrowest of escapes from death, and a magnificent block of stone is ruined. I left the ordering of the tackle to Donato during the Carnival, telling him to go to the blacksmiths and see that all the metal used was good and sound: Thou seest how he has behaved to me. Then too the blocks of every one of the pulleys he had made for me cracked at the ring while the column was being lowered and are already on the point of giving way: yet they are twice the size of those used at Santa Maria del Fiore, so that if they had been made of sound metal they would have borne any load. But the iron used was crude and defective, and could not possibly have been worse. All this has come about because Donato wished to oblige his own friend, and left him to select the metal, serving me as thou seest. One must have patience. I shall be back for the *feste* [Easter], and if it please God shall begin work. . . . (Carden)

70. *Michelangelo's answer when asked by Pope Paul III to erect the ancient obelisk of Heliopolis:*

And supposing it broke? [Michele Mercati]

71. *A workman at the quarries is killed:*

August, 1518
It was a bigger job than I had estimated to bring the column down.
There was one man hurt while lowering it and another fellow got a bit
careless and was killed instantly, and I risked my own life over it.

72. *Michelangelo had little use for the public:*

How wrong are those simpletons of whom the world is full, who look
more at a green, a red, or similar high color than at the figures which
show spirit and movement. [Armenini]

73. Poor artists cloak their poor technique with a variety of tints and
shades of color. [Vasari]

74. *A curious verse fragment on how to paint an eye:*

EL CIGLIO COL COLOR . . .
The eyelid, with its shading, does not prevent my seeing when it
contracts, but the eye is free from one end to the other in the socket in
which it moves. The eye, underneath the lid, moves slowly. The lid
uncovers a small part of the large eyeball, revealing only a small part
of its serene gaze. The eye, being under the lid which covers it, moves
up and down less. Thus, when not raised up the lids have a shorter arc;
they wrinkle less when extended more over the eye. The whites of the
eyes are white and the black more so than funeral drapes, if that is
possible, and more than leonine the yellow which crosses from one fiber
to the next. But even if you touch its upper and lower edges, you'll not
surround the yellow and black and white. (1526)

75. *Advice on draughtmanship to young Giovanni di Bologna:*

Learn first to sketch out and then to finish! [Vasari]

76. *To Antonio Mini:*
October 4, 1524
Draw, Antonio, draw, Antonio, draw—don't waste time!
[on Berenson, 1502]

77. The money spent on preliminary drawings pays off a hundred to
one. [Bernini]

78. *To Pietro Urbano:*

Try hard, and don't for anything in the world fail to draw!
(CCCXLIX)

79. *The following ironical and audacious letter was instrumental in destroying a pet project of the Pope to erect a colossal statue in San Lorenzo Square, Florence.*

October/December 1525

Messer Giovan Francesco: If I took as much strength as I took delight from your last letter, I should believe myself able to execute—and soon —all the things about which you write me; but since I haven't so much strength, I shall do what I can. . . .

About the colossus forty spans high which you tell me is to go, or be placed, at the corner of the loggia of the Medici Garden where it meets the angle of Messer Luigi della Stufa's place, I have given this thought and not a little, as you ask me. It strikes me that on the aforesaid corner it wouldn't go so well, since it would occupy too much space on the road. But it would turn out much better on the other side, in my opinion, there where the barber shop is, for it would have the square before it and would not encumber the street. And since there might be objections to carrying off said barber shop out of love for the income [*entrate*] it affords, I have thought that said figure might be made to sit down. The behind would be placed so high that, making the work empty on the inside, as befits something constructed of pieces, the barber shop could stay underneath and would not lose income. And that this shop may have, as it has now, a place for the smoke to disappear through, it seems to me that I could put in the statue's hand a cornucopia which would serve as chimney. Then since I should leave the head of such a statue empty, the same as the members, of this too I think we might make some practical use. There is here on the square a huckster, a very good friend of mine, who has told me in confidence that one could put a fine dovecote in it. Another fanciful thought occurs to me which would be much better, but it would require making the figure much larger. This could of course be done, since you can build a tower out of sections. This thought is that the head might serve as a bell tower for San Lorenzo, which badly needs one. With bells inserted up there and sound issuing from the mouth, it would appear that the colossus were crying mercy and especially on feast days, when the bells ring most often and with the heaviest peals.

80. *The munificence of the Medici as patrons, hailed in Latin verse by the poet Vida, was a consolation to craftsmen who needed a steady income for materials and assistants.*

25 November, 1523

. . . You will have heard that a Medici was made Pope; it seems to me that everybody has been delighted by this; I am confident therefore that here, in the fine arts, many things will get done.

81. *The restraints imposed by the Maecenate system which might even prescribe subject matter to the artist rob him of free will.*

CON TANTA SERVITU . . .

With such servitude, with such tedium,
And with false concepts and great peril
To the soul, sculpturing here things divine.
(1554/55)

THE ART CRITIC

82. *The irony and sarcasm of Michelangelo as art critic so impressed Bernini that he claimed Buonarroti's appraisals of other artists to be limited almost entirely to four stock comments:*
This is by a cunning knave.
This is by a knave.
This won't bother anybody.
This is by a good man. [Chantelou]

83. *French art patrons, such as Francis I, impressed Michelangelo more than did the French artists themselves.*

In France there is also some good painting, and the King of the French has many palaces and pleasure houses [*casas de prazer*] with countless paintings, both at Fontainebleau, where the king gathered together 200 well-paid painters for a certain period, and at Madrid, the chateau which he built and where he betakes himself freely on occasion, in memory of the Spanish Madrid, where he was imprisoned. [De Hollanda]

84. *If Michelangelo saw no great Spanish artists on the horizon, he was quick to attribute the fact to the stinginess of Maecenases in Spain. We know that during his lifetime he had three or four Spanish apprentices or disciples of promise.*

I know that in Spain they do not pay so well for painting as in Italy, and so you will be surprised at the great amounts paid for it [here] as people brought up on little sums. And I am informed of this by a Portuguese assistant I once had. . . . It is for this reason that whatever painters you have live here and not in Spain. The Spaniards withal have the finest nobility in the world. You will find that some applaud and praise and delight in painting just as much as you please. But if you press the point with them, they never intend even to commission a small work and pay for it. And I hold as even more contemptible their

astonishment when you tell them that there are those in Italy who pay high prices for works of painting. Certainly, in my opinion, they do not act, in this, like the nobles they say they are. They underrate that which they cannot experience or carry out. But all this falls back on their own heads, since it reflects no credit upon them and disgraces the nobility of which they boast. [De Hollanda] (Holroyd)

85. It is not surprising that the Portuguese do not know or appreciate what they have never seen and what they do not possess. . . .
[De Hollanda]

86. *Michelangelo could not help but admire the seriousness with which the Flemings took their craft, but he deplored the basic nature and the distribution of their subject matter:*

The painting of Flanders . . . will generally satisfy any devout person more than the painting of Italy, which will never cause him to drop a single tear, but that of Flanders will cause him to shed many; this is not owing to the vigor and goodness of that painting, but to the goodness of such devout person; women will like it, especially very old ones, or very young ones. It will please likewise friars and nuns, and also some noble persons who have no ear for true harmony. They paint in Flanders only to deceive the external eye, things that gladden you and of which you cannot speak ill, and saints and prophets. Their painting is of stuffs, bricks and mortar, the grass of the fields, the shadows of trees, and bridges and rivers, which they call landscapes, and little figures here and there; and all this, although it may appear good to some eyes, is in truth done without reasonableness or art, without symmetry or proportion, without care in selecting or rejecting, and finally without any substance or nerve, and in spite of all this painting in some other parts is worse than it is in Flanders. Neither do I speak so badly of Flemish painting because it is all bad, but because it tries to do so many things at once (each of which alone would suffice for a great work) so that it does not do anything really well. [De Hollanda] (Holroyd)

87. *On the mutilated Belvedere Torso by Apollonius of Athens:*

This is the work of a man who knew more than nature. It is a great pity that the [total] work has been lost. [Chantelou]

88. By a single line Apelles was distinguished from Protogenes.
[De Hollanda]

89. [Some ancient painters] were so magnificently liberal that, knowing that there was not sufficient money in the country to pay for their works,

they presented them generously for nothing, having spent on such work labor of their mind, time, and money. Such were Zeuxis, Polygnotus, and others. [De Hollanda]

90. Albrecht Dürer, a man delicate in his manner. [De Hollanda]

91. I esteem him [Dürer] so much that if I were not Michelangelo, I should prefer to be Albrecht Dürer than Emperor Charles V. [Michelangelo's reported face-to-face comment to Emperor Charles V.]
[Pierre Nougaret]

92. *On Sebastiano del Piombo's* Resurrection of Lazarus:

Keep your peace and reflect that you will be more famous for resurrecting the dead than for painting figures which appear alive. [CDVII]

93. *During the period of their active correspondence, before their estrangement, Michelangelo was capable of paying Fra Sebastiano courteous compliments:*

May, 1525
Dear Sebastiano . . . My pleasure at the reasonings [at dinner] increased, hearing your name mentioned by Captain Cuio; nor was this all; more, infinitely more, did I rejoice for art, on hearing the captain say you were unique in the world and so reputed in Rome. . . . You see then that my judgment is not false; don't deny any longer to me that you are unique, when I write it to you, for I have too many witnesses to the fact, and there is a painting here in Florence, thank God, that stands as proof of what I say to anyone who sees light.

94. *Andrea di Cione, called Orcagna:*

Ancient and noble painter. [Giannotti]

95. *On Andrea del Sarto:*

There is in Florence a little fellow who, if he were engaged upon large-scale projects, as you are, would make your forehead break out in sweat. (Michelangelo's reported remark to Raphael) [Francesco Bocchi]

96. *On Vasari's* Resurrection of Lazarus:

I am not surprised, since you are a resuscitator of dead men, that you lengthen the life of the living. [CDLXVIII]

97. *On Giorgio Vasari's* Genealogy of the Gods:

A marvelous thing. [CDLXXXIX]

98. *On Lorenzo Ghiberti's doors to the Baptistery of San Giovanni in Florence:*

They are so beautiful that they would well befit the portals of Paradise. [Vasari]

99. *On Donatello's* Saint Mark:

[I] have never seen a figure which had more the air of an upright gentleman than this one; and if Saint Mark were really such a man, then one could believe what he had written. [Vasari]

100. *On the terra cotta statues of Antonio Begarelli:*

If this clay were to become marble, woe to the statues of antiquity. [Vasari]

101. *To Benvenuto Cellini:*

I have known you for so many years as the best goldsmith who ever came to my notice, and now I see you as a sculptor of comparable stature. [CDLXXI]

102. *Again:*

Know that Messer Bindo Altoviti took me to see a bronze head and told me that it was from your hand: I took much pleasure from it, but it struck me that it was too bad that it was placed in a bad light; that if it had its right light, it would be as seen as the beautiful work which it is. [CDLXXI]

103. *On Cellini's cameo showing Hercules binding Cerberus:*

The most wonderful thing I've seen. [Cellini, *Vita*]

104. *On a Medallion by Cellini:*

If this little work, finished with the care and beauty which I perceive, were carried out in a large size, either in marble or bronze, it would appear a marvelous work; and in my opinion, I don't believe that those

goldsmiths of antiquity could have executed their works with greater excellence than has been employed on this one. [Cellini, *Due Trattati*]

105. *On the Medals of Alessandro Cesati:*

The hour for the death of art is at hand, for one could never see anything better. [Vasari]

106. *On Clement Bandinelli, natural son of his enemy Baccio Bandinelli:*

If Clement had lived, he would have equalled the fame of the most famous Greek sculptors. [Bandinelli, *Memoriale*]

107. *On the plans of Bartolommeo Ammannati's Neptune fountain in Florence:*

A beautiful fantasia which will succeed in being something marvelous.

[CDLXXXIX]

108. *Raffaello Da Montelupo, Sculptor:*

Approved among the best masters of these times. [CDXXXIII]

109. *On the lantern turret designed by Brunelleschi at San Lorenzo:*

It could be altered all right, but bettered, no! [Vasari]

110. *On Donato Bramante's first plan for Saint Peter's Basilica:*

It cannot be denied that Bramante was competent in architecture, as much as anyone from ancient times to the present. He laid out the first plan of St. Peter's, not full of confusion but clear and pure, well-lighted and set apart so that it would not interfere with any part of the palace. It was held to be a beautiful thing, as is still manifest. [CDLXXIV]

111. *On the Monastery Church of San Salvatore del Monte of Simone Pollaiuolo (Il Cronaca):*

My beautiful country lass! [Vasari]

112. *On Titian's* Danaë *in the Belvedere:*

Its coloring and manner please [me] greatly, but it is a shame that in Venice people did not learn from the beginning to draw well, and that

Venetian painters did not have a better manner in their study. If this man were strengthened by art and design as he is by nature, and especially in the counterfeiting of living things, no one could do more or better, for he possesses a very fine spirit and a very pleasing and lively manner. . . . He who has not studied design a great deal nor mulled over selected ancient and modern works cannot do well by himself in practice nor bestow upon works drawn from life that grace and perfection which is displayed by art beyond the order of nature. [Vasari]

113. *On a Titian Venus:*

God was right in doing what he did, for if these painters knew how to draw, they would be angels and not men. [Chantelou]

114. *On Raffaello:*

Whatever he had of art he got from me. [CDXXXV]

115. *On seeing a painting executed without a brush by Ugo da Carpi:*

It would have been better if he'd used a brush and painted it better!
[Vasari]

116. *On Sebastiano del Piombo, after the latter's obtaining a papal sinecure:*

What shall I say of this very amusing Venetian Sebastiano, to whom (although he did not come at a favorable moment) the Pope gave the leaden seal with the honor and profit which belong to such a post, without the lazy painter's even having painted more than two single things while in Rome, things which will scarcely impress. . . . [De Hollanda]

117. *Del Piombo "boiled in oil":*

. . . Oil painting is an art for ladies, for lazy and slack persons like Fra Sebastiano. [Vasari]

118. *Comment addressed to the son of Francesco Francia:*

Your father makes better living figures than painted ones!
[Condivi and Vasari]

119. *Francesco Francia:*

Go thou to the bordello! Thou and Il Cossa are two solemn dunces in art! [Vasari]

120. *The impatience of Donatello:*

Donatello, a man excellent in his art, except for one thing; he did not have the patience to refurbish his works, so that while they appeared wonderful at a distance, they lost their reputation when seen at close hand. [Condivi]

121. *An outburst addressed to Leonardo da Vinci, in the street:*

Explain the question yourself, you who tried to make a bronze equestrian statue and couldn't. Only those asses in Milan would have thought you could. [*Codice Magliabechiano*]

122. *Public censure of Sangallo's wooden model of Saint Peter's:*

Sangallo built it closed to all light and had piled so many orders of columns, one atop the other, and with so many protruding members, spires, and details, that it resembled a Gothic work much more than a good, classic style, or the pleasing and beautiful modern manner.
 [Vasari]

123. *On his rivalry with Nanni di Baccio Bigio:*

He who fights with nobodies wins nothing. [Vasari]

124. *On Baccio d'Agnolo's revision of Brunelleschi's plan for the cupola of the Duomo in Florence:*

A cricket cage! . . . Without design, art, or grace. [Vasari]

125. *On Baccio d'Agnolo's model for the façade of San Lorenzo:*

A childish thing. [CCCXLVI]

126. *The following passage of 1555 with its outrageous wit, did much to discredit Sangallo's plans for remodeling Saint Peter's.*

Sangallo's circle of chapels robs light from the interior as Bramante planned it. And not only this, but the structure provides no light whatsoever of itself. There are so many hiding-places above and below and so dark that they lend themselves easily to an infinite number of ribaldries: to the hiding of bandits, the counterfeiting of money, the impregnating of nuns and other monkeyshines, so that in the evening, when the church would close, you would need twenty-five men to seek out whoever might be concealed within, and it would be so built that

they could scarcely find them. There would be this further inconvenience: the addition of the circle of structures superimposed on the plan of Bramante would require the razing of the Cappella Paolina, the halls of the Segnatura and the Ruota and many others; not even the Sistine Chapel, in my opinion, would escape. [CDLXXIV]

127. *Michelangelo's pride in the artistic strides of his fatherland is revealed in this impromptu census of Italian art centers. Speaking to a group in Rome, he does not feel the need to include that capital in his panoramic view:*

You ask me a question which would take long to answer, M. Francisco, wide and difficult to put together, for we know that there is no prince or private person or nobleman in Italy, or any one of any pretension, however little curious he may be about painting (to say nothing of those excellent ones who adore it), who does not take steps to have some relic of divine painting, or who at least, in so far as he can, does not order many works to be executed. So that a good portion of the beauty of our art is spread over many noble cities, castles, country-seats, palaces, and temples, and other private and public buildings; but as I have not seen them in an orderly manner, I can only speak of some which are the principal ones.

In Siena there is some singular painting in the Municipal Chamber and in other places; in Florence, my native place, in the Palaces of the Medici, there is a grotesque by Giovanni da Udine, and so throughout Tuscany. In Urbino, the Palace of the Duke, who was himself a painter, has a great deal of praiseworthy work, and also in his country-seat called "Imperial," near Pesaro, erected by his wife, there is some very magnificent painting. So too, the Palace of the Duke of Mantua, where Andrea painted the *Triumph of Caius Caesar,* is noble; but more so still is the work of the Stable, painted by Julius, a pupil of Raphael, who now flourishes in Mantua. In Ferrara we have the painting of Dosso in the Palace of Castello, and in Padua they also praise the loggia of M. Luigi, and the Fortress of Legnano. Now in Venice there are admirable works by Chevalier Titian, a valiant man in painting and in drawing from nature, in the Library of St. Mark, some in the House of the Germans, and other churches and in other good hands; and the whole of that city is a good painting.

So in Pisa, in Lucca, in Bologna, in Piacenza, in Parma, where there is Il Parmegianino, in Milan, and in Naples. So in Genoa there is the house of Prince Doria, painted by Master Perino with great judgment, especially the *Storm of the Vessels of Aeneas,* in oils, and the ferocity of Neptune and his sea-horses; and likewise in another room there is a fresco, *Jupiter Fighting Against the Giants in Phlegra,* overthrowing

them with thunderbolts; and nearly the whole city is painted inside and out. And in many other castles and cities of Italy, such as Orvieto, Esi, Ascoli, and Como, there are pictures nobly painted, and all of great price, for I only speak of such; and if we were to speak of the private paintings and pictures that every one holds dearer than life, it would be to speak of the innumerable, and there are to be found in Italy some cities which are nearly all painted with tolerable painting, inside and out. [De Hollanda] (Holroyd)

128. *Michelangelo recognized that Italy, "where things are perfect," was the artistic center and school of the Third Classicism, after that of Greece and Rome:*

Only works which are done in Italy can be called true painting, and therefore we call good painting Italian, just as if it were done so well in another country, we should give it the name of that country or province. As for the good painting of this country, there is nothing more noble or devout, for with wise persons nothing causes devotion to be remembered, or to arise, more than the difficulty of the perfection which unites itself with and joins God; because good painting is nothing else but a copy of the perfections of God and a reminder of His painting. Finally, good painting is a music and a melody which intellect only can appreciate, and with great difficulty. This painting is so rare that few are capable of doing or attaining it. And I further say (which whoever notes it will consider important) that of all the climates or countries lighted by the sun and the moon, in no other can one paint well but in the kingdom of Italy; and it is a thing which is nearly impossible to do well except here, even though there were more talented men in the other provinces, if there could be such, and this for reasons which we will give you. Take a great man from another kingdom, and tell him to paint whatever he likes and can do best, and let him do it; and take a bad Italian apprentice and order him to make a drawing, or to paint whatever you like, and let him do it; you will find, if you understand it well, that the drawing of that apprentice, as regards art, has more substance than that of the other master, and what he attempted to do is worth more than everything that the other ever did. Order a great master, who is not an Italian, even though it be Albrecht [Dürer], a man delicate in his manner, in order to deceive me, or Francisco d'Ollanda there, to counterfeit a work which shall be like an Italian work, and if it cannot be a very good one let it be an ordinary or a bad painting, and I assure you that it will be immediately recognized that the work was not done in Italy, nor by the hand of an Italian. I likewise affirm that no nation or person (I except one or two Spaniards) can perfectly satisfy or imitate the

Italian manner of painting (which is the old Greek manner) without his being immediately recognized as a foreigner, whatever efforts he may make, and however hard he may work to do so. And if by some great miracle such a foreigner should succeed in painting well, then, although he may not have done it in order to imitate Italian work, it will be said that he painted like an Italian. Thus it is that all painting done in Italy is not called Italian painting, but all that is good and direct is, for in this country works of illustrious painting are done in a more masterly and more serious manner than in any other place. We call good painting *Italian*, which painting, even though it be done in Flanders or in Spain (which approaches us most) if it be good, will be Italian painting, for this most noble science does not belong to any country, as it came from heaven; but even from ancient times it remained in our Italy more than in any other kingdom in the world, and I think that it will end in it.

[De Hollanda] (Holroyd)

129. *In 1544 Michelangelo directed a letter to Pope Paul III with the express intention of discrediting Antonio da Sangallo's proposed main cornice for the Palazzo Farnese. The tone of the epistle is pedantic and uncharacteristic, for the simple reason that Michelangelo merely paraphrases lines from Vitruvius' Architectura. In 1909, S. Meller claimed that Michelangelo did not compose, but merely copied this letter in his handwriting although Michelangelo echoed Vitruvius on other matters cited in the present volume.*

Most Blessed Father,—As you have understood from the chapter of Vitruvius, architecture is nothing more than orderly [consistent] disposition and a beautiful order and a fitting consensus of the members of a work, and appropriateness and distribution.

First of all, here there is no orderly disposition at all; because ordering means a slight blending of the members of the work placed separately and totally, coherently set. Here rather everything within is disorder, because the members of the cornice in question are out of proportion among themselves, nor does any one have conformity with the others.

Second: Here is no disposition of any sort. Disposition is a way of placing together elegantly, arranged according to the quality and effect of the work. Here there is no quality for the work done, nor done according to the rules of Vitruvius. This cornice displays more readily Gothic [barbarous] or other qualities.

Third: a beautiful order conforming with the composition of the members as a whole. In this plan we see no uniformity whatsoever, but lack of uniformity. The first inconsistency is that of such a great expense that the work could never be completed. The second is that this plan

threatens to pull down to the ground the façade of the palace. Moreover, the cornice possesses three orders: Doric, Ionic, and Corinthian. This is not any one of these orders, but bastard.

The fourth element is a correct harmony of the whole and the parts, with the separate parts corresponding to the total order of the work with correct proportion. In this cornice there is not a single member which corresponds in just proportion to the whole cornice, for the corbels are small and few for such a great size, the friezes are too small for the general breadth, and the astragal at the bottom is too small for the total volume.

Fifth is decorous proportion, a faultless ensemble based on authority and convention. In this cornice there is no such decorum whatsoever, indeed, all is the opposite. First of all, there is that outsized top-piece over a small façade, dominating the rest, and such a top-piece is inappropriate for such a slight height; the module for the cornice just does not work in right with the intermediate floor; it is quite another matter.

Sixth, distribution . . . distribution according to the abundance of things, and a suitable dispensation of space. Here it is clear that nothing has been well dispensed, but according to chance and caprice, sometimes lavishly and others stingily. This is all I have to say to your Holiness on the matter, and I humbly kiss your feet. . . .

There is another grade of distribution when the work will be planned according to the living habits of the householder and according to the abundance of money. The buildings should be ordered lofty or humble according to his elegance and dignity. It is also evident that one must build city dwellings otherwise than rustic possessions, where fruits must be stored. Nor will usurers' homes be the same as those of the rich and delicate and powerful, who with their cogitations govern the republic. . . . [CDXLI]

THE INTERPRETER OF HIS OWN
ART WORKS

130. *Michelangelo's self-identification with David, whom he sculpted twice (stone and bronze) and painted twice, becomes apparent in this scholium penned on a sheet with drawings of the bronze David and the arm of the marble figure (1501/02).*

> David with the sling
> and I with the bow
>
> Michelangelo [G App. 3]

131. *A chronicler attached to the Robertet family, who erected the bronze David outside their chateau at Bury (Loire Valley), reported that the base of the exultant statue bore the following lines by Michelangelo:*

> I, David, in fewer than three steps
> Which I took in front of all,
> I sent Goliath to death
> With one righteous shot from my sling.

[Thode, *Krit. Unt.*, I, 85]

132. *Anyone struck by the extreme youthfulness of the Virgin in the Pietà of St. Peter's should be made aware of Michelangelo's explanation to Condivi:*

Do you know that chaste women remain much more fresh than those who are not chaste. How much more, therefore, must this be true of the Virgin who never entertained the least immodest thought which might have troubled her body. I would put this even more strongly. I believe that this freshness and flower of youth which she received in a natural manner was preserved for her in a supernatural one, so that the virginity and the eternal purity of the Mother of God could be demonstrated to the world. Such a miracle was not necessary for her Son. Quite the contrary, for if it had to be shown that the Son of God was made incarnate in man and that he had suffered all that men suffer except sin, it was not necessary to make the human disappear behind the divine, but it was better rather to let the human follow its nature in such a way that he should appear to have the age that he really had. Do not be surprised, therefore, if for these reasons I have represented the Very Holy Virgin, the Mother of God, much younger than her years would require and if I have given the Son his real age. [Condivi]

133. *When the first casting of the bronze statue of Julius II came off badly, Michelangelo was especially vexed because of the hostile attitudes of the workers of Bologna and because of his brittle relations with the pope himself.*

Bologna, 1 July, 1507

Buonarroto.—We cast my figure, and it came off in such a way that I firmly believe that it must all be done over again. I'll not write you all the details, for I've other worries on my mind. It's enough to say that the thing went off badly. I thank God for it, because I always judge everything for the best. I'll know better in a few days what must be done and I'll let you know. Give Lodovico the news and be of good will.

If it turns out that I have to do it all over, and that I cannot return [to Florence], I'll make it a point to do all that I promised you some way or other and as best I can.

Bologna, 6 July, 1507

134. Buonarroto.—I want you to know that we cast my statue of Julius II, but I did not have too much luck. The reason was that Master Bernardino, either by ignorance or bad luck, did not found the metal well. It would take too long to explain why. Suffice it to say that my statue came out well as far as the waist; the rest of the material, that is, half of the metal, remained in the furnace, since it did not fuse; so that, in order to take it out, it is necessary to dismantle the furnace. That is what I am doing now, and I shall have it rebuilt again this week. Next week we shall pour from the top, and I will finish filling the mold. I think that what began badly will end well, but not without a great deal of suffering, effort, and expense. I had so much faith in Bernardino that I would have believed he could fuse metal without fire: just the same, this does not mean that he is not a good artisan and that he did not put his heart into his work. But he who works is at times bound to fail. And he certainly did fail with much harm to me and to himself, for he is so ashamed that he does not dare lift his eyes anywhere in Bologna.

If you should see Baccio d'Agnolo, read this letter to him and beg him to inform [Giuliano da] Sangallo in Rome. Remember me to him and also to Giovanni da Ricasoli, and to Granaccio [Francesco Granacci]. If this turns out well, I think that in fifteen or twenty days I shall be all through and shall return there. If it shouldn't turn out well I may have to do it all over. I'll inform you of everything. (C. Speroni)

135. *Several months later Michelangelo was still aware of a hostility reigning in Bologna as he worked on the ill-fated statue of his patron Julius II, a work later melted into a cannon:*

10 November, 1507

Buonarroto, . . . I remain here with the greatest inconvenience and extreme fatigue, and I think of nothing but my work day and night, and I have suffered so much labor and fatigue, that had I to make another I do not think my life would last me, for it has been an immense undertaking, which if given into the hands of another he would have succeeded but badly in. But I consider that the prayers of some person have helped me, and kept my judgment sound, for it was against the opinion of the whole of Bologna that I could ever have conducted the work. After the casting, and even before, there was no one who believed me capable of ever casting it. It is enough for me that I have conducted my work to a good end, but I shall not have entirely finished it this

month as I had thought, but in the next it will certainly be finished and I shall return. (C. C. Black)

136. *Nowhere are Michelangelo's grievances against Pope Julius more fully recorded than in the following resentful letter to Fattucci, a recapitulation of earlier events.*

Florence, December 1523/January 1524

Messer Giovan Francesco,—You ask me in your letter how my affairs stand with regard to Pope Julius. I tell you that if I could claim damages and interest, according to my own estimate I should prove to be the creditor rather than the debtor. When he sent for me to Florence—I believe it was in the second year of his pontificate—I had already undertaken to decorate one half of the Council Hall in Florence, that is to say, to paint it; and I was to have 3000 ducats for the work. As all Florence knows, I had already drawn the cartoon, so that the money seemed half earned. Beside this, of the Twelve Apostles which I had been commissioned to carve for Santa Maria del Fiore, one had already been roughed out, as may still be seen; and I had already collected the greater part of the marble for the others. When Pope Julius took me away from here I received nothing with respect to one work or the other. Afterwards, when I was in Rome with the said Pope Julius and he had given me the commission for his tomb, which required a thousand ducats' worth of marble, he had the money paid over to me, and despatched me to Carrara for the material. There I remained for eight months, seeing the marble blocked out, and I brought nearly all of it into the St. Peter's Piazza, some being left at Ripa. Afterwards, when I had paid all that was due for the transport of the marble, and nothing remained of the money I had received for the aforesaid work, I fitted up the house I had in the Piazza di San Pietro with my own beds and furniture, on the strength of the commission for the tomb: and I summoned workmen from Florence, some of whom are still living, to come and work upon it. These men I paid in advance with my own money. By this time Pope Julius had changed his mind and no longer wished to have the work carried out; and I, not knowing this, went to ask him for money, and was driven from the chamber. Angered by this insult, I immediately left Rome, while everything in my house went to the dogs, and the marbles I had brought together lay about the St. Peter's Piazza until Leo was elected Pope, suffering considerable damage from one cause or another. Among other things that I can prove, two of my pieces of marble, each of them thirteen and a half spans long, were stolen at Ripa by Agostino [Chigi]: they cost me more than fifty gold ducats, and could be claimed, because I have witnesses still living. But to return to the marble. More than a year elapsed between the time when I went to quarry it in Carrara and the time when I was driven

from the Palace; and for this I never received anything, but had to pay out some tens of ducats instead.

Afterward, when Pope Julius first went to Bologna, I was obliged to go with the halter of penitence round my neck and beg his forgiveness: whereupon he commissioned me to execute a statue of himself in bronze, which was to be about seven spans [14 feet] in height, seated. When he asked what the cost would be I said I believed I could cast it for a thousand ducats, but that it was not my trade, and that I did not wish to commit myself. He replied, "Go, get to work: cast it as often as is necessary until you are successful, and we will give you enough money to satisfy you." To be brief, it had to be cast twice; and at the end of the two years I spent there I found myself four ducats and a half to the good. During all this time I never had any other money, and the whole of the expenses incurred by me came out of the thousand ducats for which I said I would cast the figure, this money being paid to me in several instalments by Messer Antonio da Legniame of Bologna.

Having hoisted the figure up to its position on the façade of San Petronio, I then returned to Rome, but Pope Julius did not yet wish me to go on with the tomb, and set me to paint the vault of the Sistine Chapel, the price of the work being fixed at 3000 ducats. The first design consisted of figures of the Apostles within the lunettes, while certain portions were to be adorned after the usual manner.

As soon as I had begun this work I realized that it would come off a poor thing, and I told the Pope how, in my opinion, the placing of the Apostles there by themselves would result in a poor effect. He asked me why. I answered, "Because they, too, were poor." Then he granted me a new commission to do what I wished, disposed to satisfy me, and told me to paint down to the stories underneath. At that time when the Vault was almost finished, the Pope returned to Bologna. When I went there two times for monies that I was due to get, I achieved nothing but to waste all that time till he returned to Rome. Back in Rome I set to doing cartoons for the aforesaid commission, that is, for the heads and faces around the Chapel of Sixtus, hoping to get monies and complete the job.

I never succeeded in getting anything. When I aired my grievances one day with Messer Bernardo da Bibbiena and Attalante—complaining that I could no longer stay on in Rome and should have to leave— Messer Bernardo told Attalante to look into this, that he wished to get me monies at all costs. He arranged to have me paid 2000 ducats of the Chamber, which was in addition to the first 1000 for the marbles budgeted on the Tomb. I guessed that I was receiving these more for the time wasted than for work completed. And out of this money, because Messer Bernardo and Attalante had restored me to life, I gave 100 ducats to the one and 50 to the other.

Then came the death of Pope Julius. Before long Cardinal Aginensis,

wishing to enlarge Julius's sepulcher, that is, make a larger work than I had originally designed, had a new contract made out. When I refused to agree that they apply to the expenses of the Sepulcher the afore-mentioned 3000 ducats I had received, pointing out that I was to receive much more, Aginensis told me that I was a swindler.

137. *Many letters are testimony of the anguish brought to Michel-angelo by the demands that he complete the sepulcher of Julius II long after the pontiff's death.*

November, 1526

Messer Giovan Francesco.—I know that in these recent days Spina wrote to Rome on my behalf in reference to the Julius tomb. If he misjudged the climate of the times we are in, I made him do so, for I insisted on his writing. Maybe passion made me try to wield too big a stick. I've had recent information on how things are going down there and this gave me quite a fright. I refer to the ill disposition which Julius' relatives have taken toward me—and not without reason —and how the lawsuit is proceeding, demanding damages and interest, so that a hundred like myself couldn't give satisfaction. This has placed me in great travail and makes me wonder where I'd be if the Pope failed me, since I'd no longer be in this world. And this is the reason that I had him write, as I said. Now I only want what the Pope wants; I know that he wishes neither my ruin nor my shame. . . . I want to get out of this obligation more than I want to go on living. Neverthe-less I don't wish to depart from the wishes of the Pope, provided that I understand them. So I beg you, in view of my state of mind, to write me the will of the Pope, and I'll not exceed that. I beg you to get it right from him and write it to me on his behalf, so that I may obey better and with affection, and even, if one day it were ever necessary, to justify myself with your letter.

138. *Painting the vast expanse of the Sistine Ceiling in the unfamiliar medium of fresco so exhausted the artist that in an extended sonnet he shared what humor the situation afforded with his friend Giovanni da Pistoia.*

I' HO GIA FATTO UN GOZZO. . . .

In this hard toil I've such a goiter grown,
Like cats that water drink in Lombardy,
(Or wheresoever else the place may be)
That chin and belly meet perforce in one.
My beard doth point to heaven, my scalp its place
Upon my shoulder finds; my chest, you'll say,

A harpy's is, my paint-brush all the day
Doth drop a rich mosaic on my face.
My loins have entered my paunch within,
My nether end my balance doth supply,
My feet unseen move to and fro in vain.
In front to utmost length is stretched my skin
And wrinkled up in folds behind, while I
Am bent as bowmen bend a bow in Spain.
No longer true or sane,
The judgment now doth from the mind proceed,
For 'tis ill shooting through a twisted reed.
Then thou, my picture dead,
Defend it, Giovan, and my honor—why?
The place is wrong, and no painter I.

(1510) (Elizabeth Hall)

139. *The miraculous creation of the sun and moon, depicted in the
second history of the Sistine Ceiling, was hailed by Michelangelo in a
sonnet as well.*

COLUI CHE FECE . . .

He who from nothing, and ere all things were,
Did time create, divided it in twain:
To one, he made the lofty sun a share;
And to the other, moonlight's dusky train.
Then in a moment came, in dread array,
Chance, fortune, fate; by which, alas, I see,
Predestined when I in the cradle lay,
The time of darkness was assigned to me.
So, struggling with my own more darkened doom,
Since where most night is, there is greatest gloom,
My labors dark are pain and grief to me:
Yet I console myself; for this my night
Aids by its contrast to set forth thy light,—
That sun which, at thy birth, was given to thee.

(1535/46) (Fanny Elizabeth Bunnett)

140. *Michelangelo reports progress on the Medici Chapel to his friend
Fattucci:*

Florence, April, 1526

Messer Giovan Francesco.—During the coming week I shall have the
figures already blocked out in the Sacristy covered up, because I want

to leave the Sacristy free for the marble masons, whom I wish to build up the other tomb opposite the one already erected. It is all squared work, or nearly so. I have been thinking that the vault might be done while this work is in progress, for, given enough men, I think that it could be finished in two or three months, though I do not know much about it. At the end of this coming week His Holiness might send Maestro Giovanni da Udine, if he should wish the work to be done now; I shall be quite ready for him.

During this week four of the columns in the recess have been put up, while another was already in position. The niches are not so well forward; however, I think it will be entirely finished in four months' time. The ceiling could be begun at once, but the lime-wood for it is not yet in the proper condition. We shall do our best to let it be as well seasoned as possible.

I am working as fast as I can, and within a fortnight I shall begin work on the other Captain; after that the only important works remaining to be done will be the four Rivers. The four figures on the sarcophagi, the four figures on the ground—which are the Rivers—the two Captains and the Madonna which is to be placed over tomb at the head of the Sacristy—these are the figures I should like to do myself. Six of them are already begun and I am confident that I can finish them in due time, and a part of the others also, which are less important. There is nothing more to tell. Commend me to Giovanni Spina and beg him to write to Figiovanni: beg him also not to take away the carters and send them to Pescia, lest we be left without stone. More than this, ask him not to make the stonecutters discontented by saying to them in a kindly way: "These people seem to have but little mercy on you, to make you work until evening in these days when it is dark at the second hour."

It requires a hundred eyes to keep any one man at his work, and even then your efforts may be spoiled by people who are too soft-hearted. Patience! I would to God that things which are not displeasing to Him were not displeasing to me! (Carden)

141. *The effigies of Day and Night under the statue of the assassinated Duke Giuliano contemplate in Greek-chorus fashion the brilliant destiny he could have achieved had he not died so young.*

EL DÌ E LA NOCTE PARLANO . . .

Day and Night speak and say: In our rapid course we have led Duke Giuliano to his death. It is quite meet that he should take vengeance upon us as he does. And the vengeance is this: We having killed him, he thus dead has stolen our light from us and with his closed eyes has

sealed our own, which no longer shine over the earth. What might he have done with us, then, had he lived? (1520/23)

142. *When Michelangelo first conceived the Medici tombs, he thought of decorating them with a figure of Fame. Alongside the drawing of Fame he wrote:*

> Fame holds the epitaphs lying still;
> Fame goes neither forward nor backward,
> For they are dead, and their activities stayed.
>
> (1520/23)

143. *The resentment of the artist against the later generation of Medicis stands out clearly in these four lines allegedly spoken by the reclining figure of Night, which begs not to be awakened.*

> CARO M'È IL SONNO . . .
>
> Sweet is sleep—Ah, sweeter, to be stone,
> Whilst wrong and shame exist, and grow;
> Not to see, not to feel, is boon,
> Then not to wake me, pray speak low!
>
> (1545/46) (Ralph Waldo Emerson)

144. *The sleeping figure of the Night in the Medici Chapel symbolizes the relaxation and refuge which the weary body and soul find in her embrace.*

> O NOTTE, O DOLCE TEMPO . . .
>
> O Night! O season fair, though black thou be,
> All strife in thee doth find its peaceful end;
> Clear eyes, pure hearts, take thee to be their friend,
> And wholesome are his thoughts who honors thee.
> Thou lopp'st away all weary cares from me;
> While dewy shades unbroken quiet lend,
> In dreams thou leadest me where I would wend,
> And high exalt'st me, from low passion free.
> Image of death! on thee the deathless soul
> Stays every sorrow fatal to life's peace.
> Irksome no more the good man's moments flow:
> His flesh and sense infirm thou makest whole,
> His tears thou driest, his weary labors cease,—
> Latest and best release from haunting woe.
>
> (1535/41) (Franklin B. Sanborn)

145. *Michelangelo's preoccupation with Night, so prominent in his Times of the Day in the Medici Chapel and the first histories of the Sistine Ceiling, makes the following sonnet of special interest:*

PERCHE FEBO NON TORCE . . .

When Phoebus doth no more encircling fold
Within his shining arms the earth's cold frame,
The multitude do night the season name,
Since now no longer they the sun behold.
And she doth seem so weak, a candle may,
A little candle, where it sheds its light,
The life of night destroy; and eke so slight
That steel and tinder do her rend and slay.
And if perchance she's anything at all,
Of earth and sun she doth the daughter seem,
Since one creates her, and she dwells in one.
Howbeit who praises her, his wit is small;
Unmated she, and of such poor esteem,
With her a glow-worm wageth war alone.

<div style="text-align: right">(1535/41) (Elizabeth Hall)</div>

146. *The rivalry of night and day is constant, for while darkness may prevail (in caves, grottoes, closed rooms, and so on) even as the sun shines, so may the tiny firefly brighten the black gloom of night.*

OGNI VAN CHIUSO . . .

Each hollow space, that closed or covered lies,
Whate'er by matter dense is screened from light.
Preserving darkness in the sun's despite,
Today her radiant privilege denies.
And if or flame or fire dark night assail,
The sun thereby, with meaner agents, may
Her holy image blur and chase away;
Yea, a poor worm to mar it doth avail.
Beneath the shining sun lies bare the earth,
And with a thousand herds and seeds she teems,
While o'er her the rude farmer ploughs his way.
But darkness only doth to man give birth,
Who than all other fruit more precious seems;
Then is the night more holy than the day.

<div style="text-align: right">(1535/41) (Elizabeth Hall)</div>

147. *The sonnet "Scarco d' un'importuna e greve salma" is a hymn to the wounded and suffering Christ to whom man must finally turn for*

forgiveness and charity. It is reminiscent not only of the artist's sketches of the stages of Christ's Passion, but of the Christus Judex of the Last Judgment, *with His upright arm and severe countenance.*

SCARCO D'UN' IMPORTUNA . . .

Eternal Lord! eased of a cumbrous load
And loosened from the world, I turn to thee;
Shun, like a shattered bark, the storm, and flee
To Thy protection for a safe abode.
The crown of thorns, hands pierced upon the tree,
Thy meek, benign, and lacerated face,
To a sincere repentance promise grace,
To the sad soul give hope of pardon free.
With justice mark not Thou, O Light Divine,
My fault, nor hear it with Thy sacred ear;
Neither put forth that way Thy arm severe;
Wash with Thy blood my sins; thereto incline
More readily the more my years require
Help, and forgiveness speedy and entire.

<div align="right">(1555) (William Wordsworth)</div>

148.

PER QUAL MORDACE LIMA . . .

Lord, in the last hours
Stretch toward me thy forgiving arms,
Withdraw me from myself and make me one who may please thee.

<div align="right">(1538/41)</div>

149. *One familiar with Michelangelo's poetry will not be surprised by the self-portrait of the artist as the dried pelt held in the fists of Saint Bartholomew (1536-41). Michelangelo's references to his worthless leathery pelt are most frequent in his Christian verses. Typical lines are:*

Now that time changes and transmutes our rind (G 5)

150. My mortal epidermis which is dissolved as from
A serpent against a rock (G 94)

151. Fallen is now the fruit and dry the husk (G 158)

152. I am enclosed like the marrow in its pelt (G 267)

153. *Perhaps Michelangelo's most difficult years were those when the old artist directed the workshop of St. Peter's, knowing that increasing*

Anderson

Creation of the Sun and the Moon (Rome, Vatican, Sistine
Chapel Ceiling)

 He who from nothing, and ere all things were,
 Did time create, divided it in twain:
 To one he made the lofty sun a share;
 And to the other moonlight's dusky train. (*see page 52*)

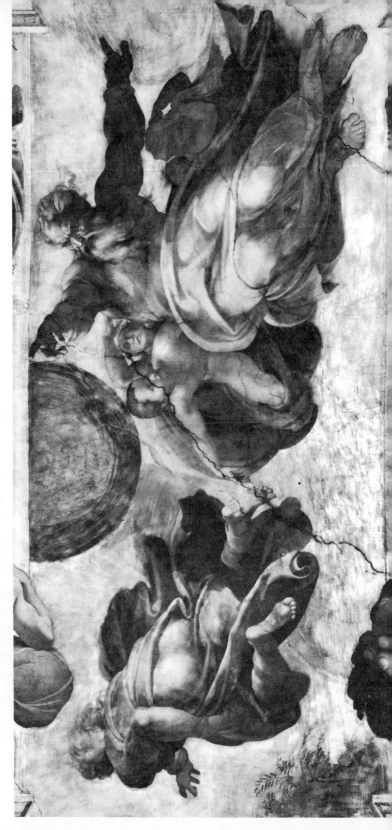

Tomb of Giuliano de' Medici, with Effigies of Day and
Night (Florence, Medici Chapel)
It is quite meet that he should take vengeance upon us
as he does. *(see page 53)*

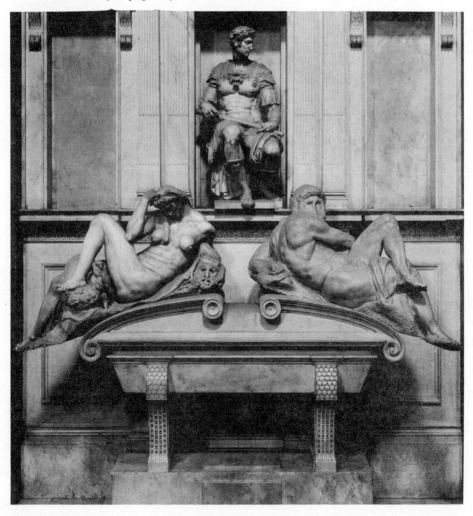

Night (Florence, Medici Chapel)
 O Night! O season fair; though black thou be,
 All strife in thee doth find its peaceful end; . . . (*see*
 page 54)

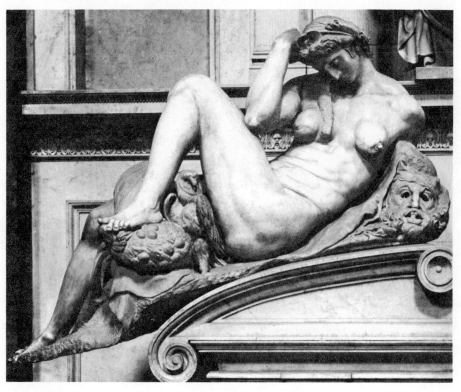

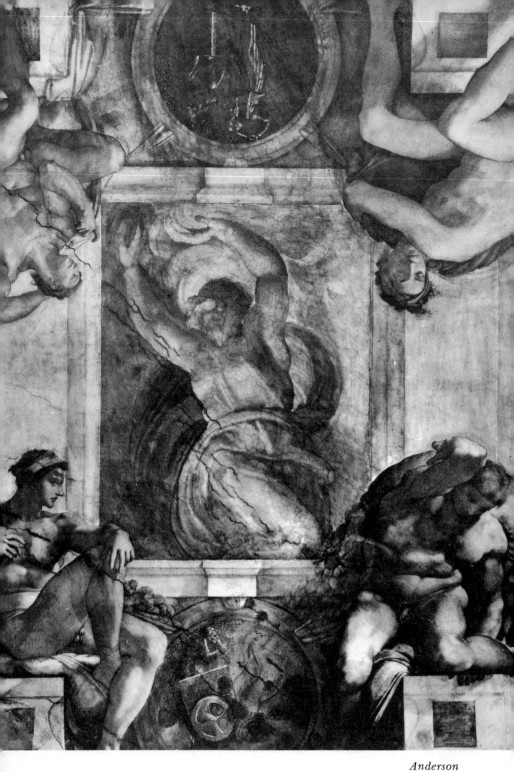

Separation of Darkness and Light (Rome, Vatican, Sistine Chapel Ceiling)

Then is the night more holy than the day. (*see page 55*)

Anderson

Michelangelo as the Pelt of Saint Bartholomew (Rome,
Vatican, Sistine Chapel, Last Judgement)

My mortal epidermis, which is dissolved as from
A serpent against a rock . . . (*see page 56*)

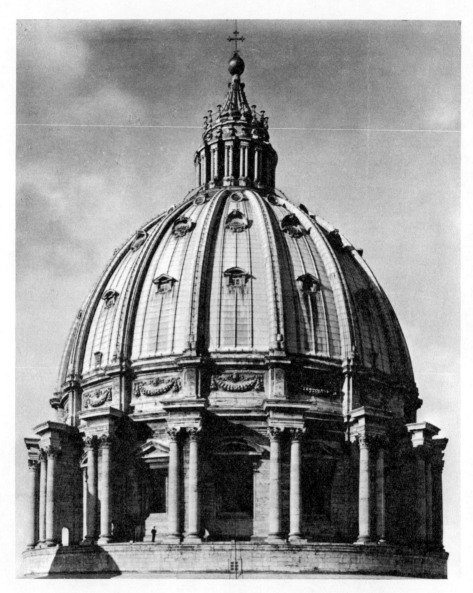

Dome of Saint Peter's Cathedral (Rome, Vatican)

God is my witness how much against my will it was when Pope Paul forced me into this work on Saint Peter's in Rome ten years ago. (*see page 57*)

infirmities and the hostility of younger men would eventually force his resignation. Yet he refused Vasari's invitation to return to Florence.

<div align="right">May, 1557</div>

Messer Giorgio. Dear Friend.—God is my witness how much against my will it was that Pope Paul forced me into this work on St. Peter's in Rome ten years ago. If the task had continued from that time forward as it was begun, it would by now be as far advanced as I had reason to hope, and I should have been able to come to you in Florence. But as the work has been delayed, the fabric is far behind schedule. It has begun to go slowly just when I have reached the most important and difficult part, so that if I left it now, it would be nothing less than a scandal to let slip all reward for the hardships against which I have been struggling these ten years for the love of God. I have written this account in reply to your letter because I have also received one from the Duke which fills me with astonishment that his Lordship should deign to write to me in such kindly terms.

I thank both God and His Excellency with all my heart. I am wandering from my subject, for both my memory and my thoughts have deserted me and I find writing most difficult, being, as it is, not my profession. What I wish to say is this: I want you to understand what would happen if I were to leave the aforesaid work and come to Florence. Firstly, I should give satisfaction to sundry robbers here, and should bring ruin upon the fabric, perhaps causing it to close down forever: then also I have certain obligations here, as well as a house and other possessions worth several thousand crowns, and if I were to depart without permission I know not what would happen to them: and finally, my health is in the condition, what with gravel and gallstones, and pleurisy, that is the lot of all old people. . . . Messer Giorgio, I commend myself to you, begging you to commend me to the Duke and do the best you can on my behalf, for there is only one thing left that I should care to do—and that is to die. . . .

THE MAN OF LETTERS

154. I have always taken delight in conversing with learned persons. If you remember well, there was not a literary man in Florence who was not my friend. So that I learned, as you see, some morsels which serve me well now when I read Dante, Petrarch, and these other authors in our Tuscan language. [Giannotti]

155. *The sculptor Michelangelo carries his* concetto *theory into the field of poetry:*

SICCOME NELLA PENNA . . .
Just as in pen and ink
There is high or low or intermediate style,
There are in marbles rich or base images,
So far as our genius can draw them out.
(—1534)

156. *Just as Michelangelo's art shows his preoccupation with capturing
basic form and consequent lack of concern for the finishing process,
so do we find him turning over poetry to others for the final labor of the
file:*

[Undated, 1542]
Messer Luigi.—You, who have the spirit of poetry, I beg you to
shorten and fix up one of these [two] madrigals, the one which seems
to you the less weak, for I am to give it to a friend of ours.

157. *After disclaiming competence in all of the major arts, Michelangelo
assures his friends that he is anything but a poet. Some of his poems are
accompanied by disclaimers such as the following:*

This carnival season it seems legitimate for those of us who don't
go around masked to commit some folly. (G 60, note)

158. While I write verse after verse I blush mightily—recalling to
whom I send my verse—rough and crude and not my profession. [G 85]

159. This poem is for the goat's milk cheese, the second one is for the
olives, if it's worth that much! [G 145, note]

19 September 1554
160. My dear Messer Giorgio, You will rightly say that I am old and
crazy to write sonnets, but since many say that I am in my second child-
hood I have tried to live up to my role.

161. *The Pindaric praises heaped upon Michelangelo by the poets left
him pleased if uncomfortable and reduced his disposition to criticize:*

20 January 1542
Messer Niccolò, I have from Messer Vincenzo Perini a letter of yours
with two sonnets and a madrigal. The letter and the sonnet directed to
me are wonderful things, so that no one could be so faultless as to find
anything in them to chasten. True it is that they lavish upon me such
praises, that if I had Paradise in my breast, they would scarcely be
insufficient. I see that you have imagined that I am what God wished
me to be. I am a poor man and of little worth, exhausting myself in

that art which God gave to me, to prolong my life as long as I can. And such as I am, I am your servant and that of all the Martelli household; and for the letter and sonnets I thank you, but not so much as I am obligated to you, for I do not rise to such lofty courtesy.

26 January 1545

162. The sonnet of Messer Donato seems to me as beautiful as anything done in our times. But because I have bad taste, I cannot evaluate a new suit, even of undyed wool, any less than I do the used garments of silk and gold that would make even a tailor's dummy seem beautiful. (Milanesi)

163. *This note was penned in the autograph of a madrigal (Note:* Mele *can mean "apples" or "honey."):*

Song born at night in the middle of bed. To be straightened out tomorrow night. It would be sweet as Adam's-Apple [preserved fruit] except that I have no honey (*mele*) in my body. [G 253, note]

164. *Michelangelo was pleased when Benedetto Varchi discoursed on two of the artist's sonnets before the Florentine Academy and then sent him the printed version of his talks* (Due Lezzioni). *The sonnet referred to in the two following selections is the well-known "Non ha l'ottimo artista alcun concetto" (see above, ¶ 8).*

[1549]

Magnifico Messer Luca [Martini],—Messer Bartolomeo Bettini has handed me your letter containing a small book in which there is a Commentary upon one of my sonnets. It is true that I wrote the sonnet in question, but the commentary must have been composed in heaven. It is indeed admirable: I do not give this as my own unsupported opinion, but as the opinion of men well able to judge, and especially of Donato Giannotti, who is never tired of reading it. He sends greetings to you all. As to the sonnet itself, I am fully aware of its true worth, but be that as it may, I cannot help feeling a certain amount of vanity seeing that I have been the cause of so beautiful and learned a Commentary. The words and praises bestowed upon me by the author show that he thinks me greater than I am in reality, and therefore I beg of you to employ such words to him on my behalf as are befitting to so much love, kindliness, and courtesy. I beg of you to do this because I feel myself inadequate, and one who has a good reputation should be careful not to run risks: it is better to keep silence than to fall from such heights. I am old, and death has already robbed me of all the thoughts of youth. Let those who do not know what old age is wait patiently until it overtakes them; they can never realize what it means

beforehand. Commend me, as I have said already, to Varchi as one who has deep admiration for his great abilities and say that I am always at his service wherever I may be. (Carden)

February, 1550

165. Messer Giovan Francesco, . . . Nothing else occurs to me except that today Messer Tomao de' Cavalieri asked me to thank Varchi in his name for a certain wonderful little book of his in print, where he says that Varchi speaks very honorably of him and no less of me. And he has given me a sonnet written to him by me, with the request that I send it to Varchi as a compensation; I send it to you in this letter; if it pleases you, give it to him; if not, give it to the fire, and reflect that I am combatting death and my head is on other matters; yet one has to do such things once in a while. For Messer Benedetto's having done me so much honor in his sonnets, as he has done, I beg you to thank him, offering him what little I am.

1524

166. My dear Giovanni [Spina].—Because the pen is always more courageous than the tongue, I am writing you that which several times today I could not bring myself to tell you outright in view of these times: and this is, that seeing that the times, as is said, are contrary to my art, I don't know whether I am to expect any further payment. . . .

167. *In a sense, the composers were the first contemporaries outside Michelangelo's circle of friends to discover him as a poet. His first printed madrigal was in a Neapolitan collection of songs dating from 1518. Thus, the artist was especially sensitive to these attentions of Tromboncino, Concilione, Archadelt, and others.*

[Undated, 1542]

Messer Luigi, dear my Lord,—The song of Arcadente is considered something beautiful; and since according to his remarks he intended to give no less pleasure to me than to you who requested it, I should not like to appear ungrateful in the matter. So I beg you to think of some present to give him, either of clothes or money, and to let me know what you have done. . . .

Later, Michelangelo added:

I should like not to appear ungrateful toward Arcadente. So, if you see a way to extend him some courtesy, I shall quickly reimburse you for what you will give him. I have a piece of satin here for a coat that Messer Girolamo cut for me. If this seems right, I'll send it to you as a gift for him.

168. *To Sebastiano del Piombo, on seeing two madrigals set to music:*

July, 1533
Dear Peer of mine, I have received the two madrigals, and Ser Giovan Francesco has had them sung several times, and according to him, they are considered something marvelous for singing; the words were certainly not worth that much. Thus you arranged it, and I've had the greatest pleasure over it. I beg you to advise me how I am to govern myself toward the person who set the poems to music, so that I may appear as knowledgeable and grateful as possible.

169. *Vasari, whose paintings rivaled nature herself, went further than nature as biographer of artists and architects, for his prose monuments will, in Horace's words, outlast bronze:*

SE CON LO STILE . . .
If with the chisel and the colours, thou
Hast made Art equal Nature, now thy hand
Hath e'en surpassed her, giving us her beauties
Rendered more beautiful. For with sage thought
Now hast thou set thyself to worthier toils,
And what was wanting still, hast now supplied
In giving life to others; thus depriving
Her boast of its last claim to rise above thee,
Is there an age whose labors may not hope
To reach the highest point? Yet by thy word
All gain the limit to their toils prescribed.
The else extinguished memories thus revived
To new and radiant life, by thee, shall now
Endure, with thine own fame, throughout all time.
(April-May, 1550) (Foster)

170. I've heard it said that Cato the Censor, a Roman citizen, learned Greek letters in the eightieth year of his life. Would it then be so surprising if Michelangelo Buonarroti, a Florentine citizen, were to learn Latin in his seventieth? [Giannotti]

15 June, 1549
171. . . . About that contract you mention, . . . it might be just as well to have it drawn up in the vernacular tongue, so that anybody can understand it.

172. *Michelangelo, considered an authority on the* Divine Comedy, *in youth as in old age, almost worshipped Dante. Longfellow, who*

translated the Comedy *and wrote a play about Michelangelo, thus paid a dual tribute in translating the following sonnet:*

QUANTE DIRNE SI DE' . . .

What should be said of him cannot be said;
 By too great splendor is his name attended;
 To blame is easier those who him offended,
 Than reach the faintest glory round him shed.
This man descended to the doomed and dead
 For our instruction; then to God ascended;
 Heaven opened wide to him its portals splendid,
 Who from his country's closed against him, fled.
Ungrateful land! To its own prejudice
 Nurse of his fortunes; and this showeth well
 That the most perfect most of grief shall see.
Among the thousand proofs let one suffice,
 That as his exile hath no parallel,
 Ne'er walked on earth a greater man than he.

 (1545/46) (Longfellow)

173. *Michelangelo does not hesitate to reject theories of the greatest Dante scholar of his time, Cristoforo Landino:*

So long as Landino does not stand up in one affirmation, it doesn't seem to me that we have to follow him. And especially since, in explaining Canto IX of *Purgatory,* he contradicts himself in another way. For he says that Dante, on the night of Good Friday, searched throughout all of Inferno, and came out from the center on the earth's surface of the other hemisphere; and in the beginning of the second day—which would be the morning of Holy Saturday according to Landino—he reached Cato. And the third night, which was that of Holy Saturday, he spent in a valley before the portal of Purgatory. These words, spoken without any consideration and full of confusion and errors, we shall let pass. It is enough that I have warned you not to trust Landino in this matter, even though he in all other matters was a singular man and worthy of the greatest praise. . . .

Shortly afterward the artist continues his attack on Landino:

Two things refute Landino's opinion. First, Dante could not in just two hours have done all the things he describes in the eighth Canto, in which he says that a multitude of souls sang that hymn which begins *Te lucis;* then the two angels appeared; then he reasoned at length with Nino de' Visconti of Pisa, appointed to the judgeship of Gallura

in Sardinia; then he saw the serpent appear which was chased off by the two angels; then he reasoned with Currado Malaspina; all of which things must have required more than two hours. The second thing is that, since the moon came over the horizon, the hours which had passed were necessarily four and not two. The moon having passed through two entire signs from the opposition to that hour, it must have been in the beginning of Sagittarius, so that it couldn't have come over the horizon until four hours after sundown. For the sun being in the first degrees of the Ram, it was necessary that after sunset there should appear before the moon all of the Scales and all of the Scorpion, which signs occupy in their ascents about four hours. And so the exposition of this commentator of yours cannot be true. . . . [Giannotti]

174. . . . Those young fellows of the Florentine Academy are reading him very zealously, and there cannot fail to come out soon some honored studies, so that this poet may be better understood, for until now [Dante] has not been understood. [Giannotti]

175. *A second sonnet to Dante again contains resentment that Dante's home town and his generation misunderstood and exiled him.*

> DAL CIEL DISCESE . . .
> He from the world into the blind abyss
> Descended and beheld the realms of woe;
> Then to the seat of everlasting bliss,
> And God's own throne, led by his thought sublime,
> Alive he soar'd, and to our nether clime
> Bringing a steady life, to us below
> Reveal'd the secrets of eternity.
> Ill did his thankless countrymen repay
> The fine desire; that which the good and great
> So often from the insensate many meet,
> That evil guerdon did our Dante find.
> But gladly would I, to be such as he,
> For his hard exile and calamity
> Forgo the happiest fortunes of mankind.
> (1545/46) (Southey)

Florence, 1 January, 1533

176. [Tommaso Cavalieri] Read the heart and not the letter, for the pen cannot draw near the good intent.

Michelangelo viewed handwriting as an art form, sometimes copying his own letters with care and theorizing that writing was a subsidiary

form of the arts of design. This belief, plus failing eyesight, occasioned such explosions as the following against his nephew (see also ¶ 548):

5 June, 1546

177. . . . Since I knew not how nor could I read your last letter, I threw it into the fire.

21 November 1552

178. Lionardo, . . . I'm not writing a reply to Guicciardino, because I haven't been able to read his letter. I don't know where you people learned how to write! Make my apologies, and give my regards to him and to Francesca.

179. *After Priscianese had explained to the artist the new art of printing, Michelangelo exclaimed:*

Priscianese has shown me the beautiful things he does and explained this whole matter of printing, which I had never examined so closely. It is certainly a marvelous thing and he who discovered it was a great genius. [Giannotti]

Musical Setting by Archadelt for Madrigal "Io dico che
fra noi" (1543)
 I should not like to appear ungrateful toward Arcadente.
 (*see page 60*)

G‍iunto e gia'l corso della uita mia
per tempestoso mar cō fragil barca
al comū porto oua render si uarca

conto eragio dognio pra falsa eria
ō de laffettuosa fatasia
chebbe larte periclose mo nar ca
conosco or bē quante ra derror carca
e quel cognuō cōtralsuo bē desia

I pē sier mie gia demie dammi lieti
che fienor ca duo morte mani cino
luna me certa e laltra mi minaccia

Ne pinger ne scolpir fie piu che quieti
lanima uolta aquellamor diuuno
caperse i croce aprendo nos le braccia

Manuscript Page of "Giunto è già 'l corso" (Florence,
Archivio Buonarroti)

The course of my long life hath reached at last . . .
(see page 169)

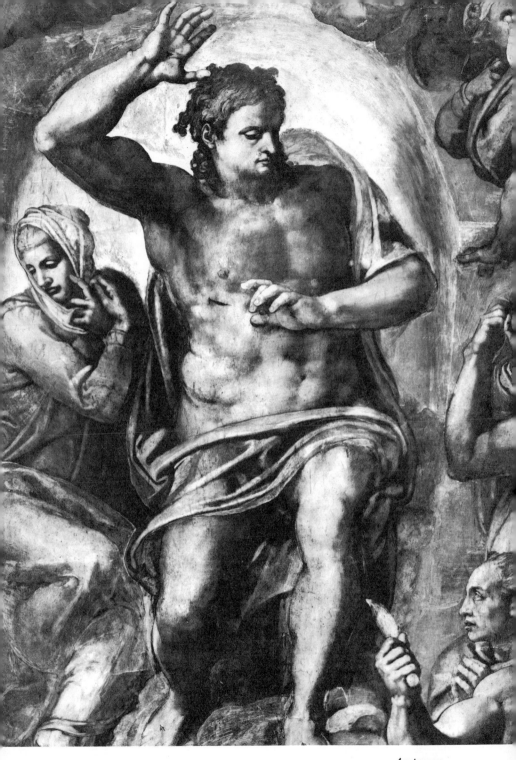

Christus Judex (Rome, Vatican, Sistine Chapel, Last Judgement)

The patience of the very Christ is spent. (*see page 66*)

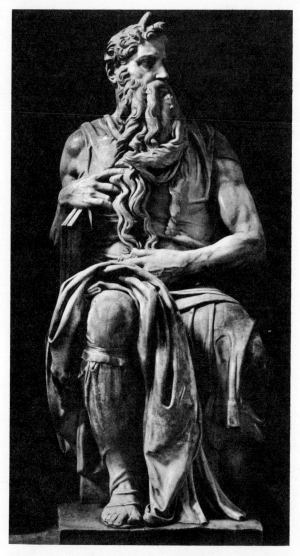

Moses (Rome, San Pietro in Vinculis)

. . . And even in the Old Testament God the Father wished that those who had only to ornament and paint the Ark of the Covenant should be masters excellent and great, but also touched by His grace and wisdom, God saying to Moses that He would imbue them with the knowledge and intelligence of His Spirit . . .

(see page 67)

II. RELIGION AND PHILOSOPHY

Michelangelo's testimonies on Christian religion and on pagan-Platonic philosophy may be legitimately grouped together, for the artist not only lived during the great conciliation between Christianity and classicism effected before the Council of Trent, but contributed to that accommodation by his devotion to both Roman Christianity and Platonism of his friend Marsilio Ficino. There are conspicuous evidences of this in his art, especially in the juxtaposition of Biblical prophets and pagan sibyls on the Sistine Vault. As a youth he had noted the intrusion of Platonic vocabulary into the fiery sermons of Savonarola, whom he much admired. During his long lifetime he broke bread alike with the famous neo-Platonists of the Medici circle and with pontiffs and prelates. If he abandoned classic themes in his art after establishing himself in Rome (with the exception of the bust of Brutus, *which however was associated in his mind with the Brutus-Judas passage in Dante's* Inferno, xxxiv *[see ¶ 397], his neo-Platonism became even more notable in the poems he composed in Rome during the 1540's and 1550's. Since Renaissance Platonism after Ficino was frequently discussed in a context of love, the reader is reminded that he will be able to assess Michelangelo's neo-Platonism only by combining this chapter with the love poetry below in Chapter III. Similarly, Michelangelo's Christ-centered religiosity, often verging on mysticism, emerges not only in these pages, but also in the magnificent Christian effusions of the 1550's, when the artist was "living on credit" as a debtor to Death and already fearing Christ's upraised arm at the Day of Judgment. These deeply moving poems are found below in Chapter VII.*

Heretofore scholars have failed to point out Michelangelo's role as an aphorist. This chapter (and Chapters III and V) should make it clear that the artist's curt temperament, wide interests, and provincial origins made him an important coiner of maxims, some of which would have entertained even Erasmus.

THE CHRISTIAN AND MYSTIC

180. Michelangelo was but one in his generation who criticised the moral laxity of Rome, a barbarous [*i.e., Turkish*] city titillated by Julius II's dreams of territorial acquisitions under the banner of Christ. Nor could the artist forget that this was the city which had sent Savonarola to his death.

QUA SI FA ELMI . . .
Here swords are wrought from cups of sacrament,
The holy blood of Christ is sold for gold,
For lance and buckler, cross and thorns are sold:
The patience of the very Christ is spent!
Let Him within our borders come no more,
Since Rome, who in her Saviour's blood doth trade,
Will sell His flesh for any price that's paid:
And hath to every virtue closed the door.
If by my work, the offspring of my mind,
I too with treasure would my coffers fill,
I see in Peter's chair Medusa throned.
Though poverty in Heaven do favor find,
What recompense shall be of earthly ill,
If earth's defeat undo the life beyond?
 Your Michelangelo in Turkey
 (1512) (Elizabeth Hall)

181. *The sentiments hostile to Savonarola which the young Michel-*
angelo found widespread in Rome only served to awaken loyalties in
the artist. His native caution is observable in the following letter from
Rome, even in the curious signature behind which he hid his identity.
(In 1942 Poggi expressed the theory that an assistant named Piero
actually wrote this letter, but this is most unlikely.)

Prudent Giovane Buonarroto di Lodovico Buonarroti, in Florence.

 In the name of God, this—day of March, 1497.
Dear Brother, for as such I esteem thee, From thy Michelagniolo. I
have received one of thy letters, from which I derived the greatest satis-
faction, chiefly because of its news of your seraphic Friar Jeronimo, who
has set all of Rome to talking. They say here that he is a vile heretic:
so much so that somehow he ought to come and prophesy a bit in Rome
for these people here; then they would canonize him. So let all his
followers be of good will. . . .
 Brother, thou art constantly in my thoughts; wherefore be of good
courage and strive to learn all thou canst, as thou art doing. . . . Fra
Mariano da Genazzano has naught but evil to say of your prophet. . . .
There is no other news, except that seven "paper bishops" [prisoners
to be tried] were made yesterday, and five of them hanged by the neck.
Give my best to all the members of thy family, and especially to Lodovico
my father, for so I esteem him. And when thou writest hither, give my
best to Michelagniolo. No more. Written in the dark.
 Thy Piero, in Rome

182. *The following speculation about the moral character of painters coincides not only with an ancient pagan tradition, but also with thoughts in Savonarola's sermons.*

In order to imitate to some extent the venerable image of our Lord it is not sufficient merely to be a great master in painting and very wise, but I think that it is necessary for the painter to be very moral in his mode of life, or even, if such were possible, a saint, so that the Holy Spirit may inspire his intellect. And we read that Alexander the Great put a heavy penalty upon any painter other than Apelles who should paint him, for he considered that man alone able to paint his appearance with that severity and liberal mind which could not be seen without being praised by the Greeks and feared and adored by the barbarians. And therefore if a simple man of this earth so commanded by edict concerning his image, how much more reason have the ecclesiastical or secular princes to take care to order that no one shall paint the benignity and meekness of our Redeemer or the purity of Our Lady and the Saints but the most illustrious painters to be found in their domains and provinces? And this would be a very famous and much praised work in any lord. And even in the Old Testament God the Father wished that those who only had to ornament and paint the Ark of the Covenant should be masters not merely excellent and great, but also touched by His grace and wisdom, God saying to Moses that He would imbue them with the knowledge and intelligence of His Spirit so that they might invent and do everything that He could invent and do. And therefore if God the Father willed that the ark of His Covenant should be well ornamented and painted, how much more study and consideration must He wish applied to the imitation of His serene face and that of His Son our Lord, and of the composure, chastity, and beauty of the glorious Virgin Mary, who was painted by St. Luke the Evangelist, the work in the Sanctum Sanctorum, and the head of our Saviour which is in San Giovanni in Laterano, as we all know, and especially Messer Francisco. Frequently images badly painted distract and cause devotion to be lost, at least in those who possess little; and, on the contrary, those that are divinely painted provoke and lead even those who are little devout and but little inclined to worship to contemplation and tears, and by their grave aspect imbue them with reverence and fear.

[De Hollanda] (Holroyd)

183. If these pains which I am enduring are not good for my soul, I am wasting time and labor. [Vasari]

184. I bequeath my soul to the hands of God, my body to the soil, and my goods to my nearest relatives, stipulating that as they go through this life they remember the sufferings of Jesus Christ. [Vasari]

185. *Among the autograph papers of Michelangelo is found a prayer,
perhaps written by himself, which coincides in spirit with his late re-
ligious verse:*

O most lofty Father, through whose kindness I was made a Christian,
only to bring me into thy kingdom; Thou didst create my soul out of
nothingness, and didst imprison it in my wretched body; give me grace,
so that as long as I stay in this prison unfriendly to my soul, in which
Thou alone dost hold me, I may exalt Thee; for in praising Thee Thou
wilt give me grace to benefit my fellow men, and in particular do good
to mine enemies and to commend them to you. Grant me grace once
more, O holy God, since having to endure corporeal sufferings, I may
recognize that these may not offend my soul; remembering Thy most
holy Son, who for the salvation of humanity died so shamefully; from
this I shall take consolation, and I shall always praise Thy holy name.
Amen.

186. *Simpler and more authenticated is a little prayer:*

Praise, little ones (*parvoli*),
Our Lord,
Praise Him ever. (G App. 15)

187.

BEN SARIEN DOLCI . . .

The prayers I make will then be sweet indeed
If Thou the spirit give by which I pray:
My unassisted heart is barren clay;
That of its native self can nothing feed:
Of good and pious works Thou art the seed,
That quickens only where Thou say'st it may:
Unless Thou shew to us thine own true way
No man can find it: Father! Thou must lead.
Do Thou, then, breathe those thoughts into my mind
By which such virtue may in me be bred
That in thy holy footsteps I may tread;
The fetters of my tongue do Thou unbind,
That I may have the power to sing of Thee,
And sound thy praises everlastingly.
(1555) (William Wordsworth)

188.

VORREI VOLER, SIGNORE . . .

Fain would I will, O Lord, what I'm not willing!
'Twixt fire and heart a veil of ice is hidden,

Damping the fire; agreement thus forbidden
Between my pen and works makes false each leaf.
I love thee with the tongue, then count it grief
That love reach not the heart; since so is hid
The door to grace, whereby the heart were rid
Of impious pride its inmost temple filling.
Rend thou the veil, O Lord, break down this wall,
Which by its hardness keeps retarding so
Thy holy sunshine, in the world gone out.
Oh, send the light, so long foretold for all,
To thy fair bride, that so my soul may glow,
And feel thee inwardly, and never doubt!

(1534/40) (John Sullivan Dwight)

189.

NON E PIÙ BASSA O VIL . . .

Lord! if by thee deserted I remain,
No viler reptile creeps upon the ground;
Weary of treading error's mazy round,
Thy help I ask, the path of truth to gain.
Draw me to thee by Faith's mysterious chain,
Where closely linked all heavenly gifts are found,
And break those carnal fetters, which have bound
My soul, to drag her to eternal pain.
The gift of Faith we should most firmly bind,
As a rich jewel, round the heart; for they
To whom that precious favor is not given,
Peace nor contentment in the world can find,
Nor true repentance can they feel; no key
But this unlocks to men the gates of Heaven.

(1555) (R. Pennell)

190.

VIVO AL PECCATO . . .

I live in sin, I live dying within myself;
Now is my life not my own, but of sin.
My grace was given of heaven, my evil of myself,
My will dissolved, free will have I no more.
My freedom in bondage, my mortal being
Is become a god to me. Oh, unhappy state!
To what wretchedness, to what a life was I born!

(1525)

191. *On hearing the report of the severe floods of the Arno in September, 1557, Michelangelo broods in a letter to Lionardo:*

I pray God to spare us from worse, as I fear for these sins of ours.

October, 1512

192. Dearest Father,—Your last letter informs me of all that is happening in Florence, although I already knew something. We must be patient, commit ourselves to God, and repent of our sins; for these adversities do not proceed from any other cause, and are chiefly due to pride and ingratitude. I never had to do with a more ungrateful and arrogant people than the Florentines. If, therefore, a judgment fall on us, it is but reasonable. . . . (Carden)

193. *It is tempting to suppose that the figure of Nicodemus—who distinctly resembles Michelangelo—in the Florentine Pietà is speaking the following consoling words to the deposed Christ.*

NON FUR MEN LIETI . . .

The blessed spirits were no less happy than disturbed and sad
On seeing that not they, but thou wast condemned to death
By which thou didst with thy blood open the gates of heaven
 to man.
They were happy, since, thou having created man,
Thou didst redeem him from original sin
Which had made his fate so miserable.
They were sad, since they felt that with harsh and cruel pain
Thou hadst become on the cross like a slave of slaves.
But whence Thou camest and who thou wast
Heaven showed by a certain sign,
For the skies darkened, the earth opened,
The mountains trembled, and the waters became turbid.
The patriarchs were taken from the shadowy kingdom
The fallen angels submerged in greater mourning;
Only man exulted, for at his baptism he was reborn.

(1555-1560)

194.

DEH FAMMITI VEDERE . . .

Oh, make me see thee, Lord, in every place!
If burns my heart, to mortal beauty bent,
Near thine will be that earthly ardor spent,
And I aflame again with heavenly grace.
Oh, my dear Lord, thee I evoke and call
Against my blind and unavailing pain

Without, within. Thou canst renew again
My will, my sense, my strength so prone to fall!
Thou gavest once to time this spirit divine,
Clothed in this frail and heavy dress;
Imprisoned here, and subject unto law,
What can I do to change this state of mine?
Nought without thee avails my heart to bless:
A power divine alone for me new lot can draw.
(1547) (Ednah Dow Cheney)

195. *Michelangelo planned a pilgrimage to Saint James of Compostela, but gave it up on hearing of the difficulties of travel through France.*

1545
. . . Therefore I am disposed, should nothing happen, to go after Christmas [*Pasqua d'Agnello*] to Saint James in Galicia, and while you are still there to proceed from wherever I understand you [Riccio] may be.

196. *As this Halloween missive explains, Michelangelo never completed a pilgrimage to the celebrated shrine of Loreto:*

31 October, 1556
. . . More than a month ago, finding that the work on the fabric of St. Peter's had begun to slow down, I made up my mind to go to Loreto as an act of devotion. But when I got as far as Spoleto, I found myself rather fatigued and accordingly remained there a little while to rest. The consequence was that I was prevented from carrying out my intention, for a man had been sent off posthaste to tell me that I was to go back to Rome. (Carden)

197. *Michelangelo's remark to an old acquaintance now dressed in a monk's robe:*

Oh you're a fine one! If you were as fine inside as I see you are outside, 'twere good for your soul.

198. *On March 23, 1549, Michelangelo reports relief from his malady of the stone.*

Lionardo.—In my last letter I wrote to thee concerning my suffering from the gallstone, a most cruel disease, as everyone knows who has had it. They sent me a certain kind of water which I had to drink, and as a result, in passing water I passed at the same time a large quantity of thick white matter together with portions of the shell of the stone. I am much better in consequence, and the doctors hope that in a short

time I shall be entirely free from it. Thanks be to God and to some devout person who has been praying for me. (Carden)

199. *On 25 April, 1549, he reported further:*

As for my malady, I'm quite a bit better now, and I am hopeful, to everyone's surprise. For I was held to be dead, and so did I believe myself. I had a good doctor [Realdo Colombo] but I believe more in prayers than in medicines.

200. *And finally, on 8 June, 1549:*

For about two months past I have had to drink every morning and evening, a certain sort of water which breaks up the stone. It is obtained from a spring about forty miles from Rome. It has broken mine and enabled me to pass water with considerable ease. I shall have to store up a supply of it in the house and use nothing else for either drinking or cooking: and I shall have to alter my mode of life. (Robert W. Carden)

201. *On the last rites of a brother:*

16 January, 1548
Lionardo.—I learn from your last letter of the death of Giovansimone. I was deeply moved by this, because I was hoping, although I am old, to set my eyes on him again before he died, and before I died. But thus was God's pleasure. Patience! It would be precious to me to learn in greater detail how he died, and if he died confessed and communicated and with all the things ordered by the Church; so that if he had these things, and I may know it, my grievance will be lessened.

202. *The artist is again reassured on learning that his dying brother Gismondo had received the rite of the viaticum:*

30 November, 1555
Lionardo: I learn from your letter of the death of my brother Gismondo, and not without the greatest sorrow. One must have patience. And since he died in good conscience and with all the sacraments ordered by the Church, God is to be thanked. . . .

THE PHILOSOPHER

October, 1512
203. . . . Make an effort to live well, and if you cannot attain the earthly honors of other citizens, be content with your daily bread and to live in Christ as poorly as I do here.

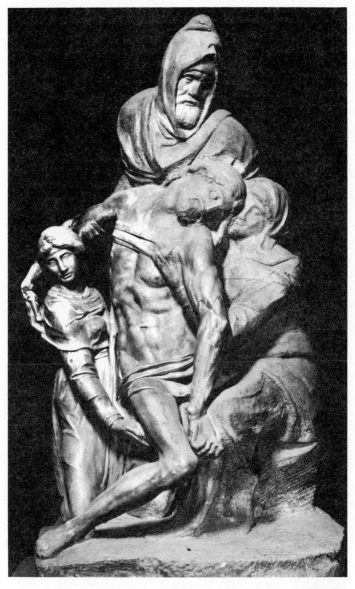

Deposition (Florence, Santa Maria del Fiore)
 Thou hadst become on the cross like a slave of slaves.
(*see page 70*)

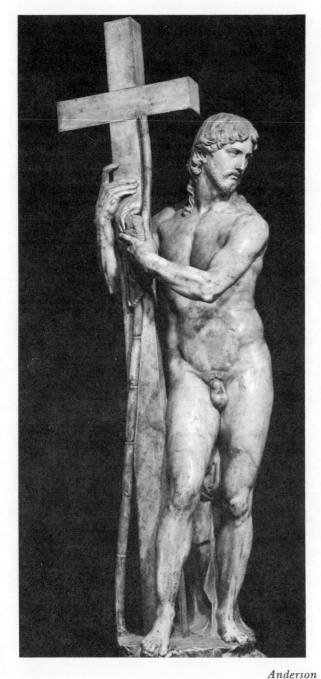

Cristo Risorto (Rome, Santa Maria sopra Minerva)
Thou canst renew again
My will, my sense, my strength so prone to fall!
(*see page 71*)

The Prophet Jeremiah (Rome, Vatican, Sistine Chapel Ceiling)

He who seeks disaster, God will give it to him.

(*see page 80*)

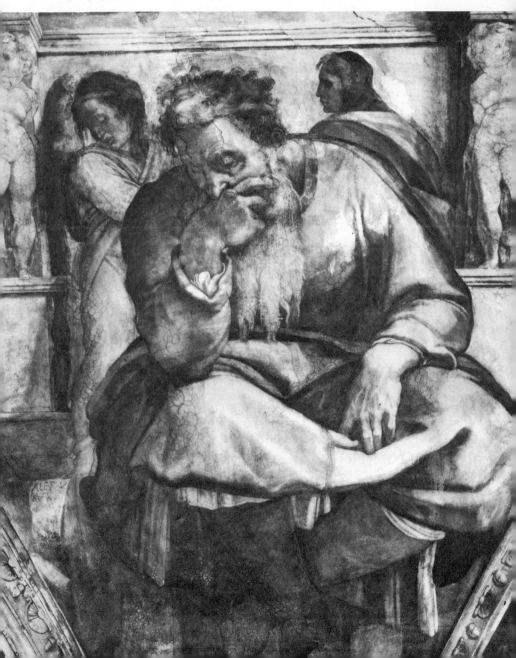

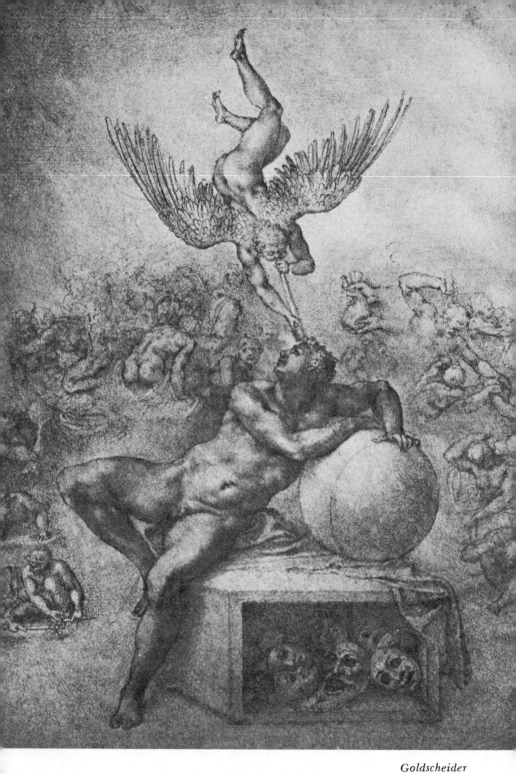

Sketch of the Dreamer, Sinners, and Masks (Weimar, private collection)

The world is blind, and bad examples still
Prevail and swallow up every best usage. (*see page 81*)

Goldscheider

Sketch of the Archers (Windsor, Royal Library)
 My soul almost arrived at the other shore
 Shields itself from thy shafts with others more merciful.
 (*see page 169*)

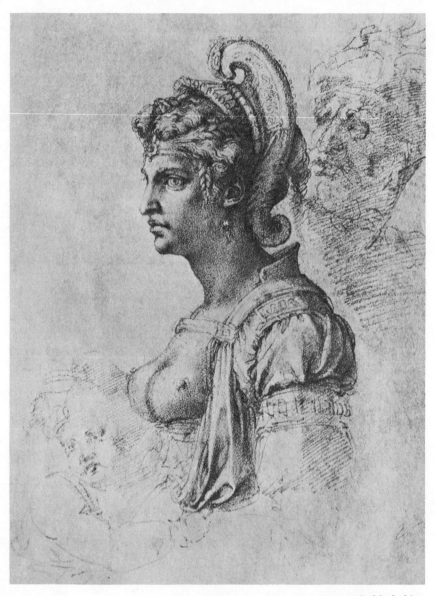

Goldscheider

Sketch of Venus, Mars, and Cupid (Florence, Uffizi)
Flee love, lovers, flee its flame;
Its burn is harsh and the wound is mortal;
For after its first assault naught avails. (*see page 84*)

5 September, 1510

204. . . . Never get upset about things; God didn't create us in order to abandon us!

205. *After thanking his nephew for sending him 40 bottles of Trebbiano wine, the aged artist makes a seemingly unconscious analogy between wine and himself:*

24 June, 1552

. . . It seems to me very good, but I cannot enjoy it much, since after giving a few bottles to friends, what is left turns in a few days to vinegar. So another year if I'm still about, it will suffice to send me ten bottles. . . .

206. *Michelangelo's persistent pessimism is attested by his poetry and by the fact that in his painting of the Last Judgment the Book of the Damned contains many more names than the Book of the Saved:*

MENTRE CHE 'L MIO PASSATO . . .
When thoughts of days long past upon me steal,
In vain I shun them; all their forms arise:
Then, o fallacious world, I deeply feel
How steeped in error man besotted lies.
The heart which yields its faith to thee,
Charmed by thy magic sorcery,
And thoughtless throbs the giddy round
Of vain delights within thee found,
By the sad issue learns to know
That pleasure is the nurse of woe.
He who is wise, at length will cease
To trust thy promises of peace;
Convinced thou never canst bestow
The good it is not thine to know.
The troubles I have proved, the griefs which dim my eyes,
Have sprung from yielding faith to thy vain fallacies.
(1534/40) (John S. Harford)

207. *The following letter on gratitude to Piero Gondi contains Michelangelo's charge, found also in his other writings, that life creates more difficulties for men of worth than for other men.*

26 January, 1524

Piero.—The ungrateful pauper has this nature, that if you succor him in his needs, he claims that whatever you give him was part of your surplus. If you place him in some job to do him a good turn, he says

you were obliged to do it, and that since you didn't know how to do the job yourself, you set him at it. And all the benefits he receives, he says that they come from the benefactor's need. And when the benefits received are obvious, he says that they can hardly be withheld. The ingrate waits a long time for him from whom he has received a favor to fall into public error, which will be the occasion for him to speak ill of the benefactor, and it will be believed by him that he is thus absolved of the obligation which he obviously has. Thus has it always happened against me: and not a one of them has turned against me (I'm speaking of workmen) but that I had done him favors willingly. Then because of some eccentricity or madness of mine—that they claim I have—which harms nobody but me, they have set to speaking ill of me and vituperating me: which is the reward of all worthy men. . . .

July 1524

208. . . . Perhaps if I were further ahead with the work than I am, the Pope would have settled the matter [of the Tomb of Julius II] and I would have gotten over this passion, but he obviously makes more of the work of a man who spoils than of a man who gets things done.

209. *Reminder to nephew:*

8 August, 1556

. . . It is quite true that self-love deceives all men. Remember thy father and the death he met, and I, thank God, am still alive.

October 1512

210. Most dear Father.— . . . I live miserably and care naught for life or honors, that is of the world, and I live with the greatest labors and with a thousand suspicions. And it's now been some fifteen years since I had an hour of peace—and all this I've done to help you all. Not that you've ever been aware of it or believed it. May God pardon all of us! I'm ready to go on still in the same way as long as I live, provided I can.

211. *About the lawsuit contemplated by the heirs of Julius II:*

19 April, 1525

. . . No one can start a litigation against me if I confess that I'm in the wrong. I'll just pretend that I've been in a lawsuit and lost, and have to give satisfaction: and this I am disposed to do, if I can.

212. *The winged-soul imagery is here Platonic:*

PER RITORNAR LÀ DONDE . . .

The immortal soul, aspiring to that height
 It stooped from, to your earthly prison came,
An angel of compassions infinite

To heal all hearts and bring our earth good fame.
By it alone, not by your face serene
　Am I enflaméd and enamored so
For never love of passing thing could lean
　On hope so sure, or equal virtue show.

So comes it when to crown her toils intent
Nature brings forth new works and excellent;
　The heavens themselves such spacious births prepare.
And God, by His own grace, I chiefly see
In some fair vesture of humanity
　Which I love only for His image there.

<div align="right">(1536/42) (Nesca Robb)</div>

213. *The habit of the eyes to discern through the object of the senses the higher prototype of divine Beauty is frequently referred to by the Platonist Michelangelo.*

LA VITA DEL MIO AMOR . . .

My love's life comes not from this heart of mine.
The love wherewith I love thee hath no heart,
Turned thither whither no fell thoughts incline
And erring human passion leaves no smart.
Love, from God's bosom when our souls did part,
Made me pure eye to see, thee light to shine,
And I must needs, half mortal though thou art,
In spite of sorrow know thee all divine.
As heat in fire, so must eternity
In beauty dwell; through thee my soul's endeavor
Mounts to the pattern and the source of thee;
And having found all heaven in thine eyes,
Beneath thy brows my burning spirit flies
There where I loved thee first to dwell for ever.

<div align="right">(1526) (George Santayana)</div>

214. *The image of the loved one becomes transformed once it passes through the eye to the soul. There it regains its pristine, lofty aspect.*

DIMMI DI GRAZIA, AMOR . . .

Poet: Tell me, O Love, I pray thee, do mine eyes
Behold that Beauty's truth which I admire,
Or lives it in my heart—for wheresoe'er
I turn, more fair her countenance appears?
Thou well must know, for thou dost come with her,

To take from me my peace, whence I complain;
And yet I would not wish one brief sigh less,
Nor that the flame within me were less strong.

Love: The Beauty thou regardest is from her,
But grows as to a better place it riseth,
If through the mortal eyes it finds the soul.
There it becomes ennobled, fair, divine;
For immortal thing assimilates the pure:
This one, and not the other, meets thine eye.

(1529) (John Edward Taylor)

215.

MENTRE C'ALLA BELTÀ . . .

As I draw my soul, which sees through the eyes,
Closer to beauty as I first saw it,
The image grows therein, and the first image
Recedes as though unworthy and without value.
Thus thy image, which immolates me outside,
Grows inside through my eyes, whence I am enlarged.

(1524/29)

216. *A fragmentary poem in octave stanzas describes a hideous giant
and his slovenly wife, who have vaunted the gods and begotten the
seven deadly sins. From her loathsome womb will issue forth other sins,
equally relentless in besieging man. The giant represents* hubris, *pride
which defies even gods:*

UN GIGANTE V'È ANCOR . . .

Still there is a giant, of such great height,
That his eyes cannot make us out here below.
Many times has he kicked over and crushed
An entire city as he set his foot down.
He aspires to the sun, and towers crumble underfoot
As he tries to reach the sky, which he cannot see,
For this tremendous and robust body of his
Has but one eye, and that set on a heel.

This earth-bound eye sees things past,
Even as he holds his head up firm and close to the stars.
It would take us two days down here to see
The strides of his great legs, and hairy is his skin.

Around his upper regions there is no winter or summer,
For to him all the seasons are equal and fine.
And as heaven itself is level with his forehead
Down on earth his feet tread every mountain flat.

As to us are grains of sand,
So are mountains underfoot to him.
Within the thick hair of his limbs he carries
Diverse forms, monstrous and huge.
Therein a whale would seem a mere fly,
And yet he is troubled or saddened or weeps
Only when the wind blasts against his single eye
Smoke or straw or spinning dust.

With him he has a lazy and slovenly wife,
Whose breast feeds this horrible figure
And to her arrogant, bold, and blind husband
Feeds pride and gives him confidence.
She stays apart from him in a narrow grotto,
Within great rocks and behind tall walls,
Even when he is idle, she dwells in shadows
And alone casts her spells, impoverishing the people.

Pallid and yellow she; and in her grave womb
She bears the sign of her lord alone.
She thrives on others' ills, weakens at their well being.
Nor is she ever sated, though feeding at all hours.
Her evil course will ne'er be slackened or stayed.
Incapable of inciting love, she hates all others.
Her heart is of stone, her arms of iron.
Into her belly she gulps mountains and sea alike.

Seven of their firstborn wander over the earth,
Seeking to the reaches of the two poles,
And war and plot only against the righteous:
And a thousand members has each one of these.
The eternal abyss opens and closes for them,
Such prey do they take from the universal throng.
And their members slowly clasp around us
As ivy from rock to rock overruns a wall.

(—1534)

217. *A sudden procession of allegorical figures interrupts the depiction
of country life in the unfinished "Stanzas in Praise of Rustic Life." In
general, the virtues pictured characterize life outside the cities and the*

vices, life within. These curious figures, not typical of the iconography of the time, preach a lesson on maintaining a strong Christian resolve. (See also ¶ 433 below.)

EL DUBBIO ARMATO E ZOPPO . . .

Doubt armed and lame is pictured,
Hopping here and there like the locust,
Trembling constantly as by his nature,
Just as a swamp reed shakes under the wind.
The figure Why is lean and round his waist
Bears many keys, but not the right ones
Able to fit the keyholes of the door.
Escorted by darkness, he wanders about the night.

He has two close of kin, How and Perhaps,
Who giants are of such a height
That each to attain the sun seems to delight,
Even when blinded on gazing at its splendor.
Whatever parts of cities their proud frames cast in shadow
Are robbed altogether of what beauty they possess.
They pick their way over steep and twisted roads, through
 rocks,
Testing with their hands which is the most solid.

218.

Poor and nude Truth goes about alone,
Who is so prized among the humble folk.
Only one eye he has, shining and clear.
His body is of gold and of diamond his heart.
In troubles he grows in stature and becomes lofty.
If he is stamped out in one place, he is reborn in a thousand.
Outwardly he is as verdant as an emerald,
And is with his faithful followers constant and solid.

With his honest eyes lowered toward the ground,
Dressed in gold and embroidered raiment
Falsehood makes his way, warring only on the just.
Hypocrite, he feigns outwardly to love all;
Because he is of ice, he cowers and cringes at the sun.
He is ever at court and seems to long for shadow,
And has for his support and company
Fraud, Discord, and Mendacity.

219.

Then next there is Adulation, laden with worries,
Young, dextrous, and handsome of person.
She is covered with more color and more clothes
Than heaven grants to flowers in the spring.
She gets what she wants with sweet deceits
And reasons only of those things which please others.
She turns on tears or laughter at her whim,
With her eyes she adores even as her hands steal.

She is not only the mother of all courtly crimes,
But breast-feeds them along and with her milk
Increases them, augments them, and defends them. . . .

(—1534)

THE APHORIST

220. *The following jotting sums up Michelangelo's ambivalent feelings
about his life as artist which provided him with creature comforts on
the one hand and on the other with difficulties, pressures, and humilia-
tions:*

Dolce stanza nell'inferno . . .
Sweet chamber in hell . . .

(G. App. 7)

APHORISMS OF A PESSIMISTIC CONTENT

221. Of life's good fortune and grace the hours are brief and short.
(G 269)
222. Evil harms much more than doth goodness help. (G 124)
223. He never dies who keeps lingering on the road to health. (G 120)
224. The longer the time the less good will can last. (G 296)
225. Suppressed misfortunes have a double strength. (G 60)
226. One who tries hardest fails. (LXIII)
227. Only the worthy are not blessed by good fortune. (G 248)
228. The seven deadly sins intrigue and war on only the just. (G 68)
229. The most perfect abound in the greatest ills. (G 250)
230. For he who is best suffers the most. (CCXIII)
231. Nowadays to do one's duty is a sin. (CXVI)
232. Heaven scorns to grant any good thing to the world when one
tries to gather fruit from a dried tree. (G 6)
233. He who does not believe remains better off. (G 85)

234. Less favor and less bounty last longer, for to the ill-starred death is lazy and late. (G 208)
235. He who seeks disaster, God will give it to him. (G 267)
236. The more one believes in himself the more he is deceived. (G 165)
237. Wise counsel is vanquished by bad habits. (G 135)
238. Things that have a bad beginning cannot come to a good end. (CCLVII)

MORE APHORISMS FROM THE LETTERS

239. He who is in good repute should not tempt fortune. (CDLXIII)
240. One must not laugh when the whole world weeps. (CDLXXII)
241. The pen cannot even approach good intent. (CDXI)

APHORISMS LESS PESSIMISTIC

242. The soul caught between two turns to the worthier. (G 15)
243. A great pleasure can absorb [support] a great trouble. (G 123)
244. He gains much who learns by losing. (G 116)
245. He cures all ills who takes life. (G 137)
246. Seeing rarely is close to forgetting. (G 163)
247. A beautiful thing never gives so much pain as does failing to hear and see it. (F xvi)
248. Sorrow, as they say, makes beautiful. (F xvi)
249. He must love the slave who the master adores. (G 117)

ON CAUSALITY

250. Best could be worst. (G 145)
251. Evil does not endure where goodness endureth not, but often the latter is transformed into the former. (G 53)

GENERAL REFLECTIONS

252. Let doubt be sweet to him whom truth can kill. (G 141)
253. He who does kindness to the good man makes him better, and to the evil man makes him worse. (CXXVII)
254. He who would do wrong harms himself. (XXIX)
255. Sweetness will counteract the serpent's bite. (G 54)
256. To him who wants only half a loaf of bread, it ill befits to give a palace. (G 148 note)
257.

> My eyes are saddened at many things
> And my heart by as many things as the world encloses.
> (G 301)

258.

> The world is blind, and bad examples still
> Prevail and swallow up every best usage.
>
> (G 295)

259.

> Good taste is so rare that it sometimes perforce
> Gives in to the erring crowd,
> Whereas within itself it derives satisfaction. . . .
> The world is blind.
>
> [G 109]

260. Oh, you make me laugh when you think of dancing. I tell you that in this world it is enough to make one weep. [Giannotti]

261. *Reminder to a suffering niece, Francesca:*

August, 1541

One cannot have in this world entire happiness.

III. LOVE

Michelangelo, like Petrarch, was one of those love poets who seldom had time for love. Indeed, we do not know the name of any woman with whom he carried on a sustained, consummated love affair. He was, as Vasari records, married to his art. Yet Michelangelo devoted time—a great deal of time—to writing love poetry, and this chapter will be made up largely of these poems. Just as symbols of love haunt his art (Venus and Cupid, Leda and the Swan, Samson and Delilah, Tityus, Ganymede, and so forth), so does the artist depict himself as a figure involved in love, like the herm pictured in his curious drawing of the Archers. As a symbolic lover he writes with consuming interest on the vagaries, suspense, power, renunciation, and even definition of love. He will warn us that "unbridled lust is sense and not love, and it kills the soul." Accordingly his love poetry, derived from the dolce stil, from Petrarchism, and from Platonism, is usually spiritualized, but a few pieces wander away from the amor onesto and his late poetry will regret this indulgence in sensual pleasure. It is necessary with Michelangelo to separate our entries into three classifications: generalities on love, expressions of love for women, and poems to men. If the wraith-like ladies who wander through his Rime can be neither identified nor even authenticated—except for his chaste autumnal love, Vittoria Colonna—the same is not true for the men. We shall include stanzas involving respectively the virtuous younger nobleman Tommaso Cavalieri, the less virtuous male model Febo di Poggio, and the adolescent mignon Cecchino dei Bracci, about whom Michelangelo composed 50 (possibly 51) epitaphs and whose tomb he designed in the Church of Ara Coeli.

THE LOVER

262. *A Dantean definition:*

Love is a beautiful image
Imagined or seen within the heart,
The friend of virtue and gentility.
(G 38)

MAXIMS ON LOVE

263. He who grows up wanting, 'tis good that he die. (G 204)
264. Weak virtue dies at a great gift. (G 150)

265. The heart loves late what the eye sees not. (G 258)
266. Habit heals every defect for the eyes. (G 256)
267. A little is too much to him who serves well and strives. (G 134)
268. One hour does not overcome the habit of many years. (G 131)
269. The habit of many years is not overcome by a day. (G 130)
270. A straight sheathe cannot hold a crooked blade. (G 54)
271. Half measure, for him who loves too much, is always the worst.
(G 157)
272. A little wind will bring down a winter flower. (G 218)
273. Fire is tested badly by a burnt log. (G 272)
274. Love requires equal state and equal youth. (G 255)
275. He who loves sleeps not. (CDLV)
276. Love does not wish a master. (CDLV)

277.

NON VIDER GLI OCCHI . . .

No mortal object did these eyes behold
 When first they met the placid light of thine,
 And my Soul felt her destiny divine. . . .
 And hope of endless peace in me grew bold:
Heaven-born, the soul a heavenward course must hold;
 Beyond the visible world she soars to seek
 (For what delights the sense in false and weak)
 Ideal Form, the universal mold.
The wise man, I affirm, can find no rest
 In that which perishes; nor will he lend
 His heart to aught which doth on time depend.
'Tis sense, unbridled will, and not true love,
 That kills the soul; love betters what is best,
 Even here below, but more in heaven above.
 (1534?) (William Wordsworth)

278. *A curious wish, with echoes of Sappho and Ficino:*

Make of my entire body one single eye, nor let there be
then any part of me not taking pleasure in thee!
 [G 166]

279. *The perfect union:*

S'UN CASTO AMOR . . .

If one pure love, if one supreme devotion,
One fate unite two hearts in harmony,

If grief of one the other's sorrow be,
If by two minds is felt one spirit's motion:
If one eternal soul is made for twain,
Uplifting both, and in one flight to heaven:
If by one burning shaft two breasts are riven,
Which deep implanted doth for aye remain:
If, self forgotten, each the other love,
With joy, that such sweet intermingling hath,
Each for his own the other's will doth take;
If all twice-told the hundredth part would prove
Of such great love, and bond of mighty faith;
Shall wrath avail to loose it, or to break?

(1532) (Elizabeth Hall)

280.

IO T'HO COMPRATO . . .
I've bought for thee, though it cost me dear,
A little something fragrant as can be,
By its odor I'll learn to find my way,
Wherever thou may be, wherever I shall be.
Without any doubt I'm certain and clear of this.
If thou hidest away from me, I'll pardon thee.
Bearing it wherever thou go'st always with thee,
I could find thee even were I quite blind.

(1520/34)

281.

FUGGITE, AMANTI, AMOR . . .
Flee love, lovers, flee its flame;
Its burn is harsh and the wound is mortal;
For after its first assault naught avails,
Neither force nor reason nor moving away.
Flee, now that you have before you many examples
Of love's deadly arm and its sharp arrow.
Read in me what will be your ill fate,
What will be its game, without respect or pity.
Flee, and do not tarry at the first glance.
For I had always thought I could come to terms with love.
Now I suffer, and you see how I burn.

(1524)

282.

CRUDELE, ACERBO, E DISPIETATO . . .

Cruel, bitter, and pitiless heart,
Clad in sweetness and full of love,
Thy faith is slowly born, to last less time
Than do the flowers in a mild winter.

(1521)

283.

COME PUÒ ESSER CH'IO . . .

How can it be that I am no longer my own?
Who from myself, O God, hath taken me?
Who has been closer within me
And holds more sway o'er me than I?
How is my heart pierced, O God,
By that which seemeth to touch me not?
What is this, Love,
That through the eyes doth enter the heart,
Appearing in little space within to grow?
What then will happen should it overflow?

(1511)

284.

IL MIO REFUGIO . . .

The haven and last refuge of my pain
(A safe and strong defense)
Are tears and supplications, but in vain.
Love sets upon me banded with Disdain,
One armed with pity and one armed with death,
And as death smites me, pity lends me breadth.
Else had my soul long since departed thence.
She pineth to remove
Whither her hopes of endless peace abide
And beauty dwelleth without beauty's pride,
There her last bliss to prove.
But still the living fountain of her tears
Wells in the heart when all thy truth appears,
Lest death should vanquish love.

(1536/46) (George Santayana)

285.

RENDETE AGLI OCCHI MIEI . . .

Restore, ye springs and rivers, to mine eyes
That stream, not yours, which doth not cease to flow,
And you so richly nourisheth, that so
Beyond your wont with swift increase ye rise.
And thou, dense air, made heavy with my sighs,
That from my sad eyes shadest heaven's light,
Restore them to my heart, and let my sight
Pierce to the brightness which thy mists disguise.
Let earth its footprints to my feet restore,
The herb spring up again, which they did press,
And dullard echo send back my lament.
And let thine eyes give back my looks once more,
That I one day some other loveliness
May love, since thee so little I content.

(1534/38) (Elizabeth Hall)

286.

CREDO, PERCH'ANCOR FORSE . . .

Oh, that ardor of love be not yet extinguished
In the wintry chill of my fading years.
Love, who remembers his arrows never failed
in their swift, sure course to a gentle heart,
suddenly bends the bow.
And in the autumn of my life I know a second spring.
For a fair face I succumb to the last dart,
more sorely wounded than at the first.

(1536/46) (Carmine Mezzacappa)

WOMEN

1 February, 1549

287. It's easy for a girl to become a whore, especially girls without a family.

288. Chaste women remain much more fresh than those who are not chaste. [Condivi]

289. The number of widows is always greater than the number of widowers. [CCLXIII]

290. *Advice to marry a girl of modest means:*

If you do so you would not be obliged to endure the coquetries and madnesses of women. [CCXLII]

291. *In his poetry Michelangelo had included a maxim to the effect that there must be parity of age and condition in a love affair. As a marriage counselor he is even more specific:*

1547

Lionardo, . . . But above all seek counsel from God, for this is a serious step in life. I would remind thee that there should be always at least ten years difference between the age of husband and wife; and have a care that she be healthy as well as good. I have no more to say.

(Carden)

16 August 1550

292. Lionardo, . . . With regard to thy taking a wife, thou sayest thou wishest first to come to Rome and talk the matter over with me. My living arrangements are exceedingly bad and cost me a great deal, as thou wilt see for thyself; but I do not mean by this that thou art not to come, though it seems to me better that thou shouldst wait until the latter half of September, and in the meantime I will try to get a good and clean serving-woman, though it will be difficult because they are all whores and pigs [*puttane e porche*]. Let me hear from thee. I pay ten *julii* a month: I live poorly, but I pay well. . . . (Carden)

293. *One of the most ingenuous hoaxes of Michelangelo studies concerns a beautiful young Bolognese girl who aroused the young sculptor when he was working on the bronze Julius II in that city (1506-07). The whole romantic episode was based on the following sonnet, which is merely, however, an exercise in poetizing heavy with borrowing from Petrarch and Poliziano.*

QUANTO SI GODE . . .

How great must be that happy garland's bliss,
That wreathes with flowers the hair of one I know:
Each flower would swifter than its neighbor go,
That he may first those golden tresses kiss.
All day contented with its happy lot
That bodice clasps her breast, or with it heaves:
And what the name of golden thread receives
Her cheek and neck from touching ceaseth not.
But joy more exquisite than aught beside

That ribbon hath, with golden fringes gay,
Which on the breast it laceth, resteth so;
And the neat girdle round her waist that's tied,
Saith to itself, "This let me clasp away":
What then remaineth for my arms to do?

(1507/08) (Elizabeth Hall)

294. *Not always a somber love poet, Michelangelo sometimes adopted the sprightly and peppery tone of his comrades in poetry, Lorenzo the Magnificent and the ironic Francesco Berni:*

IO CREDEREI, SE TU FUSSI DI SASSO . . .

Methinks, though thou wert stone, the charm I'd know
(So strong and faithful is my love for thee)
To lead thee with me wheresoe'er I go;
If thou wert dead, I'd make thee speak to me;
Wert thou in heaven, I'd draw thee down below
With sighs, and prayers, and tears of agony:
But since as living flesh thou here dost dwell,
What hopes may not be his who loves thee well?

(1529/32) (Channing)

295. *The following comical "rustic" song was no doubt modeled on a shepherd's love-song in Lorenzo de' Medici's* Nencia da Barberina.

TU HA' 'L VISO . . .

Sweet is thy visage, as newly pressed wine;
The oft-trod path of a snail's promenade
Beseems it to glow, like turnips in brine.
Thy teeth, tinted white, with mustard parade
(Even the Papacy thinks thee divine).
Thine eye boasts the color of marmalade!
More flaxen than onions are shaded thy tresses;
Alas! I shall die without thy caresses.

Thy beauty appeareth even more fair
Than portraits in churches of somber men painted.
Thy mouth to me with a pouch doth compare,
Made swollen with beans, as mine is acquainted.
Thine eyelash skillet-hued credence doth bear,
And twisted, as Syrian arches are tainted.
Thy teeth are when powdered both white and red,
As poppies sprinkled on new cheese are shed.

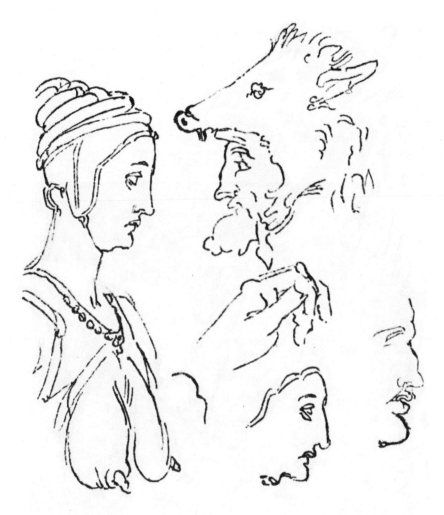

Sketch of Michelangelo Coifed in a Boar's Head, Vittoria Colonna with Sagging Breasts, and Vulgar Gesture (Florence, Archivio Buonarroti)

The fairest of fair, howe'er ugliest. (*see page 89*)

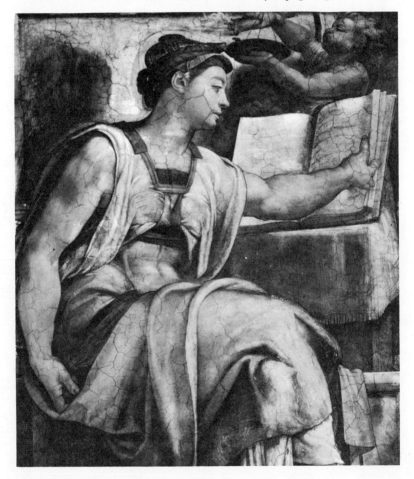

Anderson

Sibilla Eritrea (Rome, Vatican, Sistine Chapel Ceiling)
Therefore take thou my heart's unwritten page,
And write thou on it what is wanted there. (*see page 89*)

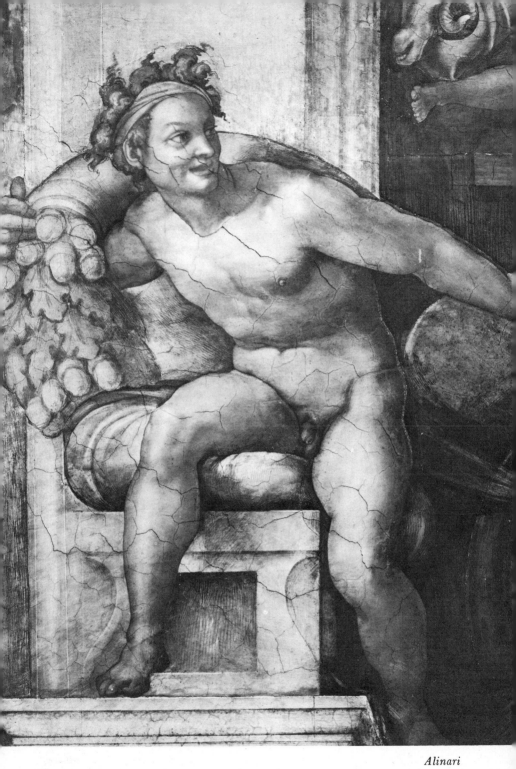

Nude Youth (Rome, Vatican, Sistine Chapel Ceiling)
And though the throng, malign and brutish, free
Its gibes and scoffs at what the few possess,
There fails no joy from this warm eagerness,
This chaste desire, this love, this fealty. *(see page 94)*

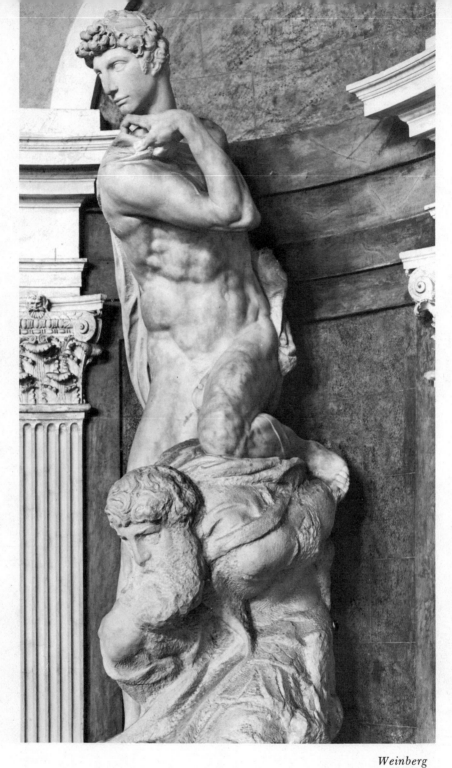

Weinberg

The Spirit of Victory (Florence, Palazzo Vecchio)
I remain prisoner of an armed cavalier. (*see page 151*)

Thy hands, thine arms, thy neck, and all the rest,
The fairest of fair, howe'er ugliest.
 (1513/24) (Donald Remstein)

296. *Michelangelo designed a Crucifixion for Vittoria Colonna:*

1545

Signora Marchesa, . . . Seeing that I am here in Rome it does not
seem to be necessary that you should delegate the matter of the Crucifix
to Messer Tommao or use him as an intermediary between your Lady-
ship and myself, your servant, in order to obtain my services, especially
as I wish to perform more for you than for anyone I ever knew in the
world. But the absorbing occupations that have claimed my attention
in the past and still engage me have prevented my proving this to your
Ladyship. I know you are aware that love submits to no master and
that he who loves does not sleep, so it seems to me that there is all
the less occasion for an intermediary; and although it may seem that
I do not remember, I was doing something I did not speak of in order
to effect something you did not look for. My design has come to nought:
"He sins who faith like this so soon forgets." (Carden)

297. *Vittoria Colonna inspired poetry in both life and death:*

ORA IN SUL DESTRO . . .
Now on the one foot, on the other now,
'Twixt vice and virtue balancing below;
Wearied and anxious in my troubled mind,
Seeking where'er I may salvation find;
Like one to whom the stars by clouds are cross'd,
Who, turn which way he will, errs and is lost,
Therefore take thou my heart's unwritten page,
And write thou on it what is wanted there!
And hold before it in life's daily stage
The line of action which it craves in prayer!
So that amid the errors of my youth
My own shortcomings may not hide the truth,
If humble sinners lower in heaven stood
Than the proud doers of superfluous good.
 (1538/41) (Fanny Elizabeth Bunnett)

298.

NON MEN GRAN GRAZIA . . .
Great joy no less than grief doth murder men.
 The thief, even at the gallows, may be killed

If, while through every vein with fear he's chilled,
Sudden reprieve do set him free again.
Thus hath this bounty from you in my pain
 Through all my griefs and sufferings fiercely thrilled,
 Coming from a breast with sovereign mercy filled,
And more than weeping, cleft my heart in twain.
Good news, like bad, may bring the taker death.
 The heart is rent as with the sharpest knife,
 Be it pressure or expansion cause the rift.
Let thy great beauty which God cherisheth
 Limit my joy if it desire my life—
 The unworthy dies beneath so great a gift.

<div align="right">(1536/46) (Emerson)</div>

299.

PER NON S'AVERE . . .

Pure and unsullied beauty Heaven lent
Unto one noble, lofty, fair alone,
Beneath a spotless veil, that when through death
Reclaim'd, it should not have to leave so many.
If Heaven indeed had shared it among all
That mortal are, it scarce could have withdrawn
It back, and re-enrich'd its treasury.
Heaven has reta'en it from this mortal goddess
(To call her so), and borne it from our eyes;
Yet the sweet, beautiful, and holy verse
Cannot so soon into oblivion pass,
Although the mortal be removed by death.
But pity, merciless, appears to us
To show that, if to each one Heaven had given
The beauty of this fair one to partake,
We should be all obliged to suffer death,
That Heaven might repossess it of its own.

<div align="right">(1547) (Taylor)</div>

300. *Bereavement at a loved one's death (since Longfellow's day, it has become less certain that this sonnet was written for the Marchioness of Pescara):*

QUAND' EL MINISTRO . . .

When the prime mover of my many sighs
 Heaven took through death from out her earthly place,
 Nature, that never made so fair a face,

Remained ashamed, and tears were in all eyes.
O fate, unheeding my impassioned cries!
 O hopes fallacious! O thou spirit of grace,
 Where art thou now? Earth holds in its embrace
Thy lovely limbs, thy holy thoughts the skies.
Vainly did cruel death attempt to stay
 The rumor of thy virtuous renown,
 That Lethe's waters could not wash away!
A thousand leaves since he hath stricken thee down,
 Speak of thee, nor to thee could Heaven convey,
 Except through death, a refuge and a crown.
 (1547) (Longfellow)

301.

LA FORZA D'UN BEL VISO . . .

Rapt above earth by power of one fair face,
Hers in whose sway alone my heart delights,
I mingle with the blest on those pure heights
Where man, yet mortal, rarely finds a place.
With Him who made the Work that Work accords
So well, that by its help and through His grace
I raise my thoughts, inform my deeds and words,
Clasping her beauty in my soul's embrace.
Thus, if from two fair eyes mine cannot turn,
I feel how in their presence doth abide
Light which to God is both the way and guide;
And kindling at their luster, if I burn,
My noble fire emits the joyful ray
That through the realms of glory shines for aye.
 (1547/50) (Wordsworth)

302. *Attaining the superb simplicity of Montaigne's explanation of his deep friendship with Étienne de la Boétie ("Because he was he and because I was I"), Michelangelo writes to Fattucci three years after Vittoria Colonna's death:*

 1 August 1550
Messer Giovan Francesco, my dear friend.— . . . So that this letter will not be so brief, having nothing further to write, I enclose one of my little novellas [poems] which I used to write to the Marchioness of Pescara, who was most fond of me and I no less of her. Death took from me a great friend. Naught else occurs to me. I am, as always, enduring with patience the defects of old age.

MEN

303. *Love performs a fusion of will with Tommaso Cavalieri:*

VEGGIO CO' BEI . . .

Through thee I catch a gleam of tender glow,
Which with my blind eyes I had failed to see;
And walking onward, step by step with thee,
The once-oppressing burdens lighter grow.
With thee, my groveling thoughts I heavenward raise,
Borne upward by thy bold, aspiring wing;
I follow where thou wilt—a helpless thing,
Cold in the sun and warm in winter days.
My will, my friend, rests only upon thine;
Thy heart must every thought of mine supply;
My mind expression finds in thee alone.
Thus like the moonlight's silver ray I shine:
We only see her beams on the far sky,
When the sun's fiery rays are o'er her thrown.

(1530/34) (Fanny Elizabeth Bunnett)

304. *Michelangelo drew up three versions of the following letter sent to Tommaso Cavalieri on New Year's Day, 1533.*

Without due consideration, Messer Tomao, my very dear Lord, I was moved to write to your Lordship, not by way of answer to any letter received from you, but being myself the first to make advances, as though I felt bound to cross a little stream with dry feet, or a ford made manifest by paucity of water. But now that I have left the shore, instead of the trifling water I expected, the ocean with its towering waves appears before me, so that, if it were possible, in order to avoid drowning, I should gladly retrace my steps to the dry land whence I started. Still, as I am here, I will e'en make of my heart a rock, and proceed further; and if I shall not display the art of sailing on the sea of your powerful genius, that genius itself will excuse me, nor will be disdainful of my inferiority in parts, nor desire from me that which I do not possess, inasmuch as he who is unique in all things can have peers in none. Therefore your Lordship, the light of our century without paragon upon this world, is unable to be satisfied with the productions of other men, having no match or equal to yourself. And if, peradventure, something of mine, such as I hope and promise to perform, give pleasure to your mind, I shall esteem it more fortunate than excellent; and should I ever be sure of pleasing your Lordship, as is said, in any particular, I will devote the present time and all my future to your service; indeed, it will grieve me much that I cannot regain the past, in order to devote

a longer space to you than the future only will allow, seeing I am now too old. I have no more to say. Read the heart and not the letter, because "the pen toils after man's good will in vain."

I have to make excuses for expressing in my first letter a marvelous astonishment at your rare genius; and thus I do so, having recognized the error I was in; for it is much the same to wonder at God's working miracles as to wonder at Rome's producing divine men. Of this the universe confirms us in our faith.

It would be permissible to give the name of the things a man presents, to him who receives them; but proper sense of what is fitting prevents its being done in this letter. (Symonds)

305.

NON SO SE S'È . . .

I know not if from uncreated spheres
Some longed-for ray it be that warms my breast,
Or lesser light, in memory expressed,
Of some once lovely face, that reappears,
Or passing rumor ringing in my ears,
Or dreamy vision, once my bosom's guest,
That left behind I know not what unrest,
Haply the reason of these wayward tears.
But what I feel and seek, what leads me on,
Comes not of me; nor can I tell aright
Where shines the hidden star that sheds this light.
Since I behold thee, sweet and bitter fight
Within me. Resolution have I none.
Can this be, Master, what thine eyes have done?
 (1533) (George Santayana)

306. . . . I note that you have given a copy of the aforesaid madrigals to Messer Tommaso [Cavalieri]: I remain obliged to you and beg you, if you see him, to tell him something about me to keep me in his memory. For if he slipt out of my mind, I believe that I should suddenly fall dead.

307. *More than six months after the New Year's Day letter to Tommaso, Michelangelo writes anew to the young nobleman:*

28 July, 1533
Dear My Lord, Had I not believed that I had made you certain of the very great, nay, measureless love I bear you, it would not have seemed strange to me nor have roused astonishment to observe the great un-

easiness you show in your last letter, lest, through my not having written, I should have forgotten you. Still it is nothing new or marvelous when so many other things go counter, that this also should be topsy-turvy. For what your lordship says to me I could say to yourself. Nevertheless, you do this perhaps to try me, or to light a new and stronger flame, if that indeed were possible. But be that as it will: I know well that, at this hour, I could as easily forget your name as the food by which I live. Nay, it were easier to forget the food, which only nourishes my body miserably, than your name, which nourishes both body and soul, filling the one and the other with such sweetness that neither weariness nor fear of death is felt by me while memory preserves you to my mind. Think, if the eyes could also enjoy their portion, in what condition I should find myself. (Symonds)

[Torn fragment of a letter, 11 October, 1533]
308. . . . thus, if I desire without intermission day and night to be there [in Rome], it is for no other reason than to return to life, which cannot exist without the soul; and because the heart is truly the mansion of the soul, and since my heart was originally in the hands of him to whom you have given my soul, it was a natural force which returned it to its dwelling place. Would that you might have done the same with my body! for it would have willingly gone to that same place with its soul, and I should not be here in such a passion. Since it did not go there, let it get there as soon as possible—that is best—for it cannot go on living eternally elsewhere.

My dear Bartolomeo, although it may appear that I am bandying words with you, know rather that I am speaking most sensibly, for I am aged and diminished by twenty years and twenty pounds since I have been here

309. *Very conscious that gossip circulated about their friendship, and smarting under allegations (such as Aretino's) of a homosexual relationship with "Tomao," Michelangelo urges his friend to disregard talk:*

VEGGIO NEL TUO BEL VISO . . .
That, friend, which in thy gracious face I see
Scarce in this present life may man express;
The spirit, wearing yet its fleshly dress
By this upborne has looked on deity.
And though the throng, malign and brutish, free
Its gibes and scoffs at what the few possess,
There fails no joy from this warm eagerness,
This chaste desire, this love, this fealty.

For every beauty that we look on here
Brings, to wise souls, in recollection clear
The merciable fount whence all things flow;
Nor other pledge nor other fruit have we
Of heaven on earth. Who loves thee faithfully
To God ascends, and makes death precious so.

<div align="right">(—1534) (Nesca Robb)</div>

310. *Michelangelo once again uses poetry to explain the innocence of his relationships with young men like Tommaso Cavalieri.*

PER FIDO ESEMPLO . . .

For faithful guide unto my laboring heart
Beauty was given me at birth,
To be my glass and lamp in either art.
Who thinketh otherwise misknows her worth,
For highest beauty only gives me light
To carve and paint aright.
Rash is the thought and vain
That maketh beauty from the senses grow.
She lifts to heaven hearts that truly know,
But eyes grown dim with pain
From mortal to immortal cannot go
Nor without grace of God look up again.

<div align="right">(1536/42) (George Santayana)</div>

311. *We have restored the possessive adjective in the last line from "her" to "his."*

GLI OCCHI MIEI VAGHI . . .

Ravished by all that to the eyes is fair,
Yet hungry for the joys that truly bless,
My soul can find no stair
To mount to heaven, save earth's loveliness.
For from the stars above
Descends a glorious light
That lifts our longing to their highest height
And bears the name of love.
Nor is there aught can move
A gentle heart, or purge or make it wise,
But beauty and the starlight of his eyes.

<div align="right">(1536/42) (George Santayana)</div>

312.

AL COR DI ZOLFO . . .

A heart of fiery sulphur, flesh of straw,
And bones that are like wood the sun has dried;
A soul unbridled, that admits no guide,
Instant desire, and will that knows no law;
Reason with halting utterance, blind and lame,
A world that teems at every turn with snares,
What marvel is't, if man at unawares
With the first fire he meets shall flash to flame?
And beauteous art, if this from heaven on high
We bring with us, o'er nature's strength prevails,
Howe'er she strive with still unquenched desire:
If to that art nor deaf nor blind am I,
Responsive made to what my heart assails,
His is the fault, who doomed me to the fire.

(1534/36) (Elizabeth Hall)

313. *This note to Febo di Poggio from Florence shows in a veiled way how Michelangelo debased himself to retain the love of this young and apparently insipid male model. Note that Michelangelo realizes that such a sensual love puts his salvation in jeopardy.*

December, 1533

Febo, Although you bear me great hatred, I know not why. I can hardly believe it is because of the great love I bear you, but because of the words of others, words which you should not believe, having put me to the test. I cannot help, however, writing you this. I am leaving tomorrow and go to Pescia to meet the Cardinal di Cesis and Messer Baldassare. I shall go with them to Pisa and then to Rome. I'll not return here again. I want you to understand that so long as I live, wherever I shall be, I shall always be at your service with loyalty and love, as much as no other friend you may have in this world.

I pray God to open your eyes for a while longer, so that you may recognize that he who desires your welfare more than his own salvation, knows how to love and not hate as an enemy.

(Charles Speroni) [Unsigned]

314. *The following pieces, describing how Michelangelo "fell to his ruin" by loving this young man, pun on the name Febo = Phoebus (and poggio = "hill").*

BEN FU', TEMPRANDO IL CIEL . . .

When first the heavens forged thy living ray,
Alone to eyes not mine unveiled devotion,
Racing o'er their course with timeless motion,
Yielded us thy light, thee the journey's way.
Blithe bird, excelling us by fortune's sway,
Of Phoebus thine the prize of lucent notion,
Sweeter yet the boon of winged promotion
To the hill, whence I topple and decay!

<div align="right">(1534/41) (Donald Remstein)</div>

315.

BEN MI DOVE' . . .

Easily could I soar, with such a happy fate,
When Phoebus brightened up the heights,
Up from the earth I rose with his wings,
And death itself I could have found sweet.
Now he has disappeared from me . . .
His feathers were wings to me and the hill the stair.
Phoebus was a lantern to my feet; nor would death then
Have seemed to me less than a marvelous salvation. . . .

<div align="right">(1535)</div>

316. *Michelangelo's affection for the fifteen-year-old Cecchino de' Bracci passed beyond the bounds of discretion. In a letter to Luigi del Riccio, the boy's protector, the artist revealed his feeling:*

<div align="right">1542</div>

I sent this [madrigal] a short while ago to Florence. Now that I have reworked it more fittingly, I send it to you, so that if it pleases you, you may give it to the flame, that is, that one which consumes me. I should even like another favor from you, and that is that you should clear up a certain perplexity which has laid hold of me since last night, when greeting our idol in a dream, it appeared to me that he was laughing and threatening me; and I not knowing to which of the two things I am to believe in, I beg you to find out from him, and that when we see each other tomorrow, you may clear it up for me.

<div align="right">Yours with infinite obligations and as always . . .</div>

If it please you, have it copied clearly and give it to those bonds which unite men without discretion, and remember me to Messer Donato.

317. *Among the many poems for this young boy, one quatrain among others which speak of his lovers stamps the boy as a homosexual adolescent used by older men. Michelangelo ironically sends to Riccio two alternate pairs of final verses.*

LA CARNE TERRA . . .

The earthly flesh, and here my bones deprived
Of their charming face and beautiful eyes,
Do yet attest that grace and delight was I,
In what a prison here the soul doth live.

Do yet attest for him how gracious I was in bed
When he embraced, and in what the soul doth live.

Choose these two verses below, which are a moral thing; and this I send you to pay off my fifteen I.O.U.'s.

(1544)

318. *The following note to Luigi del Riccio contains allusions to the artist's passion for young Cecchino, so veiled that more than one sober commentator has assumed that it was a business letter concerning the Tomb of Julius II. The postscript, like the letter, is most revealing.*

Undated, 1542

Messer Luigi, my dear lord,—My love has ratified the agreement which I made to him of myself; but of the other ratification which you know, I don't know as yet what he thinks about me and of it; so I enclose my best wishes to you and to Messer Donato and to the third party, afterward or before as you wish.

Your Michelangelo full of worries, Rome
Old things out of [or, for] the fire without witness.

Pretending to accede to the bribes of Luigi del Riccio, all fancy delicatessen items, Michelangelo composed fifty or fifty-one brief epitaphs on the death of Cecchino. (All of these stanzas date from the year 1544. All but number VII below are translations by Ednah Dow Cheney.)

II

319. Ah! keep your tears, if pity fills your eyes
For me, who here released from earth have place;
Keep them to bathe the weary breast and face
Of him who subject low to earthly fortune lies.

IV

320. Death wished to strike, without the heavier blow
Of weary years or overweight of days,

The beauty that lies here, that seen in heavenly rays
We still his earthly countenance might know.

VII

321. Here am I buried, who was born of late;
To whom came Death with such untimely speed,
That scarcely did my naked soul give heed,
In leaving earth, that she had changed her state.

 (Charles Eliot Norton)

IX

322. The soul while in the body could not see,
Like us, the form enshrouded in this tomb;
But if Heaven granteth not so fair a room,
Death had not gained the power to set it free.

XII

323. They do believe me dead—I who still shed
Delight on all the world, living in thousand souls
In breasts of lovers true. No death controls,
Taking one soul alone. I am not dead.

XVI

324. Here fate has willed me ere my time to sleep:
I am not dead, though changed my dwelling be;
While thou dost look and weep, I rest alone in thee,
Since lovers each the other's image keep.

XVII

325. If years to kill, the power in moments lies,
A luster might eternal life betray!
Ah! no; he lives a hundred years in single day,
Who in that time learns everything, and dies.

XVIII

326. To lie here dead, I deem a blest estate;
Such grace from Heaven I have, to grow not old:
The best of earthly gifts to me all told,
Aught else than death would give me harder fate.

XX

327. If so it were, that life might be regained,
Tears clothe these bones with living flesh and blood,
Ah! cruel would he be, who deemed it for my good
To bind again my soul, in Heaven unchained.

XXII

328. That I once lived, thou stone alone doest ween,
 Who lock'st me here: if one remembers me,
 He seems to dream; death grasps so greedily,
 That what has passed seems never to have been.

XXV

329. A Bracci I was born, and after birth below
 But little time mine eyes might see the sun.
 Here am I now forever. Life is won,
 If I remain alive in him who loved me so.

XXXVII

330. Death has given earth to earth, to Heaven my soul.
 To him who loves me yet in death the same,
 Is given to guard my beauty and my fame;
 This stone forever keeps my earthly whole.

XLV

331. I was Cecchino, now divine I live:
 Short time the world I had, but Heaven now is mine.
 For such a fair exchange, to death I praise assign,
 Who many dead, but me brought forth alive.

The notes penned by Michelangelo on the funeral verses to the fifteen-year-old Cecchino Bracci are harsh and discordant, and cast his relationship with the boy in a curious light. The notes hover about the theme of the gourmet's tid-bits by which Luigi del Riccio prods the artist into writing more and more commemorative stanzas. The cumulative effect of these notes leads one to discern a mad or ghoulish hilarity in the aged artist.

332. If you don't want any more of these [verses], don't send me anything more. [XII]

333. I didn't want to send this to you, because it's silly, but the trout and truffles would force heaven. [XVI]

334. Now that the promise behind the 15 I.O.U.'s is carried out, I'm no longer indebted to you for them, if another doesn't show up from Heaven, where he [Cecchino] is. [XVIII]

335. For the salted mushrooms, since you wish nothing else. [XX]

336. This clumsy piece, said a thousand times, for the fennel. [XXI]

337. This piece is spoken by the trout, and not by me; so, if you don't like the verses, don't marinate them any more without pepper. [XXIII]

338. I send you back the melons, but not yet with the I.O.U. and the drawing: but I'll do it in any case, since I can draw better now [after his illness]. Remember me to Baccio, and tell him that if I'd had here some of those meats and sauces that he gave me there, today I'd be another Gratian. [XXVIII]

339. For the turtle: for the fish Urbino will do the honors, for he gobbled them down. [XXIX]

340. Clumsy things. The fountain is dry. One must wait till it rains, and you're in too much of a hurry. [XXXIII]

341. Clumsy things, but in wishing me to do a thousand of them, there has to be a bit of everything. [XXXVI]

342. For the fig bread. [XL]

343. Because poetry tonight has been in a calm, I send you four crude ring-cakes for the three honey-cakes of the economizer. [XLV]

344. For the fun of it and not to make up the total. [L]

IV. FAMILY AND FRIENDS

The conscientious stream of letters to members of the artist's family, from March 1497 to December 1563, pictures a Michelangelo unusually proud of his reported lineage from the Counts of Canossa, generous to raise the status and fortunes of his family, interested in the health and welfare of each of the males who constituted that household, and hopeful for a brilliant survival of the Buonarroti line. The letters also reveal a son, brother, and uncle impatient with any relative's weaknesses or ingratitude, prodigal with complacent advice and devoted to his kin in direct ratio to their willingness to stay away from him and let him work. These letters are complemented by the "angry letters" to his family in these epistles however, and the superb if incomplete poem in tercet rime on the death of his aged father Lodovico (¶355) should be read by anyone hoping to understand the deep, restless, and troubled personality of the artist. For good measure this section will include some avuncular counsels and caveats about marrying, addressed to the nephew on whom alone he counted to perpetuate the Buonarroti-Simoni line.

If we possess 341 letters to his family, we have only 154 letters to his acquaintances. Michelangelo's roster of friends was so narrow that he could write of neither possessing nor desiring companionship. Too often when he wished to give of himself completely to a long-term friend— Vittoria Colonna and Giorgio Vasari would figure in this group—such alien factors as geography came between them. With some, like Tommaso Cavalieri, he tried too hard and they shied away. Other devoted friends, like Sebastiano del Piombo and Luigi del Riccio, did trivial things which irritated him; his friendship could not weather such real or imagined offenses. Thus, Michelangleo concluded that in friendship as in love, the best thing is not to give of oneself completely. In this more limited, more guarded sense, Michelangelo had many friends, as when he boasted to Giannotti that there was not a Florentine humanist who had not been a friend of his. In a fuller sense Raphael was right, and Michelangelo was too often as lonely as a "hangman."

THE SON, BROTHER, AND UNCLE

345. I have too much of a wife, and that is this art, which has already given me tribulations, and my children will be the works I leave behind. For even if they will be of little value, they will last for a while.

<div align="right">[Vasari]</div>

1508

346. I have exposed my very life to a thousand perils, merely to help my family.

347. *Michelangelo's marked leanings toward the nobility led him to believe that his family descended from the Counts of Canossa. As Vitruvius had written (and Michelangelo repeated in his purported letter to Pope Paul) the family house must correspond to the family lineage.*

4 December, 1546

Lionardo, . . . As for buying the house, I urge you to seek a house that is honorable, of 1500 or 2000 crowns and is in our [Santa Croce] quarter, if possible. And as soon as you have found something fitting, I shall arrange to have the money paid there. I say this because a fine town house gives much honor, for it displays more than do farm lands, and because we are moreover citizens descended from a most noble lineage. I have always sought to restore our household, although I haven't had the brothers for it. Therefore try to carry out what I write you to do, and let Gismondo come back and live in Florence, so that it will no longer be said here [Rome] to my great shame that I have a brother at Settignano who tramps behind oxen. And when you have bought the house, we'll go on buying other things.

Some day when I have time, I shall inform you of our origins and whence and when we came to Florence, since perhaps you don't know it. For that reason we mustn't let be taken from us what God has given us.

348. *Michelangelo's genealogical pretensions and hopes were unfounded. Although no ancestor was of the nobility, or of the Canossa family, as the artist was wont to claim, one Buonarrota had become a Prior of the Florentine commune in 1380.*

December, 1546

Lionardo,—About a year ago there came into my possession a manuscript Florentine Chronicle, in which I find that about 200 years ago, if I remember rightly, a certain Buonarroti Simoni was several times one of the Signoria: after him there was a Simone Buonarroti, then a Michele di Buonarroto Simoni, and later on a Francesco Buonarroti. I found no mention in it of Lionardo, who was also one of the Signoria, and the father of our father Lodovico, because the book was not continued down to his day. Therefore it seems to me that thou shouldst sign thyself as "Lionardo di Buonarroto Buonarroti Simoni." There is no occasion for me to reply to the rest of thy letter because I have not yet been able to make out what it is thou hast written, nor about the house.

(Carden)

6 January 1548

349. Lionardo, . . . Count Alessandro di Canossa once came to visit me in Rome, as a relative. . . .

350. *Michelangelo's pride in his family centered on his nephew Lionardo, the only Buonarroti of the succeeding generation to marry and sire children.*

April, 1554

Lionardo, . . . I gather from your letter that Cassandra is about to give birth to a child and that you would like to have my opinion concerning your children's names. If it is to be a girl, you tell me, in view of your wife's good behavior, that you have already made up your mind; if it should be a boy, I do not know what to say. I feel strongly that the name Buonarroto should remain in the family, since we have had it for three hundred years already. (Charles Speroni)

351. *Discussing the choice of a bride with his nephew, the old artist calls the young man to task.*

28 February, 1551

As to the suggestion that thou desirest to ennoble thyself, as thou saidst in a former letter, there is no possibility of truth in it, for it is known that we are descended from Florentine citizens of ancient days. Think over all I have said, for fortune has not favored thee in face or figure so extensively as to be worthy of the first beauty in Florence. Be very careful that thou deceive not thyself.

August, 1508

352. Dearest Father,—I have had, within the last days, a letter from a nun, who says she is an aunt of ours, and begs me to take compassion on her. She says she is very poor and in the greatest want, and that I should give her alms on that account. I send you five broad ducats that you should, for the love of God, give her four and a half, and of the half which remains I beg you will tell Buonarroto that he should buy me either from Francesco Granacci, or from some other painter, an ounce of lac, or as much as he can get for the said money, that it should be the best that can be found in Florence, and if there is none to be got of a fine color, let it be. The above-spoken-of nun, our aunt, I think, must be in the monastery of San Giuliano. I beg you to try to find out whether it is true that she is in such want, for she writes to me in a way I do not like, and which makes me suspicious as to her being some fraudulent nun, and that I'm being hoodwinked. So that if it should be a hoax, keep them for yourself. . . . (after C. C. Black)

Goldscheider

Sketch of Phaeton (Windsor, Royal Library)

Of Phoebus thine the prize of lucent notion,
Sweeter yet the boon of winged promotion
To the hill [*poggio*] whence I topple and decay. (*see pages 96–97*)

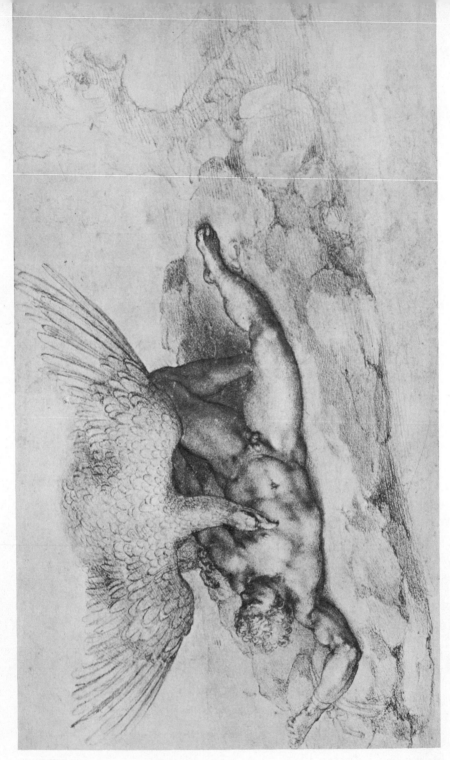

Sketch of Tityus (Windsor, Royal Library)

Easily could I soar, with such a happy fate,
When Phoebus brightened up the heights . . .
Now he has disappeared from me . . . (*see page 97*)

Florence, 1516

353. Dear Father,—I was much astonished when I did not find you at home yesterday: and now, as I hear that you have complained about me and said that I had driven you from home, I am still more astonished. For this I know as certain—that from the day of my birth to the present it has never entered my mind, either as regards trivial things or more important ones, to do anything that would be opposed to you. I have burdened myself with all my labor and work only for your sake; and you know well, since I have come back from Florence to Rome, that I have remained in Florence for your sake alone, and that I consider all that belongs to me as your property. A short time ago, when you were ill, I promised you never willingly to leave you; and now I cannot but feel astonished that you have so quickly forgotten all. Thirty years you have known me for what I am; and you know how I have done and intended good for you wherever I could.

How could you now say that I have thrust you out of the house? This alone was wanting to all the pain I have had about other things, and all for your sake. And this is my thanks for it.

But now, so be it. Let it be I who drove you from the house: be ashamed of me and consider you have suffered injury through me. It shall be so. Then let me beg for forgiveness; forgive your son; and if he has never been good for anything, and has brought you all imaginable harm, yet once more, I pray, forgive me, criminal as I am, and don't let the shame remain on me, of having driven you out of the house; for it means more to me than you believe, and I am still your son.

The bearer of this is Raphael of Gagliano. For the sake of God, and not my own sake, I beg you to return to Florence: for I must start on my journey, and I have important things to communicate to you, and I cannot come to you. My servant Pietro has not behaved as he ought. I shall send him tomorrow morning to Pistoia, where he shall remain. I'll not have mischief arise through him in our household. Had you all spoken to me sooner about it, knowing what a man he was—something of which I was unaware—this scandal then would not have happened.

I am urged to set out, and I cannot do so without having spoken to you. You must remain at Settignano. I beg you, forget all the sad business and come.

354. *The tone of a later letter changes from one of resignation to anger and even menace:*

June, 1523

. . . The whole of Florence knows that you are a rich man, and that I have given my life for you, and gain only punishment for it. You, however, gain great praise for it. Tell people what you will, but write

to me no more. For it would hinder me at my work, if I were now to remind you what you have received from me through twenty-five years. I should prefer not to have to say this to you: but I cannot change the necessity for doing so. Beware of those of whom you have to beware. We die only once, and we don't return again to make amends for what we have done amiss. Have you therefore lived so long to act thus?

<div align="right">(after Fanny Elizabeth Bunnett)</div>

355. *A lifetime of disputes is quickly forgotten when Michelangelo learns of the death of his father Lodovico, shortly after that of his brother Buonarroto. The date is commonly set at 1534, although Wilde in 1949 proposed instead 1531. Michelangelo envies them for being above and beyond the vicissitudes of fortune. The long poem breaks off uncompleted.*

ANCOR CHE 'L COR . . .

Deep grief such woe unto my heart did give,
I thought it wept the bitter pain away
And tears and moans would let my spirit live.
But fate renews the fount of grief today.
And feeds each hidden root and secret vein
By death that doth still harder burden lay.
I of thy parting speak, and yet again
For him, of thee who later left me here,
My tongue and pen shall speak the separate pain.
He was my brother, thou our father dear:
Love clung to him and duty bound to thee,
Nor can I tell which loss I hold most near.
Painted like life my brother stands to me:
Thou art a sculptured image in my heart.
And most for thee, my cheek is tinged with piety.
Thus am I soothed: death early claimed the part
My brother owed, but in full ripeness thou.
He grieves us less who doth in age depart.
Less hard and sharp it is to death to bow
As growing age longs for its needful sleep,
Where true life is, safe from the senses now.
Ah! who is he who sadly would not weep
To see the father dead he held so dear,
He ever, living still, in frequent sight did keep?
Our griefs and woes to each alone are clear,
As more or less he feels their fatal power;
Thou knowest Lord to me the loss how near.
Though reason holds my soul some calmer hour,

'Tis by such hard constraint I bind my grief,
The lifted clouds again more darkly lower.
And but this thought can give my heart relief
That he died well and resting smiles in Heaven
On death that brought in life a fear so brief.
For deeper grief would grow and crush me even
Did not firm faith convince my inmost mind,
Living well here, he rests himself in Heaven.
So closely doth the flesh the spirit bind
That death the weary heart can most oppress
When erring sense forbids the truth to find.
Full ninety times in Ocean's deep recess
Of cooling shade, the sun its torch had laid
Ere peace Divine thy weary heart did bless.
Oh! pity me who now art left here dead,
Oh! thou through whom Heaven willed me to be born,
Since Heaven at last thy suffering life has stayed.
Divine thou art, Death of Death's power is shorn.
Nor fearest thou life's changes ever more;
I write almost with envy here forlorn.
Fortune and Time which bring us grief so sure
With joy uncertain, claim no more their right,
Their fickle changes enter not your door.
There is no cloud to dim your shining light,
No chance nor need to bind your onward way,
No time to urge you with its rapid flight.
Your splendor grows not dim by night nor day,
Though dark the one, the other heavenly clear,
Nor when the sun sends down its warmer ray.
By thine own death, oh! Father ever dear,
I learn to die, and see thee in my thought,
Where the world rarely lets us linger near.
Think not, like some, Death only evil wrought
To one whom Grace to God's own seat has led
And from the last day to the first has brought.
Where, thanks to God, thou art, my soul has said,
And hopes to meet thee if my own cold heart
By reason rises from its earthly bed.
And if 'twixt son and father, Love's best art
Grows yet in Heaven, as every virtue grows. . . .

<div style="text-align:right">(1534) (Ednah Dow Cheney)</div>

<div style="text-align:right">October 17, 1509</div>

356. Buonarroto,—I received the bread; it is good, but it is not good enough to invest in as there would be little profit. I gave the messenger

five *carlini,* but he would hardly hand the bread over. From thy last letter I learn that Lorenzo [Strozzi] will pass this way and that thou wishest me to entertain him. Evidently thou hast little understanding of how I am placed here. However, I hold thee excused. What I can do I will. I hear that Gismondo is coming here to arrange his affairs. Tell him from me that he is not to expect any help from me, not because I do not love him as a brother, but because I am unable to help him in any way. . . . (Carden)

5 September, 1510

357. Dearest Father,—I have had a letter from you today, September the 5th, which gave and still gives me great anxiety, as it tells me that Buonarroto is ill. I beg of you, as soon as you have read this, to let me know how he is, because if he is really very ill, I will drop everything and come by the post coach to you during the ensuing week, although this would be the greatest hindrance to me, for this reason, that I am to be paid five hundred ducats when I have earned them; this is the agreement I have made with the Pope, and as many more he will give me when I have begun another part of my work. But he has gone from here, leaving me no orders whatever, so that I find myself without money, nor do I know what to do if I go away. I should not like him to despise me and lose me my earnings, in which case I should be badly off. I have written him a letter, and am waiting the answer. Yet if Buonarroto be in danger let me know of it, because I shall leave everything. Make arrangements for his comfort, and do not let him want for money to help him. (C. C. Black)

January 10, 1511

358. Buonarroto,—Some days ago I received a letter from thee setting forth thy views in detail: and as it would be a lengthy matter to reply in full to all thou sayest, I will tell thee briefly what I think. With regard to the shop, I am minded to do all I promised you as soon as I return to Florence: and although I wrote saying this was the time to invest in a piece of land, I am still inclined to buy the shop, because when I have finished my work here and have received all that will then be due to me, there will be enough to allow for my keeping my promises to you. As to thy being able to find someone now who will lend thee two or three thousand ducats for opening a shop, this must be a man with a longer purse than mine. I think thou shouldst by all means accept the offer, but have a care that thou be not deceived, for people are not inclined to do good to any but themselves. Thou sayest this man desires to give thee one of his daughters to wife, and I tell thee that all the offers he has made will fall to the ground—except the wife—when thou hast gotten her set fast upon thy back: her thou wilt find cling to thee more closely than thou desirest. And furthermore, I tell thee I do not like these rapacious dealings with men whose code of morals is lower than thine

own. Avarice is a grievous sin, and nought that is concerned with sin can come to a good ending. My advice is that thou shouldst continue to show interest and keep the matter open until I have finished here, when I shall know how I am situated. This will be within three months, or thereabouts. For the present act as seemeth to thee best. (Carden)

Rome, 1545

359. Lionardo,—I wrote to thee last Saturday to say that I would rather have a couple of flasks of Trebbiano than the eight shirts thou sentest me. Now I have to tell thee that I have received a whole load of the Trebbiano, that is to say, forty-four flasks. Of these I have sent six to the Pope and some to other friends—so that I have given nearly all of it away, as I cannot drink it myself. Although I wrote as I did, there is really no occasion for thee to send me either one thing or the other. It is enough for me if thou art a man of integrity, and an honor to the rest of us. (Carden)

August, 1548

360. Lionardo, . . . Messer Giovan Francesco writes me that you would like to come to Rome for a few days: I am amazed, for, if it's true that you have formed a company, I do not see how you can leave. So take care not to throw away the money I sent you and the others. Likewise, Gismondo must also be careful with it, for whoever has not earned his money does not appreciate it. This is borne out by experience, for the greatest part of those who were born rich throw their money away and die bankrupt. So open your eyes and consider and realize what misery and hardship I undergo, being old as I am. Recently a Florentine came to talk to me of one of the Ginori's daughters. He says that you too have been approached regarding her in Florence, and that you like her. I do not believe that is true: besides, I can give you no advice because I know nothing about her. But I certainly don't like the idea that you should marry a girl whose father would not give her to you in marriage if he had enough money to give her a suitable dowry. I would like you to marry a girl whose father likes you, not your money. It seems to me it is up to you to look for a girl who may not have much of a dowry, and not up to others to offer you a girl because she does not have a dowry. Also, you should prefer soundness of mind and body to nobility of blood and consider her manners and her relatives, for that is very important. (Charles Speroni)

361. *Michelangelo, who once admitted that he had wife enough in his art, wanted to see his grandnephew safely married off in order to perpetuate the line of the Buonarroti:*

1 February 1549

Lionardo, I sent you in my last a memorandum on several marriageable girls that was sent me from up there, I believe from some marriage

broker, who cannot help but be a man of little judgment, for I having been stuck here in Rome for sixteen or seventeen years, he should have considered what little news I have of the families in Florence.

Wherefore I tell you, if you wish to take a wife, not to rely upon me, for I cannot give you the best counsel; but I can at least tell you not to go after money, but only after goodness and a good reputation.

I believe that there are likely in Florence many noble and poor families, and that it would be a bounty to marry into them, even if there weren't a dowry for you; nor would you have to contend with family pride. You have need of a girl who will stay at your side and whom you can command, and who doesn't want to parade about, taking in banquets and marriages every day. Because wherever there is a court, it's an easy thing to become a whore, and especially those girls without a family. And you will excuse my adding that it might be well for you to enter the nobility, for it is well known that we are ancient Florentine citizens and just as noble as any other house. Have trust in God and pray that He will arrange for your needs; and I shall be obliged if, when you have found something that seems fitting to you and before you unite in marriage, you keep me informed.

21 February, 1549

362. Lionardo, I have written to you several times that about taking a wife, you must not believe any man who speaks with you about it in my name, unless you see it in my own writing. I bring this all up again, since Bartolomeo Bettini has for over a year been trying to tempt me into giving you a niece of his. I've always given him vague words in reply. Now once again he's been making a strong, new try through a friend of mine. I've replied that I know that you've turned to a girl who pleases you and have practically committed yourself, and that I don't want to take you away from her. I inform you of this so that you'll know how to reply, for I believe that up there he has people talking to you warmly about her. Don't get hooked on the bait, because there are plenty of girls being offered, and you're not going to end up wanting. Bartolomeo is a gentleman and lord-in-waiting but he is not our equal, and you have your sister in the Guicciardini house. I don't believe there's any need to tell you more, because I know that you know that honor is worth more than worldly goods. I have naught else to tell you. . . .

2 May, 1549

363. Lionardo, . . . About thy getting married: I mentioned a daughter of Lionardo Ginori to thee because I had been urged to do so by a friend of mine. Thou hast replied reminding me of what I said last concerning the same matter. I wrote as I did because I distrust the pomps and vanities which are so dear to those belonging to exalted families, and to avoid the possibility of thy becoming the mere tool of a woman. Nevertheless, if thou findest the proposal agreeable I would not have thee heed what

I said, for I am altogether ignorant of the Florentine citizens of today. Therefore, if the alliance pleases thee pay no attention to what I have said: and if it please thee not, have no more to do with it. As to the damsel, thou art the person to be satisfied, and if thou art satisfied with her I shall be satisfied too. . . . (Carden)

From Rome, 19 July, 1549

364. Lionardo, . . . I have this day received a letter from the weaver's wife saying she wants thee to marry a girl whose father is a Capponi and her mother one of the Niccolini: she is at present in the convent of Candeli. She wrote me a whole discourse including a short sermon exhorting me to live a good life and give alms: and she says she has entreated thee to live a Christian life—I expect she will have told thee that she has been inspired by God to wed thee to this girl. I fancy she would find it more satisfactory to attend to her weaving or spinning than to spend her time distributing all this sanctity around her. It seems as if she is aiming at becoming a second edition of Sister Domenica: however, place no confidence in her. . . . (Carden)

20 December, 1550

365. . . . As for beauty, since you are scarcely the handsomest youth in Florence, you are not to be too concerned about it, provided she's not crippled or repulsive.

28 October, 1552

366. Lionardo, . . . And this, also, I tell thee—beware how thou buyest a cat in a sack; examine the damsel very carefully with thine own eyes for she might be lame or diseased, and thou wouldst never be satisfied. However, be as diligent over the matter as thou canst, and commit thy cause to God. I have nothing to add, and writing gives me great discomfort. (Carden)

367. *Almost nowhere in his speaking of writing does Michelangelo ever mention jewelry, which adornment he condemns in his "Stanzas in Praise of Rustic Life." It is with relief therefore that we find him abandoning his intransigence when it came time to give a gift to his nephew Lionardo's new wife:*

20 May, 1553

Lionardo,—I gather from your last letter that you have brought a wife into your house and that you are very satisfied with her, and also that you send me her regards and that you haven't yet settled the dowry. I am very happy that you are satisfied with her, and I think that you should continually thank God for it as well as you can. As for settling the dowry, if you have done nothing, do nothing, and keep your eyes open; for these money problems always give rise to disagreements. I am

not a good judge of such things, but it seems to me that you should have settled everything before getting married. As for her sending me her regards, thank her and tell her for my part what you think I should tell her, since you can tell her better by word of mouth than I could say it on paper. I want to give concrete evidence of how I feel toward the wife of a nephew of mine, but I have been unable to do so because Urbino was out of Rome. He returned two days ago, and now I am thinking of giving some token of my love. I have been told that a valuable pearl necklace would be appropriate. I have asked a jeweler friend of Urbino's to look for one, and I hope to find it; but do not tell her anything yet; and if you think I should send something else, let me know.

Nothing further occurs to me. Take care of yourself, and keep your wits about you, since the number of widows is always greater than that of widowers. (Charles Speroni)

24 October, 1553

368. Lionardo,—I have the news from your letter that Cassandra is expecting; whereat I have the greatest pleasure, because I've hoped that there would remain of us some heir, whether it be female or male; and at all this it is fitting to thank God.

April, 1554

369. Messer Giorgio, my Friend,—I took great pleasure from your letter, first because you still remember this poor old man, and then because you were present at the triumph of which you write me, to have seen another Buonarroto [his first grand-nephew] born. For this news I thank you as much as I am able and know how. But such celebration displeases me, for man should not laugh when the whole world is weeping; so it appears to me that Lionardo is not very judicious and especially in making much ado about one who is born, with that joy which is to be reserved for the death of one who has lived well. Nothing else occurs to me. I thank you fully for the love you bear me, although I am unworthy of it. Things here are as usual. Some day or other of April, 1554.

370. *In this letter the gruff old artist condoles with his nephew Lionardo on the death of a newborn son. The note is explained by Michelangelo's belief, expressed also in his poetry, that it is better to die young and have greater certainty of salvation:*

March, 1555

Lionardo, I learned through your last of the death of Michelangelo, and as much happiness as I derived from him, I now have of passion; even much more. One must have patience and judge that it was better this way than if he had died in old age. Get along with your living, for property would be merely a burden without man's enjoying it. . . .

371. *Having lost two grand-nephews, the old artist learned of the death of a grandniece, about which he wrote the following comment on 2 December, 1558. At the time only one grand-nephew survived.*

Lionardo,—I learned of the death of the baby girl: I am not surprised, because there never was in our house more than one at a time.

372. *Within a year of his own death, Michelangelo renounces the pen before he renounces the chisel.*

28 December, 1563

Lionardo,—I received your last letter along with twelve excellent marzolini cheeses: I thank you for them. I rejoice over your good health; I am well also. In the past I received several letters from you; the reason I did not answer them is that my hand is no longer any good at writing. So from now on I shall have someone else write and I will sign my name. I have nothing else to say. (Charles Speroni)

373. *Michelangelo accepted as godson the son of his assistant Urbino. After Urbino's death he rebelled, however, at the widow's desire to entrust the child to him as a pupil. Michelangelo's intention to return to Florence, voiced here, was far from certain:*

28 March, 1557

To Cornelia, widow of Urbino,—I had been aware that you were vexed with me, but I hadn't found the reason. Now from your letter I understand why. When you sent me the cheeses, you wrote that you wanted to send me several other things, but that the kerchieves were not yet ready. And I, so that you would not incur expenses because of me, wrote you not to send me anything more, but if you would request anything you would please me greatly, aware and even certain of the love which I still bear to Urbino, although dead, and to everything of his. As for coming there to see the children or sending little Michelangelo here, I had better explain to you how things stand here. Sending Michelangelo here is out of the question, for I am without a maid and without a handy-man, and the lad is still of too tender an age, and something could happen at which I should be very unhappy. And then there's also the fact that the Duke of Florence, God grant him grace, for the past month has been pressing me with the greatest of offers to return to Florence. I have asked him for time to arrange my affairs here, so that I may leave the workshop of Saint Peter's on good terms; I judge that I shall stay here this summer and settle my affairs as well as yours at the Monte della Fede, and then this coming winter return to Florence for good, for I am old, and I'll not have time to return to Rome. I'll pass by your home. And if you wish to give me Michelangelo then, I'll keep him in Florence

with more love than the children of Lionardo my nephew, teaching him what I know, and what his father wished him to learn.

25 March, 1553

374. . . . I have spent sixty years attending to family matters. Now I am old and it is necessary that I think of my own.

THE FRIEND TO FEW

To his enemies' charge that he was a man without friends, Michelangelo responded early and late in life with an Horatian disdain:

1509

375. I have no friends of any kind, nor do I wish any, and I have not so much time that I can afford to waste it.

1545

376. Don't talk about the matter to friends, for few are the good friends to be found.

1548

377. I go about always alone, I get out very little, and I speak to no one.

378. *Michelangelo's susceptibility to handsome and intelligent young men like Tommaso Cavalieri is explained by the following statement he made to the gathering in Donnato Giannotti's home.*

Whenever I see someone who possesses some *virtù,* who displays some agility of mind, who knows how to do or say something more suavely than the rest, I am constrained to fall in love with him. . . . [Giannotti]

379. *In the precious area of friendship, Michelangelo believed that it is better to give than to receive.*

20 October, 1515

Buonarroto,—I wish to say that I am adverse to laying any burden upon Pier Francesco Borgherini, and I wish to be under as little obligation to him as possible, for I have undertaken to execute a certain piece of painting for him, and it might seem as though I sought to be paid in advance. For this reason I do not wish to be under any obligation to him, for I like him and I do not want anything from him. I wish to serve him for the sake of my personal regard, not because I owe him a service. I shall work for him, if I am able, more willingly than ever I worked for anyone else, for he is in very truth a goodly young man, and if I mistake not, hath no equal among the Florentines here in Rome.

4 September, 1525

380. Giovan Francesco Fattucci, . . . Nothing else occurs to me—except to say this to you: that you set my business aside, and even your own, and come back to Florence, for I understand that the plague is returning with a great fury, and it is more dear to me to have you alive than my affairs settled. So come back. If I die before the Pope, I'll have no need of settling anything; if I live, I'm sure that the Pope will settle things, if not now, then another time. So come back. Last evening I was with your mother and I advised her, with Granacio and Giovanni the turner present, that she should make you come back.

381. *When the young protégé of Lorenzo the Magnificent arrived in Rome for the first time, he set immediately to writing of his activities to his erstwhile benefactor:*

2 July, 1496

Magnificent Lorenzo,—I write this merely to inform you that on Saturday last we arrived here in safety and went immediately to visit the Cardinal di San Giorgio, to whom I presented your letter. I believe he was glad at my arrival, and he straightway expressed a desire that I should go and inspect certain statues, which detained me for the remainder of that day, so that I was unable to deliver your other letters. On the Sunday the Cardinal went to his new house and there caused me to be summoned. I went to him accordingly, and he asked my opinion of the statues I had seen. I told him what I thought, and certainly I consider that some of them are very beautiful. He then asked me if I had sufficient courage to undertake a beautiful work on my own account. I replied that I should not be able to produce any work equal to those I had been shown, but that I was willing he should see for himself what I could do. We have bought a piece of marble sufficiently large for a life-size figure, and on Monday I shall begin work on it.

Last Monday I delivered your other letters to Paolo Rucellai, who turned over the money to my disposal, and likewise that of the Cavalcanti. Afterward I gave the letter to Baldassare and asked him to give me back my *Cupid,* saying that I was willing to refund the money. He answered me with rough words, saying that he would rather break it into a hundred pieces. . . . He complained bitterly of you, saying you had spoken ill of him. Some of our Florentines took the matter up, hoping to get it settled, but they were unable to do anything. I now hope to arrange the matter through the medium of the Cardinal's good offices, for so I have been advised to proceed by Baldassare Balducci. I will keep you informed as to how the business proceeds. I have nothing more to add. I commend myself to you. May God guard you from evil.

(Carden)

382. *One unhappy year before the French monarch's death, Michel-angelo turned down a commission from Francis I with all the tact of a seasoned courtier:*

Rome, 26 April 1546

Sacred Majesty—I do not know which is the greater, your gracious act, or my marveling that Your Majesty should deign to write to such as me, and furthermore to ask for things within my gift in no way worthy of the name of Your Majesty. But such as they are, Your Majesty may under-stand that for a long time I have desired to serve Your Highness, but as no suitable opportunity has presented itself since Your Majesty has not been in Italy to see my work, I have been unable to do anything. I am now an old man, and the next few months will be taken up with com-missions for Pope Paul; but, if there remains to me after that occupation some space of life, given more time to work for Your Majesty, I shall strive to execute what I have always hoped to make, that is something of marble, a thing of bronze, and one of painting. And if death interrupts this desire of mine, provided one may carve or paint in the next life, I shall not fail you there where no one grows old. And to Your Majesty I pray God may give a long and happy life.

383. *Michelangelo knew how to handle Aretino, the "scourge of princes," who tried first to cajole the artist and then virtually blackmailed him in order to extort the gift of a painting or carving. The irony in the following letter did not escape its recipient:*

September, 1537

Magnificent Messer Pietro, My Lord and Brother. The receipt of your letter gave me both joy and sorrow: joy because it came from you who have no equal in the world for talent, and much sorrow because, as I have already finished a large part of the fresco, it is too late for me to adopt your conception of the subject, although it is so splendid that if the Day of Judgment had actually arrived and you had seen it with your own eyes you could not have better described it in words. Now as to your writing about me, I reply that I not only desire it but I beg you to do so, for Kings and Emperors esteem it the greatest honor to be mentioned by your pen. In the meantime, if I have anything you would care to possess, I offer it to you with all my heart. In conclusion, do not break through your resolution never to set foot in Rome on account of the picture I am painting, for it would be too great an honor. I commend myself to you. (Carden)

384. *On the death of his disciple Urbino:*

PER CROCE E GRAZIA . . .
. . . I weep and speak of my dead Urbino
Who, were he yet living, would perhaps be here at my side,
As I had intended he should. His death then
Hastens me and draws me along toward another road,
Where he is waiting for me to sojourn with him.

 (1556)

385. *Even as he follows his custom of renouncing any inheritance from
a brother, Michelangelo prepares to dower the widow and family of his
beloved assistant Urbino.*

 4 December, 1555
 Lionardo, With regard to the property left by Gismondo mentioned
in thy letter, I have to say that every portion is to be thine. Be careful
to do all he directs in his will and to pray for his soul, which is all thou
canst do for him.
 I have to tell thee that yesterday, the 3rd of December and at the
fourth hour, Francesco called Urbino passed from this life, to my deepest
sorrow. He leaves me in affliction and distress so great that it would have
been better for me if I had died too, such was the love I bore him. Nor
did he deserve less of me, for he had grown to be a man of worth, full of
loyalty and faithful service; wherefore I feel as though his death had
deprived me also of life, and I can find no rest. . . . (Carden)

 Rome, 23 February, 1556
386. Messer Giorgio, Dear Friend, Although I write badly, I would
respond to your letter with a few words. You know that Urbino is dead.
One must thank God for this, but only to my heavy loss and infinite
sorrow. My thanks are explained by the fact that while Urbino in life
kept me alive, in dying he has taught me how to die, not with dis-
pleasure but with a desire for death. I had him with me twenty-six
years and always found him loyal and true. Now that I had made him
rich and expected him to be a staff and consolation during my old age,
he has disappeared; nor does any hope remain to me other than that
of seeing him again in Paradise, and of this God has given a sign in
Urbino's most happy death. Even more than dying, it grieved him to
abandon me to this treacherous world, with so many troubles. The best
part of me went along with him, and nothing is left to me but infinite
sorrow.

387. *Michelangelo disliked excessive attentions, including gifts, and when he thanks Giorgio Vasari for a bounty of sugar, candles, wine, and a mule, his stanzas express his inability to reciprocate.*

AL ZUCCHERO A LA MULA . . .

Sugar thou givest, lamps, a mule to ride,
And add'st thereto a flask of ruddy wine;
Gifts which do so outrun all needs of mine,
That with St. Michael I the wealth divide.
Lapped in a calm too deep, my little boat,
With idle sails, upon a windless sea,
Is like to lose its way, and seems to be
A straw upon the rolling waves afloat.
With kindness such as thine, and bounty rare,
The food, the drink, the riding to and fro,
The thought wherewith my every want is met:
Dear friend, the present would as nought compare,
Could I myself and all I have bestow:
No gift he gives, who only pays a debt.

 (1555) (Elizabeth Hall)

388. *As usual in writing a poem to Giovanni da Pistoia, Michelangelo adopts a bantering tone and, like Dante, curses Pistoia as an enemy of Florence.*

IO L'HO VOSTRA MERCÈ . . .

My thanks for your most courteous compliment!
Your missive I full twenty times have read:
As is a feast to one already fed,
So hate is to your native temperament.
Since parting from you, I have learnt, 'tis true,
That Cain hath in your pedigree a place,
Nor do you your great ancestor disgrace.
Your neighbor gaineth ought? 'tis loss to you.
The foes of heaven, with hatred filled and scorn,
Mercy's sweet face is loathsome in your sight,
Who to your hurt alone have fealty sworn.
Enough if that which Dante once did write
Of thy Pistoia in thy mind be borne—
And thou woulds't flatter Florence! Hypocrite!
 A jewel of delight
She is; but not to thee her worth she shows,
He knows her not, who little virtue knows.

 (1532/34) (Elizabeth Hall)

29 April, 1527

389. I record that a few days ago Piero, son of Filippo Gondi, asked permission from me to hide certain things belonging to his family in the new Sacristy of San Lorenzo, by reason of the danger which now threatens us. This evening he began to carry certain bundles there: he says they contain linen clothes belonging to his sisters. As I did not wish to pry into his affairs or to see where he hid the stuff I gave him the key of the Sacristy for the evening.

4 July, 1556

390. Lionardo, . . . I received the Trebbiano, that is 36 bottles. It's the best you've ever sent me; I thank you, but it pains me that you have gone to such expense, and especially because, all of my friends having disappeared, I have no one left to whom to give any.

V. GOVERNMENT AND SOCIETY

Dedicated to his art and inclined to be pessimistic about men in general, Michelangelo could only conclude that politics was an unsubtle, unattractive business to be shrugged off by a serious artist. He wrote, "Plenty of other [artistic] matters give me enough worries without politics." The political machinations he witnessed at the siege of Florence in 1529 only deepened his mistrust of leaders and their motives. He entertained hopes for a united Italy, as had his idols Dante and Petrarch before him. Yet he set neither himself nor his art to an active political purpose, even though he held brief public office on Florence's Gran Consiglio. He became most aware of politics not under the bellicose Julius II, but rather during the 1540's when Rome was congested with political refugees and self-imposed exiles from the Medici dominion over Florence. His familiars Giannotti, Del Riccio, the Strozzi, and even the father of Cecchino de' Bracci were all fuorusciti [exiles], waiting for the liberation of Tuscany. Under their influence Michelangelo managed to lose some of his caution about politics. He wrote the political dialogue to be found in this chapter and executed the bust of Brutus. Perhaps he even felt at these moments that he too was in self-imposed exile.

War, as a consequence of politics, would always involve the artist, as Michelangelo knew from his reading of Vitruvius. After his services in the defense of besieged Florence, he considered himself an accomplished military architect—an opinion shared by others. Yet he continued to feel, as he wrote when a young man in Bologna, that war made "the times bad for our art."

In this chapter we include finally Michelangelo's ambivalent thoughts on another great problem of society, finances. Here are presented the master's opinions—as a consumer, a taxpayer, a depositor, and an artist—on money, which, as he wrote in an irascible letter, "isn't found in the streets."

POLITICS

391. *In writing to Duke Cosimo de' Medici, Michelangelo uses a Latinism extremely rare in Renaissance Italy:*

5 March, 1560

Most illustrious, excellent and conspicuous Lord: . . . It would be my duty to do it as a service to your Excellency and to the *Nation*.

392. . . . Give my regards and thanks to Messer Giovan Francesco, because I am much indebted to him, and tell him that the gentleman who replied to him that I am no man of politics cannot fail to be genteel and discreet, because he spoke the truth. Plenty of other [artistic] matters in Rome give me enough worries without politics!

APHORISMS ON THE POLITICAL AND SOCIAL TURMOILS OUTSIDE HIS STUDIO WALLS

393. 'Tis better to keep silent than to fall from high. (CDLXIII)

394. He who wins by flight, let him not stay on the field. (G 175)

395. Those who begin early as the asses of princes have their burden cut out for them until after their death. (Vasari)

396. In equality there's no room for lordliness. (G 160)

397. *Michelangelo's discussion of the guilt of tyrants and of Brutus and Cassius is one of the most illuminating passages in his known conversations. It explains fully his bust of Brutus, offered as a gift to Donato Giannotti, who recorded the following thoughts:*

Pray, just hear me out, for a bit, for I shall show you that I do not contradict myself. . . . If you have read diligently the first Canticle [of the *Divine Comedy*], you will have seen that Dante knew all too well the nature of tyrants, and with what sufferings they deserve to be punished, both by God and by men. Accordingly, he places them among the violent against their fellow man, whom he wishes to have punished in the first *girone* of the seventh Circle, in boiling blood, in which they are more or less immersed according to the guilt of each; and whoever of them wishes to come out of that blood, no longer able to endure its extreme heat, is attacked by the arrows of Centaurs, who are fierce beasts, as they are. He speaks therefore of these tyrants, in the twelfth Canto, as follows:

> I saw people immersed up to their eyelashes.
> And the chief Centaur said, they are tyrants
> Who were bent on blood and seeking plunder.

He tells then of Alexander of Pherae, Dionysius of Syracuse, Azzolino, Tarquin, and others. And if any tyrant is saved, through grace bestowed upon him by God for having done, among all the wickednesses which tyrants ordinarily commit, some work pleasing to God, he wants Purgatory to purge his sins with a very severe punishment. For that reason he puts them there among the proud, who are purging their pride on the first terrace of Purgatory, where they go about laden with heavy weights, whose heaviness presses them down until they almost crawl over the

earth. And in this place Dante shows that he knew very well what tyrants are like. For, speaking of Provenzan Salvani of Siena—who being born a citizen like others, nor having more rights in the City of Siena than any other citizen, nevertheless, through pride and presumption, made himself tyrant over it and reduced it entirely under his power—Dante says:

> This is, he replied, Provenzan Salvani,
> And he is here because he was most presumptuous,
> Delivering Siena wholly into his own hands.
> He has gone about thus, and he goes without repose
> Since he died: such coin must one return in repayment
> Who up there dared too much.

Dante, having known then very well the nature of tyrants and their evil-doings, assigned them both in Purgatory and in Hell suitable punishments. For since tyrants are enriched by blood and the property of their fellow men, thus it is reasonable that they be punished in Hell in boiling blood. And since their pride and presumption lead them to attribute to themselves what belongs to others and their peers, thus it is fitting that in Purgatory (if any one of them should get there, which must perforce happen only rarely) they should purge their pride and presumption with punishments which make them henceforth as humble and abject as they had been proud and presumptuous before.

So I say, Dante having known all this I am saying, it is scarcely to be believed that he did not know that Caesar was the tyrant of his fatherland, and that Brutus and Cassius slew him justifiably, since all the laws in the world promise, as you yourself said, most honored rewards to the slayers of tyrants. Without which, it can probably be said that he who kills a tyrant kills not a man, but a beast in human form. For, all tyrants being despoiled of that love which every man ought to bear toward his fellows, it is suitable that they lack human feelings and are consequently no longer men, but beasts. That tyrants bear no love to their fellow men is manifest, otherwise they would not have seized what belongs to others nor have tyrannically set themselves over other men. Note that I am talking of those dominators who are tyrants, and not of those princes who have held their states through long succession or have been freely elected *Signori* and govern their cities through popular consent. I say this so you will not give some malign interpretation to my words.

It is thus clear that he who kills a tyrant does not commit homicide, killing not a man but a beast. Brutus and Cassius then did not sin when they killed Caesar. First because they killed a man whose life every Roman citizen was obliged to take through the commands of law. Second, because they did not kill a man, but a beast dressed in the image of man. Dante knew these things as well as any other man. Just tell me, haven't you read in the *Banquet* those honored words which he says of Cato:

"Oh, most sacred heart of Cato, who will ever presume to speak of thee" and all that follows? If he had judged that Caesar had been unjustly put to death, would he have spoken so honorably of Cato, who was Caesar's adversary and who took his life rather than see his fatherland in servitude? But what other testimony of Dante do you wish than those verses which speak of Cato in the first Canto of *Purgatory?* Dante says in those verses that Cato died for Rome's freedom, which he was defending against Caesar. And yet, if Cato was defending liberty and Caesar was opposing it, it follows of necessity from Dante's opinion that Caesar was a tyrant. And if he was a tyrant, as he was, he was justly punished, and Brutus and Cassius should not have been punished, but rewarded and exalted. Dante had known the nature of tyrants, and how rightly they have been wiped out by men, since he speaks so honorably of those who have taken the pains to bring their ruin. And consequently you must admit that he recognized that their destroyers, like Brutus and Cassius slayers of Caesar, and others, merited honorable rewards and not vituperative punishments. . . .

[After being interrupted by Donato Giannotti.] You don't have the patience which I am displaying. Just hear me out for a bit, and perhaps you'll quiet down. As you have been well aware, Dante punishes the gravest sins in the Circles which gradually are nearer the center, so that in the last circle, that of Ice, he punishes traitors who are separated into four kinds, for this wickedness is committed against four types of person: family, fatherland, friends, and imperial and divine majesties. This fourth type of betrayal, as more serious than the others, is punished in the last sphere of ice, that is the one which surrounds the center, called Giudecca. And because Dante, following Christian opinion, intends to convey that through special providence of God, empire of the world was reduced to the power of the Romans and then of the Emperors; it seems to him that whoever betrays the majesty of the Roman Empire must be punished in the same place and with those same punishments as he who betrays divine majesty. Having then to give examples of someone who betrayed the Roman Empire, he took Brutus and Cassius, who killed Caesar and in his person betrayed the aforesaid Roman Empire. . . . He needed conspicuous examples, and he couldn't find others of greater or equal fame than Brutus and Cassius, who betrayed imperial majesty, which he symbolizes through Caesar, yet Dante withal did not relieve Caesar of the infamy of having reduced the fatherland to slavery and of being a tyrant.

. . . But I shall even go so far as to suggest this: How do you know that Dante held the opinion that Brutus and Cassius did wrong in killing Caesar? Don't you know what a general catastrophe was born in the world by the latter's death? Don't you see what a disastrous succession of emperors it brought about? Was it not better that Caesar should continue living and carry out his projects?

[To Donato's reply that "Caesar's projects" were that he should be called King.] I agree with this, but wouldn't that have been better than what actually happened? How do you know that he, having tired at length of dictating, might not have done as Silla did, that is, restored liberty to the fatherland and re-established the Republic? Now, had he done that while still living, might not Brutus and Cassius have done a bad thing in killing him? It is a great presumption to kill the prince of a public administration, however just or unjust he may be, without knowing for certain what good may result from his death, or whether one might expect some good from his continued living. So much so that I find some people annoying who think that good may not be brought about except by what starts out evil, that is, by deaths. They do not think that times change, new incidents are born, wills change, men tire out; whence many times inexpectedly and without any one's working at it or being imperiled, that good is born which one has hoped for. Don't you believe that in the time of Silla there were many wishing for the liberty of Rome who would have approved the killing of Silla? But when they saw then that Silla left his dictatorship willingly and restored liberty, don't you think they were happy about it, seeing the Republic restored with peace and quiet, and subsequently regretted the desire they had felt to see Silla murdered? If then Caesar had gone on living and done what Silla did, he who had thought of killing him in the beginning would have done a great wrong. And so Dante was perhaps of the opinion that Caesar was to imitate Silla, and so judged that Brutus and Cassius erred and merited the punishment which he meted out to them.

398. *When the Bolognese rebels, under Annibale Bentivogli, tried to wrest their city back from the legate of Julius II, the Cardinal of Pavia, they apparently got little sympathy from the young artist employed by the Pope:*

Bologna, 2 May, 1507

Giovan Simone, . . . Know that everyone here is smothered in armor, and for four days now the country has been in arms and in great rumor and peril, and especially the party of the Church. This has been because of the exiles, that is, the Bentivogli, who have made an attempt to re-enter Bologna with a horde of people. But the great courage and prudence of the command of the Legate, with the great precautions he took, has by now liberated the land once again from them, because at eleven P.M. last night the news came from their camp that they were retreating with little honor to themselves. No further news. . . .

399. *Advice written to his family concerning civic upheavals:*

5 September, 1512

. . . Do as people do during the plague: be the first to flee!

Rome, 18 September [1512]

400. Buonarroto,—I read in thy last letter about the great peril which was menacing the Territory, and I was exceedingly distressed at the news. It is now said that the Medici have returned to Florence and that everything has quieted down. I suppose, therefore, that the threatened danger —from the Spaniards, that is to say—is averted, and that there is now no need for you to flee from the city. Remain peacefully where you are, therefore, and be neither friendly nor confidential with anybody, save with God alone; neither speak about anybody, whether it be good or ill, for the end of this business is still obscure. Let your own affairs occupy all your thoughts. . . .

401. *When his father writes that the artist was reportedly speaking out against the Medici, Michelangelo becomes concerned for his family back in Florence and for himself. The Sack of Prato, carried out by the Imperial troops to reinstate the Medici in Florence (August-September, 1512), shocked everyone, but Michelangelo denies having spoken out.*

From Rome [October, 1512]

Dearest Father,—In your last letter you tell me to be careful not to keep money in the house and not to carry any about with me; also that I am reported in Florence as having spoken against the Medici.

As to the money, all I have lies in Balducci's bank, and I keep none of it either in the house nor upon my person, except such sums as are necessary from day to day. With regard to the Medici, I have never uttered a single word against them except in the general terms in which everybody talks—as, for instance, after the sack of Prato. I think that even the very stones would have spoken of it, had they been able. There have been many other things said since then, to which, when I heard them, I have always replied: "If they are really doing these things, they are doing wrong." Not that I believed the reports, and God grant they be not true. About a month ago someone who pretended to be my friend criticized their actions very adversely. I rebuked him, saying that those who spoke in such a way did wrong, and that he was not to mention the subject to me again. However, I should like Buonarroto to find out quietly where the man in question heard that I had spoken against the Medici, so that I may endeavor to trace the origin of the rumor, and find out whether it came from someone professing to be my friend. I shall then be upon my guard. I have nothing more to add. . . . (Carden)

402. *Michelangelo held too many properties in Florence to risk having them confiscated by the despotic Cosimo de' Medici.*

[October, 1547]

Lionardo, . . . I am glad that you have reminded me of the laws of banishment; for however cautious I have been up to the present time in

speaking with the exiles, and in having intercourse with them, I shall in the future be still more on my guard. With regard to my having lain ill in the Strozzi's home, I was not in their house, but in the dwelling of Luigi del Riccio, my intimate friend; for, since the death of Bartolomeo Angelini, no man had better or more faithfully cared for my affairs; and after his death, as all Rome can testify, I have had nothing more to do with the house. How I live here, everyone knows. I am always alone and solitary, speaking with no one, and least of all with Florentines. When I am, indeed, greeted in the street, I return a friendly bow, and go my way. But if I knew who the exiles referred to are, I would not give even this sign of recognition. In the future, I shall be on my guard, especially as I have so many other things on my mind that might render my intercourse with them dangerous. (Bunnett)

403. *Despite the disclaimer just above, Michelangelo's associations with the Tuscan exiles in Rome encouraged him to voice his belief that the late Medici Dukes were ravishing Florence:*

PER MOLTI, DONNA, ANZI . . .

The Exile: For many, Milady, for even a thousand lovers
Wast thou created, angelic of form.
But now it would seem that heaven sleeps
While one lone man takes for himself what was given to so
 many.
On hearing our plaints, give back to us
The beauty of thine eyes, that gift seemingly denied
To him born in the wretched state of exile.

Florence: Pray, trouble not your righteous desires,
Since he who seems to despoil me and deprive you of me,
Fearful as he is, enjoys not his great sin.
For the state of lovers whose great desire
Is checked by the very abundance of their ill-got gains
Is less happy than a wretched state yet full of hope.

 (1545/46)

404. *Michelangelo wittily reproached the Tuscan exiles he met at Giannotti's home:*

Rarely does one of us agree with the other. And whenever a great number of Tuscans find themselves together discussing some topic, there are always a thousand divisions. Out of these intransigent minds, so formed, have perhaps been born the vicissitudes and ruin of our Tuscany. I cannot therefore do other than praise the reply made by one of our townsmen, a nobleman, to another who was asking him to join forces with a certain company which several seditious men had set up. He

replied that it was enough for him to be a member of the Grand Council of Florence, which seemed to him a magnificent and honored company.

[Giannotti]

405. *Like his idol Dante, Michelangelo decries the cruelty and* hubris *of the Florentines.*

October, 1512

Most dear Father,—From your last letter I've gathered how things are going up there, even though I had a partial idea before. We must have patience and place our trust in God and correct our errors. For all these adversities arise from nothing other than pride and ingratitude: I've never dealt with more ungrateful and haughty people than the Florentines.

406. *Complaints in a letter from Bologna to his brother Buonarroto in Florence reveal the artist's homesickness:*

10 August, 1507

You write telling me about the heat back there and about the high cost of living. Know then that it's still just as hot here, for it hasn't rained since I've been here, except once, and we've had heat waves the likes of which I never believed existed in the world. The wine is as costly here as there, but wretched as possible, and the same goes for everything else, so that it's a poor existence here and it seems to me a thousand years since I came from Florence.

Bologna, 20 April [1507]

407. Giovan Simone, . . . You write me of a certain doctor friend of yours who told you that the plague is an evil malady and that one dies of it. I am glad to have learned this, for here there is plenty of it, and these Bolognese haven't yet noticed that one dies of it. So it would be good if he came up here, for maybe they would gain understanding from his experience: which would be most useful to them. I have naught else to say to you. . . .

WAR

Rome, October, 1509

408. Dearest Father, . . . Other things aren't working out so well as I thought they would. I blame the times, which are very contrary to our art.

409. In time of the toga and peace . . . we see that some men find themselves so expert in idle things that they are capable of making a

name for themselves with things of no nobility, profit, knowledge, or substance. They are able to win profit, honor, and substance for themselves, and whoever gives them their profit, he must take a loss. In the domains and states which are governed by a senate and republic, we see people utilizing painting in many public works, such as cathedrals, temples, tribunals, courts, porticoes, basilicas, palaces, libraries, and other public showplaces of this nature. Similarly, every noble citizen individually possesses in his palaces or chapels, villas or farms, a goodly number of paintings. But if, in those states where no one is permitted to make more of a display than his neighbor, they give commissions to painters which make them appear rich and well-off, with how much more reason, in obedient and peaceful kingdoms where God has permitted only a single person to defray those magnificent expenses and commission all the sumptuous works which his taste and honor may wish and demand, should people avail themselves of this rewarding art and science? What a great opportunity it is for one person to be able to do alone, without any adviser, many things which a number of men cannot do collectively. A prince would be wronging himself, to say nothing of the fine arts, if after having attained tranquility and a holy peace, he were not disposed to undertake great projects of painting for the ornament and glory of his state and for his personal satisfaction and recreation of his spirit.

Furthermore, in peacetime there are so many profitable uses to which painting may be put that it almost seems that peace is sought by such strife of arms for no other reason than to bring about an opportunity to effect painting's productions and achievements in the quiet which they require—and merit, after the service which painting has rendered during wartime. Nor will the name of any man prevail after a great victory or feat of arms, if afterward in peacetime he does not leave behind to dwell in our memories through the power of painting and architecture arches, triumphal monuments, sepulchers, and many other things. This provision is an important and necessary one among men.

Augustus Caesar did not disagree with this statement of mine when, during a period of universal peace in all countries, he closed the gates of the Temple of Janus. For in closing those doors of iron, he opened the doors to the gold of the imperial treasuries, in order to spend larger sums in peace than he had in war. And by chance he may have paid as much for a single figure of painting as he would pay a company of soldiers in a month, especially when one considers with what ambitious and magnificent works he decorated Mount Palatine and the Forum.

This is why I say that peace should be desired by eminent princes: in order that they may commission great works of painting for their republics, for the ornament and glory of their state, and to receive from them particular spiritual satisfactions and stirring spectacles. [De Hollanda]

410. *Michelangelo's remarks on the military uses of art echo his readings in Vitruvius and his own personal experience:*

And what is there more profitable in the business and undertaking of war, or what is of more use in the operations of sieges and assaults than painting? Do you not know that when Pope Clement and the Spaniards besieged Florence, it was only by the work and virtue of the painter Michelangelo that the besieged were defended a good while, not to say, the city released, and the captains and soldiers outside were for a good while astonished and oppressed and killed through the defenses and strongholds which I made on the tower, lining them in one night on the outside with bags of wool and other materials, emptying them of earth and filling them with fine powder, with which I burnt a little the blood of the Castilians, whom I sent through the air torn in pieces. So that I hold that great painting is not only profitable in war, but exceedingly necessary for the engines and instruments of war and for catapults, rams, mantlets, testitudines, and iron-clad towers and bridges, and (as this bad and iron time does not make any use of these arms, but rejects them) mortars; for the shaping of the mortars, battering-rams, strengthened cannons, and arquebuses, and especially for the shape and proportions of all fortresses and rocks, bastions, strongholds, fences, mines, countermines, trenches, loopholes, casemates; for the entrenchments for horsemen, ravelins, gabions, battlements, for the invention of bridges and ladders, for the emplacement of camps, for the order of the lines, measurement of the squadrons, for the difference and design of arms, for the designs of the banners and standards, for the devices on the shields and helmets, and also for new coats of arms, crests, and medals which are given on the field to those who show great prowess, for the painting of trappings (I mean the giving of instruction to other lesser painters as to how they ought to be painted, and seeing that the excellent painters can paint the trappings of the horses and the shields and even the tents for valorous princes); for the manner of dividing and selecting everything; for the description and assortment of the colors and liveries, which but a few can determine. Moreover, drawing is of exceedingly great use in war to show in sketches the position of distant places and the shape of the mountains and the harbors, as well as that of the ranges of mountains and of the bays and seaports, for the shape of the cities and fortresses, high and low, the walls and the gates and their position, to show the roads and the rivers, the beaches and the lagoons and the marshes which have to be avoided or passed; for the course and spaces of the deserts and sandy pits of the bad roads and of the woods and forests; all this done in any other way is badly understood, but by drawing and sketching all is very clear and intelligible. All of these are important matters in warlike

undertakings, and the drawings of the painter greatly aid and assist the intentions and plans of the captain. What better thing can any brave cavalier do than show before the eyes of the raw and inexperienced soldiers the shape of the city that they have to attack before they approach it, what river, what mountains, and what towns have to be passed on the morrow? And the Italians at least say that if the Emperor [Charles V] when he entered Provence had first ordered the course of the river Rhône to be drawn, he would not have sustained such great losses, nor retired his army in disorder, nor would he have been painted afterwards in Rome as a crab, which crawls sideways, with the words borne by the columns of Hercules, *Plus ultra,* for wishing to go forward, he went back. And I well believe that Alexander the Great in his undertakings frequently made use of the skill of Apelles, even if he himself did not know how to draw. And in the works and commentaries, written by the monarch Julius Caesar, we may see how much he availed himself of drawing, through some capable man he had in his army. And I even think that the said Caesar was extremely intelligent in painting, that the great captain Pompey drew very well and with style, he being vanquished by Caesar, as Caesar had become the better draftsman. And I assert that a modern captain who commands a great army and who is not capable and intelligent in painting and cannot draw, cannot do any great feats or deeds of arms. He who understands and esteems it will do deeds of renown which will be long remembered, and will know his ways and how he stands, and how and where he will break through or order his retreat, and he will know how to make his victory appear much greater. For painting is not only advantageous in war but very necessary. What country warmed by the sun is more warlike and better armed than our Italy, or where are there more continuous wars and greater routs and sieges? And in what country warmed by the sun is painting more esteemed and celebrated than in Italy? [De Hollanda] (Holroyd)

411. *What should the citizenry do when plundering hostile troops draw near? Michelangelo counsels flight to his family in Florence.*

5 September, 1512

Buonarroto,—I have not written to thee these last few days because there was no occasion for it: but now, seeing the course matters are taking in Florence, it seems advisable that I should speak out. As, judging by what people are saying here, the Florentine territory is in an evil plight, I think you ought all of you to retreat to some place where you will be in safety, abandoning all you possess: for life is more precious than worldly goods. If you have not the wherewithal to depart from Florence, go to the Hospitaler and make him give you money. If I were with you, I should draw all my money from the Hospitaler and go to Siena; there I should take a house and stay until matters had settled down again. I believe the power of attorney I gave Lodovico has not yet expired, so

that it will enable him to withdraw my money. If there is any occasion for it, let him do this; and in all such moments of peril draw out and spend whatever may be necessary. The remainder you will keep for me. Do not under any circumstances involve yourselves in the affairs of the territory, either by word or deed. . . .

412. *Retort to a pope worried over the nudities in the* Last Judgment:

 Tell the Pope that this is a trivial matter, and can easily be arranged. Let him set to straightening out the world, for pictures are quickly straightened out. [Vasari]

MONEY

413. I haven't a farthing and am naked and shoeless. . . .
 [XCI; also XIX]

 24 October, 1525
414. . . . I haven't received my stipend for over a year and I'm combatting poverty; I am much given to worries and I have so many of them that they keep me more occupied than does art.

 19 December, 1506 [from Bologna]
415. . . . I am here in a wretched room and have bought a single bed in which we are four persons.

416.

> NON È NON DEGNA . . .
> The soul is not unworthy, as it awaits
> Eternal life, in which there is peace and quiet,
> Where one is enriched by the only coin
> Which heaven mints for us, and nature here spends.
> (1545/46)

417. Promises, bribes, and gifts corrupt justice. [CDXCI]

418. *Reminders to his nephew, 29 April, 1546, and later (undated) in 1547:*

 Money isn't found in the streets!

419. . . . These are hardly times to be throwing monies up in the air: and I don't find that the established families of Florence have maintained themselves well except through solid financial policies.

 July, 1542
420. . . . I'd be more pained by losing the respects of the Pope than by losing 200 ducats.

21 February, 1549

421. . . . Honor is worth more than goods!

25 April, 1556

422. . . . Try to live as much as you can, for goods don't last after people have gone!

423. *Whatever his financial troubles, Michelangelo avoided dealing with banks; his distrust of them is more than once expressed in his letters.*

19 August, 1497

Dearest Father, . . . I inform you that on Friday Buonarroto arrived here. As soon as I knew, I went to see him at the inn. He told me how you are getting along, and also that Consiglio the merchant [Lodovico owed him 90 florins] troubles you a great deal: that he is unwilling to settle on any sort of agreement and that he wants to have you arrested. I say that you must try to come to an understanding with him, and that you should advance him a few ducats; let me know what you agree to give him, and if you do not have that amount I shall send it to you. Though, as I told you, I have little money, I'll do my best to borrow some, so that we may avoid taking the money from the bank, as Buonarroto suggests. Do not be surprised if I have occasionally written you in such angry tones; at times I am quite upset by things that happen to one who is away from home.

I agreed to make a statue for Piero de' Medici and bought the marble; I never began it, though, because he did not keep his promise to me. For this reason I keep to myself, and I am carving a statue for my own pleasure. I bought a piece of marble for five ducats, but it wasn't any good. I've simply thrown that money away. Then I bought another piece, also for five ducats, and I am now working it for my own amusement. So you must realize that I too spend money and have my own troubles. Just the same, I shall send you what you may ask of me, even if I have to sell myself as a slave. (C. Speroni)

424. *Advice to his nephew, 9 May, 1545:*

. . . When I wrote you that if you wanted to do something else with the money I was sending you, something safe, I understood by this buying some property, like that land of Nicolò della Buca or some other you might like, but not to put the money into some bank, for all of them are fraudulent.

425. *Further advice of 11 May, 1549, after suggesting the purchase of a shop and a farm:*

. . . I give you free commission to spend up to four thousand gold ducats and don't deal in anything but properties: this will be better than keeping the money in banks, because I don't trust them!

426. *Complementary advice to the nephew, 11 February, 1547:*
. . . If you keep money in the house, let not one hand trust the other, for it is a great peril.

3 November, 1515

427. . . . You write that the money-broker is unhappy about me since I've withdrawn so much money in so short a time; it seems to me he's a great fool to complain about such things, since he's simply giving me back my money which he used for so long. [CX]

June, 1508

428. Dearest Father, . . . I have received no money from the Pope for the last thirteen months but I expect to have some without fail within the next month and a half, as I have made very good use of what I have already received. Should he not give me any I shall be obliged to borrow in order to return to you, as I have not a farthing. There is one good thing about it, I cannot be robbed.

30 July, 1513

429. To his Brother Buonarroto, . . . [Michele the stoneworker] related how you told him of your spending sixty ducats at Settignano. I recall that you also talked about this at table, telling of many ducats of your own you had spent. I pretended not to get the point, and showed no surprise, for I know you. I believe that you have jotted these ducats down and are keeping account of them in order to demand them back one day. I should like to know from your ungrateful self how you ever earned this money. I should also like to know whether you are keeping account of those 228 ducats you took from me for Santa Maria Nuova, and if you've forgotten the many hundreds I have spent on our home and on you, and the hardships and penury I have endured to help you. Have you really kept account of these things? If you had enough intelligence to recognize the truth, you'd not say, "I've spent so much of my money," and you'd not have come here to beg from me on your behalf, seeing how well I've conducted myself toward you in the past; rather you'd have said, "Michelangelo knows what he has written to us, and if he doesn't do thus now, there must be some impediment which we don't know about." So then be patient, for it's not good to spur a horse running as fast as he can, or faster. But you've never known me nor do you understand me. May God pardon you!

July, 1524

430. Yesterday I ran into someone who told me that I was going to have to pay [indemnities on the Tomb of Julius II] or else by the end of

this month I'd have to pay penalties. I didn't believe that there were other punishments than those of hell, or an income tax of two ducats if I were the draper of a silk craft or a gold beater, and I lent the rest at usury. We have paid taxes in Florence for three hundred years: once at least I could have been an associate of the Rector of the Judges and Notaries' Guild. And still I have to pay! Everything will be stripped from me, and I'll have to come back down there to Rome. If my affairs were settled, I'd have sold something and bought credits at the Bank which might have paid my taxes, and I could then stay in Florence.

431. *Asking for just mediation of the claims of Julius' heirs:*

October, 1542

I never cheated anyone, and yet in defending myself from louts, it is necessary at times that I become crazy, as you see.

I don't want to remain any longer under this weight or be reviled as a cheat every day by one who has taken away my life and my honor.

432. Avarice is a very great sin, and nothing involved with sin can come to a good end. (LXXXV)

433. *Among the many condemnations of avarice by the artist, one is curiously expressed by means of an allegorical figure representing this petty sin. Wealth is pictured as uncertain and fearful.*

O AVARIZIA CIECA . . .

O Avarice blind, O mean and base desires
O those who pass the gifts of Nature by!
For gold alone your wretched pride aspires,
Restless for gold from land to land ye fly;
And what shall quench your never-sated fires,
Ye slaves of Envy, Sloth, and Luxury,
Who think not, while ye plot another's wrong,
Man wants but little, nor that little long? . . .

Wealth, sad at heart the while, and full of dread,
Goes all adorn'd with gems and gay with gold;
And every cloud which passeth overhead
As ominous of change doth she behold;
But Poverty her happy days hath led,
Vex'd with no hope to have, nor fear to hold;
Amid the woods in homely weeds bedight
She knows no cares, no quarrels, no affright.

(—1534) (William Wordsworth)

434. *In 1535 Pope Paul granted to Michelangelo a yearly income of 600 ducats collected at the port of Piacenza (actually paid between 1538 and 1545 or 1546). The loss of this regular income was a blow to the artist.*

Florence, December, 1545

Messer Luigi, dear friend, . . . In my last letter I wrote you that if you were to be delayed in returning, I was thinking of coming [to Lyon] to see you. And this intention I repeat, for having lost the Port of Piacenza, and not being able to stay in Rome without an income, I should rather consume what little I have on inns than stay numbly around Rome like a beggar. . . .

May, 1518

435. During our conversations, [Luca Signorelli] asked me for the loan of forty *giuli*, specifying where I was to send them for him, in the care of a certain shoemaker. I did so. Several days later he came to my studio at Macel dei Corvi, which I still maintain. He told me his troubles, and requested the loan of another forty *giuli*, stating that he wished to leave. I went up and returned with the forty *giuli*, which I turned over to him with a Bolognese biddy of mine as witness. He took the money and left. I have never seen him since. . . . I write you this, for if the aforesaid facts were recalled to the aforesaid Maestro Luca, he would remember them and not claim to have repaid me. . . . It is not true that I am a rogue and I should be if I tried to get back what I had already received. Your Lordship may think what you will: I have yet to get my money back and so swear to you!

2 May, 1548

436. Lionardo, . . . Tell the priest not to address me any more as *Michelagnolo scultore*. For I am not known here by any other name than that of Michelagniolo Buonarroti; tell him also that if there is a Florentine who wishes to have an altar-picture painted he had better go and find a painter to do the work. I was never the sort of painter or sculptor who keeps shop. I have ever been careful for the honor of my father and of my brothers, although I have served three Popes, having been obliged to do so. (Carden)

437. *To his nephew Lionardo in an undated letter from Rome, 1547:*

. . . And I reply again to you about setting up a shop, that this is not my profession and I cannot write to you about it. The good and bad decisions you all make, that's your own business.

438. *The lofty artist has to teach his nephew the elementary haggling techniques of the peasant:*

1 August, 1556

Lionardo,—Thy haste [with regard to Cepperello's farm] hast cost me at least fifty crowns more than it need have done; but what grieves me most is that thou shouldst have more regard for a piece of land than for what I say. Thou knowest well what I said to thee: thou wert to pretend that I did not want the land, and to make them come to us and beg us to buy. But thou, as soon as thou hadst returned to Florence, set the agents to negotiate for it with the greatest eagerness. However, since it is done take care of thy health so that thou mayst live to enjoy it.

439. . . . I tried, in order not to be stripped bare [of cash], to sell houses and possessions, and to give away the *lire* for ten *soldi;* I have not found and am not finding customers. So I think it would be better to delay than to throw away. (CDX)

1545

440. Messer Luigi, I send regards to you and your loved ones. Messer Giuliano [de' Medici] and Messer Ruberto [Strozzi] of whom you write, I am their servitor, and if I don't do what is proper, I am fleeing creditors, for I have great debt and little money.

13 September 1560

441. . . . So, to be brief, I beg your most illustrious and reverend Lordship that he will consent to let me resign from this worrisome post [supervision of the Vatican workshops], in which I have served, at the Pope's orders as you know, willingly and without salary for 17 years.

442. *Michelangelo's self-professed disinterest in money extended to any dowry which his nephew might be seeking:*

23 February, 1548

Lionardo. . . . As for taking a wife, I've told you about three girls of whom people have talked to me here. I committed myself in no way. It's up to you to take her or not, and to decide which one, provided that she be noble and well brought up, and rather without dowry than with a large dowry, so you may live in peace.

443. *To his Father:*

15 September, 1510

There are certain ducats in small coin, which I wrote to you about, that you should claim. If you have not taken them, ask for them at your leisure, and if you need more, take just what you may require, for as much as you want so much will I give you, even if you spend it all. And if it be necessary that I should write to the Hospitaler let me know. I

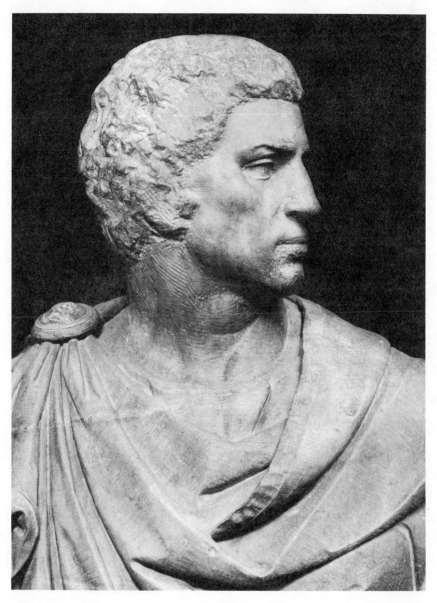

Bust of Brutus (Florence, Bargello Museum)
And so . . . Dante judged that Brutus and Cassius erred and merited the punishment which he meted out to them. (*see page 124*)

Judith and Holofernes (Rome, Vatican, Sistine Chapel Ceiling)
Fearful as he is, enjoys not his great gain. (*see page 126*)

have heard from your last how affairs are going. I am anxious about them. I cannot help you in any other way, but do not, on this account, alarm yourself, and do not give yourself an ounce of melancholy; because if goods are lost life is not lost. I will do so much for you that it will be more than what you may now lose. But do not look forward to it too much, as it may fail. Nevertheless, do your best, and thank God that as this sorrow had to come, it came in a time when you were better able to help yourself than in times past. Think only of your life, and sooner let the things go than suffer inconvenience, for it is more precious to me to have you alive and poor than all the gold of the world if you were dead; and if those chatterers, either there or elsewhere, reproach you, let them talk, for they are ignorant men and without compassion.

(C. C. Black)

444. *Whenever a death in the family occurred, the artist always turned back to the family any inheritance left him by a member of the family:*

Rome, 28 April, 1548

Lionardo,—I refuse the inheritance of Giovansimone, and enclose the notarized statement of the same.

4 December, 1555

445. Lionardo,—About the worldly goods which Gismondo left, of which you write, I tell you that everything is to stay with you. Try to carry out his will and to pray for his soul, for that's the least you can do for him.

446. *Expenses for Buonarroto's daughter Francesca:*

13 September, 1528

8 soldi for an ell of *bottana* cotton cloth.
6 soldi for three quarters of cloth to line a dress.
24 soldi for *bottana* cotton cloth.
5 soldi for thread for the coat.
2 *crazie* [Tuscan halfpennies] for thread for the dress.
50 soldi for the tailoring of the coat.
25 soldi for the tailoring of the dress.
4 soldi for the ribbon of the dress.

Rome, 31 May, 1556

447. Lionardo, . . . I've had a letter from Francesca in which she requests that I give alms of 10 ducats to a confessor of hers for a poor girl

he's putting into the Convent of Santa Lucia. I want to do this for the love of Francesca, because I know that if it weren't a good alms, she wouldn't ask it of me.

July, 1508

448. . . . When there is nothing left to spend, God will help us.

VI. SELF-PORTRAIT, PHYSICAL AND MORAL

Michelangelo toyed with the obvious thought that every time a painter picks up a brush he ends up by painting himself. Supporting this idea consciously or unconsciously, Michelangelo executed at least ten alleged self-portraits in his art, including the Saint Proculus *in Bologna, the pelt of* Saint Bartholomew *in the* Last Judgment, *the aged vanquished man in the Florentine* Genius of Victory, *the decapitated* Holofernes *on the Sistine Ceiling, and the bearded old man in a boar's head pen-sketched on a folio [40b] (see title page). This self-projection or self-portraiture becomes even more demonstrable when a writer picks up a pen. Every passage in the present volume fills in Michelangelo's portrait like so many hatchings or shadings. We have read evidences of his loyalty, generosity, forbearance, and so on. Chapter VI begins with an amusing physiological and emotional self-portrait in tercet rime and then proceeds to the various components of Michelangelo's character and personality: modesty, pride, arrogance, confidence, prudence, resolution, and so on. The extent to which Michelangelo's sense of humor was tinged with irony will be clear from other testimony, couched in anecdotal form. A number of evidences of Michelangelo's difficult and even irascible temperament will help fill out the picture, that temperament which earned for him a broken nose from his fellow-student Pietro Torrigiani. Other unhappy characteristics—mistrust, vindictiveness, and sundry anxieties—will be revealed, as well as a longing to flee the ills and vanities of city life and find peace in some Vaucluse.*

Finally, a curious and little-known susceptibility to visions discernible in various, disparate sources, rounds out our moral and physical self-portrait of the artist.

BODY AND SOUL

449·

IO STO RINCHIUSO . . .
Here I am poor and alone
enclosed like the pith in its rind,
or like a spirit holed up in a decanter;
and my dark tomb affords little flight.
where Arachne and a thousand spiders labor

and in spinning make of themselves spindle-racks.
About the exit are dung-heaps of giants,
as though all those who have taken of grapes or physic
do not go elsewhere to stool.
I have become well acquainted with urine
and the tube whence it issues through the crack
which summons me before the morning sun.
Cats, carrion, beetles, or cess—
he who comes to change me never fails to find them
heaped up by the housekeeper.
My soul has this advantage over the body,
that if the obstruction gave way to let out stench,
it could not hold it in with bread or cheese.
Coughs and cold do not let the soul die,
for if it cannot issue forth from the exit below,
it can scarce come forth with the breath of the mouth.
My loins are strained, I'm out of breath,
fractured and broken by my labor, and death
is the hostel where I live and eat on credit.
Melancholy is my joy, and my repose
are these discomforts; for to him who seeks it
God will give calamity!
Anyone who might see me celebrating the Magi
would really be seeing something, or even more
if he saw my house here amid such rich palaces.
No flame of love has remained within my heart,
for the greater pain always expels the lesser,
and the wings of my soul have been clipped and shorn.
I have a voice like a hornet in an oil jar,
coming from a leathern cask and a halter of bones;
I have three pebbles of pitch [gallstones] in a tube.
My eyes are purplish, spotted, and dark.
My teeth are like the keys of an instrument,
for by their moving the voice sounds or falls still.
My face has a shape which strikes terror.
My clothes are such as chase crows to the wind,
away from the dry seeds, without the aid of other weapon.
A spider-web lies hidden in my one ear,
while all night long a cricket chirrups in the other.
At my catarrhous breathing, I neither sleep nor snore.
Love, the muses, and the flowery grottoes—
My scribblings and drawings now are used
For inns and privies and for brothels.
What avails it to try to create so many childish things
If they've but brought me to this end, like one

Who crosses o'er the sea and then drowns on the strand.
Precious art, in which for a while I enjoyed such renown,
Has left me in this state:
Poor, old, and a slave in others' power.
I am undone if I do not die soon.

(1546/50)

24 July, 1512

450. Buonarroto, . . . I try harder than any man there ever was, ill in health and with the greatest of effort. And yet I have patience to get to the desired end. . . .

March, 1518

451. . . . I have a bell ringing in my ears which prevents me from thinking of the things I wish to.

July, 1523

452. I am old and in bad shape, for if I work for one day, I have to rest for four.

March, 1544

453. I cannot accept the commission of Duke Cosimo because of the troubles I have, but even more because of old age, for I cannot see light.

1544

454. If I don't show myself more often to your Holiness [Pope Paul III], the cause of this is my illness, since every time I've gone out I've had a relapse.

(1558/59)

455. . . . I remain entirely yours, old, blind, deaf, and scarcely in control of my hands and my person.

456. Fever, pains in my sides, diseased eyes and teeth. (G App. 16)

16 June, 1557

457. Lionardo, . . . As for my health, I am in bad shape, with all the illnesses old people have; the stone, so that I cannot urinate; my side and back, so that often I cannot go upstairs; and what is worse, I'm all stirred up; so that if I left the conveniences I have here for my maladies, I couldn't survive three days.

14 February, 1562

458. . . . I have had most severe colic pains.

5 July, 1555

459. I was not able to [write] before because of the most cruel pain which I have had in one foot, which has prevented my going out and

has given me several kinds of trouble. They say it is a kind of gout. That's all I need in my old age!

460. *Evidences of Michelangelo's generosity are numerous:*

August, 1547

Lionardo, . . . Make enquiries and try to find some needy Florentine with daughters to be married or placed in a nunnery, and give him the money: but do it secretly and take care not to be deceived. Get a receipt from him and send it to me. I say secretly because I am speaking of burgesses, and I know that the needy ones are ashamed to go about and beg. . . . (Carden)

15 March, 1549

461. If thou shouldst come to hear of a case of extreme poverty in some noble family—and I believe that such cases are to be found—please let me have information about it, with the name; and I will then send thee any sum up to fifty crowns so that thou canst give it to them for the good of my soul. This sum will in no way diminish what I have set aside for any of you in my will; therefore, do as I say without fail. (Carden)

20 December, 1550

462. Lionardo,—I should be pleased, if you are aware of a case of extreme poverty of some noble citizen and especially of those who have daughters at home, for you to let me know, so that I could do him some favor for the good of my soul.

463. *Discussing the disposition of his now considerable fortune, Michelangelo shows a late concern for the underdogs of society:*

20 February, 1552

. . . I intend to make out a will leaving what I have in Tuscany to Gismondo my brother and to thee my nephew, with neither one free to dispose of it without the consent of the other; and if the two of you remain without heirs, you will leave everything to Saint Martin; that is, the income is to be given for the love of God to the needy, that is, poor citizens, unless you advise me of a better plan.

July, 1540

464. Lionardo,—I have received your letter and along with it the three shirts. I am very astonished that you would send them to me, for they are so coarse that there is not a farm hand hereabouts who wouldn't be ashamed to wear them. Even if they'd been made of a thinner cloth, I wish you hadn't sent them. When I want shirts I'll send you the money to buy them.

465. *Comment on the public reaction to his quarrel with Pope Julius II:*

There was a lot of talk, to the shame of the Pope. (CDXXXV)

8 September 1515

466. Buonarroto, . . . Thou writest as though to thy mind I care more than I ought for this world's goods: well, I care more for them for your sakes than I do for my own, as I have always done. I do not believe in old wives' tales, and I am not quite mad, as you seem to think. Some time hence I believe you will have a better opinion of the letters I have written you during these last four years than you have at present, unless I am deceiving myself: and if I deceive myself, it is not in a bad cause that I do so, for I know that in all seasons it is wise to look after one's own self and possessions. I remember that about eighteen months ago— it may have been more, or less, I do not remember—thou desiredst to do a certain thing. I wrote saying it was not the proper time, and that thou wouldst do well to let a year pass. Then a few days afterward the King of France [Louis XII] died, and thereupon thou didst reply, or rather, didst write, saying that the King was dead and there was no further danger to be feared in Italy; also, that I believed in old wives' tales and friars' chatter, and thou didst mock at me. Now, however, thou hast learnt that the King [the equally aggressive Francis I] is not dead; and it would have been far better for all of us if you had followed my advice years ago. But enough. . . .

467. *When Michelangelo hears that his brother Gismondo is coming to Rome to solicit help for a business project, Michelangelo writes a warning to his brother Buonarroto:*

17 October, 1509

I am obliged to love myself more than others, and I cannot offer myself the necessities. I am here in great troubles and in great bodily exhaustion, and I haven't friends of any kind, nor do I want any. I don't have so much time that I can eat what I need. So don't let me be given any more annoyances, for I couldn't endure an ounce more.

The following phrases spoken by Michelangelo during the dialogues with Donato Giannotti reveal the fixity of his thinking:

468. Nevertheless, I'm firm in my opinion. . . .

469. I don't contradict myself.

470. I grant you that, *but*

471. If that's all you have to say, I'll abide by my original opinion.

[Giannotti]

472. *Conjecture on people's reaction if he quit his Vatican post:*

. . . It would be to my shame throughout all Christendom!

(CDLXXV)

473. *Satisfaction with his plans of a church for the Florentines in Rome:*

Never Romans or Greeks ever accomplished such a thing in their temples. [Vasari]

474. *Michelangelo's definition of his projected façade of San Lorenzo:*

The mirror of all Italian architecture and sculpture. (CCCXLVIII)

August, 1518

475. The spot where we are quarrying is very difficult, and the men ignorant in such work; so we'll have to be patient for a few months, until we have domesticated the mountains and trained the men; then we'll get along faster; let it suffice that what I have promised I'll do one way or another, and I'll make the most beautiful work ever done in Italy, with the help of God.

476. *Counsel written to his nephew on 14 April, 1543:*

. . . and when thou writest me, do not put on the address:
Michelagniolo Simoni, nor sculptor; it is enough to put, Michelagniolo Buonarroti, for thus am I known here. And so inform the priest also.

8 August, 1556

477. It is quite true that self-love deceives all men.

478. There is nothing which makes a modest man blush more than praising him in his presence. So without clothing me with the vestments of others, leave me alone wrapped up in my shroud. [Giannotti]

479. It seems to me that you are flattering me so, that if Messer Donato rescues me not, I shall become like that crow in Aesop—if the legitimate owners of these ornaments with which you have clothed me will come for them, I shall remaining nude be the laughing stock of all.

[Giannotti]

480. *After eighteen months of exhausting work on the Sistine Vault, Michelangelo observed simply in a letter to his father:*

October, 1512

I've finished that chapel I was painting. The Pope is quite satisfied.

481. *After delivering a smashing commentary on the very technical matter of how many hours Dante spent in the Inferno and the Purgatory, Michelangelo says with a sprezzatura which would have delighted old Count Canossa:*

I well realize that you have today made me enter into a subject which is beyond my forces, and any one of you would have treated it better than I. [Giannotti]

482. *A single disclaimer was written by Michelangelo concerning competence in fresco painting (X), making daggers (XLVIII), writing letters (CDLXXXII), running a shop (CLXXXIII and CXCV), painting, sculpturing, practicing architecture (CDLX), or writing poetry (G 85):*

It's not my profession.

483. *This great genius who has left us almost 500 revealing letters summarizes his feelings about the epistolary art to his brother Buonarroto:*

30 June 1515
. . . I wrote the letter that you asked of me. I know that it wasn't well done, because it's not my profession and I don't have the head for such things. (XCVIII)

484. Be careful, perhaps my courtesy was born of love of myself; be careful, perhaps I have lent too willing an ear to the praises you have expressed of this building. [Niccolò Franco]

485. *Counsel given to his nephew:*

1552
Proceed with leaden shoes, for there is never any turning back.

486. *From a letter to the artist's brother Buonarroto, 24 July, 1512:*

. . . I strain more than any man who ever lived, unhealthy and with great exhaustion; and yet I have the patience to arrive at the desired goal. . . .

487. *A verse of Dante (Paradise, XXIX, 91) written on a Pietà which the artist designed for Vittoria Colonna:*

They do not realize how much blood it costs! [Bernini]

488. *A claim made by the artist in the presence of Bartolommeo Am-
mannati:*

In my works I defecate blood!

489. *In one of his madrigals [ca. 1541/44] the artist describes the exer-
tions demanded by the profession of art.*

> That I should burn, die, and fall
> For what if weighed would scarcely be an ounce;
> And by the pound takes the blood from my veins and fibers
> And disarranges the body from the soul.
>
> [G 172]

490. I enjoy and thrive on precisely what kills others. [G 136]

491.

> COME FIAMMA PIÙ CRESCE . . .
> As a flame grows assaulted by the wind,
> Every virtue which heaven exalts
> Shines the more as it is more offended.
>
> (1525/35)

492.

> Nor does the unique phoenix take on new life
> If not first burned, whence I, if I die burning,
> Hope to rise up again more bright. [G 62]

493.

> He who does not wish leaves,
> Let him not come around in May. [G 278]

THE IRONIC SENSE OF HUMOR

15 July, 1518

494. . . . Now if the Pope is issuing Bulls permitting people to steal, I
pray your most reverend Lordship to get me one of these Bulls, since I
need one more than others do.

495. *A prince placed in a building some niches far too narrow and deep
for their height and for the rest of the plan. A ring was attached to the
top of each niche. When several statues failed to fit into them, Michel-*

angelo was asked what to do with these niches. The great architect of the Capitol and the dome of St. Peter's, solved the problem.
"Hang some bunches of eels from the rings." [Vasari]

496. *Someone showed Michelangelo an unknown Pietà and asked his opinion of it. He studied it for a while and then nodded, as if in approval:*
"Quite. . . . Quite right. It's a pity [pietà] just to look at it." [Vasari]

497. *According to Cinzio, the writer who gave Shakespeare ready-made the plot of Othello, Michelangelo was asked to comment on a portrait done by the presumptuous young artist Alazone. To the assembled company the master paid the compliment so frequently heard in Renaissance salons and studios. He said that the portrait was so lifelike that it could speak. Then someone asked the obvious, inquiring what the picture would say:*
"That not a single part in it is any good!" [Giraldi Cinzio]

498. *Michelangelo, who punned so often in his poetry, challenges us with an unspoken pun in his painting. For a long time no one knew why the Cumaean Sibyl on the Sistine Ceiling holds her book at such a far distance from her face. The reply, which the artist did not deign to give:*
"This sibyl is far-sighted."

499. *When Fra Guglielmo della Porta restored the legs of an ancient Hercules in the Farnese Palace, only to have the missing legs brought to light, everyone was slightly embarrassed. It was decided to have Michelangelo arbitrate. He ruled that Della Porta's restoration should stay. His punning explanation was:*
"Such a worthy restoration will show that the works of modern sculpture can stand on an equal footing with ancient works!" [Baglione]

500. *Michelangelo made Piero Soderini, the political secretary of Florence, the unwilling participant in an improvised game of optics. The gonfaloniere complained to the sculptor that the nose of the marble David was too long. Concealing some marble dust in his palm, Michelangelo climbed up his ladder and, appearing to work with his hammer and chisel, pretended to reduce the proportions of the offending member. After a while he solicited another opinion from Soderini, and the latter cried:*
"I like it much better that way. You have given life to the statue!"
[Vasari]

501. *Plagiarism in the arts often stirred Michelangelo to sarcasm. He was once shown a vast wall painted by an artist who had appropriated so many parts from other drawings and paintings that there was little original left in it. Michelangelo observed:*

"He's doing fine. But I don't know what that wall will do on Judgment Day when all bodies will take back their members, for there won't be anything left to it!" [Vasari]

502. *Michelangelo believed as a Platonist that art-forms are implanted within the materials themselves of art. As if to demonstrate his mastery in apprehending pre-existing art forms and to minimize the importance of the finishing process, Michelangelo gave a simple stone-mason a series of running oral instructions on how to carve a little statue. While the fellow "took dictation," Michelangelo ordered him to hew away here and level off there. When the figure was completed it won general approval, including the master's. Michelangelo asked:*
"How does it look to you?"
"Very good, sir. I'm very much obliged to you."
"Why so?"
"Because thanks to you, I've discovered a talent I didn't know I possessed." [Vasari]

503. *As Doni retells this same incident, it takes on fuller accretions of Michelangelo's thought. The grateful stone-cutter exclaims:*
"Who would have thought that there was such a handsome man in this ugly rock? If you hadn't made me uncover him, I'd have never seen him within." [Anton Francesco Doni]

504. *Bernini has left us a story illustrating Michelangelo's impatience with the fetish of literal imitation. Daniele da Volterra, working on a Pallas, had trouble painting the shield on her arm, which he was copying from a real shield. In despair he turned to his good friend Michelangelo and asked the older man to do this part for him. Michelangelo agreed, on condition that Daniele leave the room while he did it. Daniele retired to an adjoining chamber.*
Michelangelo unhurriedly removed the shield from its position near the painting and turned it face down on the floor in a corner. After a moment he picked up a brush, walked to the door and recalled Volterra.
"Now how do you like the imitation?"
Marveling at the painted shield which could no longer be compared to the original, poor Volterra's response was immediate:
"Perfect." [Bernini]

505. *In those days when he was working in Bologna on the bronze statue of Julius II, Michelangelo was annoyed by a Bolognese gentleman who had sidled alongside and was firing questions. Finally the worthy fellow asked whether this statue would be larger than a team of oxen. (In the popular speech of the time oxen had the meaning of dunces.) The artist replied tartly:*

*"That depends on the oxen. If you mean those of Bologna, well, there's
no doubt that ours in Florence are smaller."* [Armenini; Vasari]

506. *When the news broke that Michelangelo was to supervise the
Vatican workshop, the resident staff courteously expressed their pleasure
and told him that the "model of St. Peter's was a meadow where there
would never lack good pasturage." Admitting later that he implied that
there was pasturage for oxen (see above), Michelangelo replied to these
workers who were eventually to turn against him:*
"You speak true words." [Vasari]

507. *Michelangelo's humor was once topped by a pope. The artist took
a dislike to the master of ceremonies of Paul III and painted him as
Minos in the* Last Judgment. *When that dignitary sought redress from
the pontiff, the pope played right along. He reminded his servitor:*
"We have no authority in hell." [Lorenzo Ortiz]

508. *The Renaissance Spaniards Diego de Mendoza and Núñez Alba
both record a painfully blunt rejoinder of Michelangelo's to someone
making less than favorable comments on one of his paintings. Stretching
out his arm, he demanded:*
*"You who are such a great painter, take this brush and paint me a
pumpkin."*

509. *After listening to the grievances of his Portuguese disciple and
Boswell decrying the fact that the nobility in Portugal deprecated paint-
ing, the older artist looked gravely at the younger:*
"They do right!" [De Hollanda]

510. *Raphael, dismissing Michelangelo as a lonely and antisocial fel-
low, nicknamed him the "hangman," to the older artist's discomfiture.*
 *Noting the constant throng of admirers and hangers-on at the papal
court who surrounded his gracious rival, Michelangelo invented for him
the epithets of "provost" and "troop commander"* [bargello].
 [Lomazzo]

511. *Whatever Michelangelo's creative furies may have been like, there
was in his work a total absorption which withdrew him completely from
the concerns and even the awarenesses of everyday life. At these periods
the necessity of dating a letter became a minor nuisance or even a source
of daft humor. Thus, one reads such bemused datings as:*
I don't know what date this is, but yesterday was St. Luke. (LXXI)

It's some date in February, according to my biddy. (CCCLXXVI)

The hilarious notation of 6 January, 1548 reads:
I don't know the date, but today is Epiphany.

512. *One day the Florentine humanist Benedetto Varchi paid Michelangelo one of those compliments to which the Renaissance was addicted:*
"Signor Buonarroti, you have the brain of a Jove."
The sculptor, always uncomfortable at flattery, surprised his friend with the rejoinder:
"But it takes the hammer of Vulcan to get anything out of it."

 [Vasari]

513. *Someone, praising a contemporary architect to Michelangelo, raved,*
"He has great genius."
Michelangelo assented,
"That's true enough. But he has poor judgment." [Vasari]

514. *Michelangelo's comment when shown some drawings made by a youth of whom it was explained, "And he's been studying for just a short time."*
"That's obvious!" [Vasari]
Actually this was the very reply he made when told that Vasari's paintings in the Sala della Cancelleria had been executed in just a few days.

515. *Michelangelo painted his famous and scandalous* Leda and the Swan *at the behest of the Duke of Ferrara. When the agent arrived to pick up the purchase, he eyed it for a while and then remarked that this was "trifling stuff" to turn over to a duke.*
The artist turned a withering eye on him and inquired,
"What, pray, is your business."
"A merchant," replied the agent.
Michelangelo on several occasions expressed his scorn for merchants, scarcely knowing that one day his body would be packed and sent from Rome to Florence in a merchant's packing crate. On this occasion he burst forth,
"This time you've done some bad merchandising for your lord. Now, get you hence!" [Armenini]

516. *A comic letter of recommendation:*

 Florence, June, 1520
Monsignor,—I beg your most reverend Lordship, not as a friend or servant, for I am not worthy of being either, but as a low, poor, and crazy man, that now that Raphael is dead you have Sebastiano del Piombo, the Venetian painter, share in the works of the Palace. And if it should seem to your Lordship that kind offices are wasted on a man like me, I am of the opinion that on certain rare occasions one may find some satisfaction in being kind even to fools: in the same way that a man who is tired of eating capons, for the sake of a change in diet finds pleasure in eating onions. You do favors to important men every day: I beg your

Lordship to try to do a favor to me; it will be a very great favor, and the said Sebastiano is a talented man. If your favor should be wasted on me, it will not be on Sebastiano, for I am certain that he will prove a credit to your Lordship.

517. *Puns are common enough in Michelangelo's poetry. Punning was a habit he learned earliest from his master Petrarch, and like Petrarch, he punned especially on the names of his friends.*

Tommaso Cavalieri: I remain prisoner of an armed Cavalier. [G 98]

518. *Febo di Poggio:* Phoebus's beautiful face, and . . . the hill [*poggio*] where I fall to my ruin. [G 100]

519. *Febo di Poggio:* At that time when Phoebus [Febo] was scorching the lofty hill [*poggio*]. [G 99]

520. *Clement VII (de' Medici):* To the greatest Medico of our ills.
[G 85]

521. *Monsignor Pietro Carnesecchi:* Meat [*carne*] which in salt is purged and stretched. [G 85]

522. *Faustina Lucia Mancini:* If with her right hand she had defended herself, she would have escaped; but she did not, being left-handed [*mancina*]. [G 177]

523. *Ceccchino de' Bracci:* Here the arm [*braccio*] stretched out, to gather bitter fruit. [G 222]

524. Better were it to be of the feet and escape, than of the arms [*dei bracci*] and make no offense against it. [G 184]

525. *Pope Julius II [the Pope's name Della Rovere means "of the oak"]:*

> . . . since one is asked
> To gather fruit from a tree [an oak] that is withered. [G 6]

THE TORTURED SOUL

526. Upon your faith, stop reasoning about matters dealing with me, however true or false may be all that you affirm about me! [Giannotti]

15 March, 1560
527. Know that the greatest annoyance which I have in Rome is to answer letters.

Undated, 1543

528. Messer Luigi my Lord,—I know that you are as much a master of
ceremonies as I am alien to them. . . . In my name thank Cardinal Cesi
with that ceremony which comes so easily to you and so hard to me. . . .

529. *Michelangelo's unwillingness to spend precious time in social gath-
erings is clear from direct testimony recorded by both Francisco de Hol-
landa and Donato Giannotti:*

I do not promise you yet that I shall come to dinner. I prefer to stay
by myself, because when I find myself in these companies, as would
happen if I dined with you, I become too gay, and I don't wish to re-
joice too much. . . . I tell you that in this world it's better to weep.
[When you say that Nature invites us to laugh], you are in great error,
and to show you that you've spoiled your own case with this argument
you've advanced to persuade me to come to dinner with you, know that
I am the man more disposed than anyone in the world to love people.
Whenever I see some one who possesses some virtue, who shows some
quickness of genius, who can do more, say something more fittingly than
others, I am constrained to fall in love with him, and I give myself to
him as booty, for I am no longer my own, but all his. If, then, I came
to dine with you who are all endowed with virtues and gentilities, be-
yond that which each one of you three here has robbed from me, each
of those present at the dinner would take a share from me. The musician
would take another part from me, the dancer another, and thus each of
the others present would have his share. So that, believing that I was,
as you say, through rejoicing recovering and refinding myself, I should
be quite diminished and lost: for many days after I should not know
in which world I was. . . . [Giannotti]

530. There are many persons who maintain a thousand lies, and one is
that eminent painters are eccentric and that their conversation is intol-
erable and harsh. They are only human all the while, and thus fools and
unreasonable persons consider them fantastic and fanciful, allowing them
with much difficulty the conditions necessary to a painter. It is quite true
that such conditions are necessary only when there is a real painter, to
be found in very few places, as in Italy, where there is perfection in
things. But foolish, idle persons are unreasonable in expecting so many
compliments from a busy man. Few mortals fulfill their duty well; one
who does will not accuse another who is fulfilling his. Painters are not
in any way unsociable through pride, but either because they find few
pursuits equal to painting, or in order not to corrupt themselves with the
useless conversation of idle people, and debase the intellect from the lofty
imaginings in which they are always absorbed. And I affirm to your Ex-
cellency that even his Holiness annoys and wearies me when at times he

talks to me and asks me somewhat roughly why I do not come and see him, for I believe that I serve him better in not going when he asks me, little needing me, when I wish to work for him in my house. And I tell him that, as Michelangelo, I serve him better thus than by standing before him all day, as others do. . . .

If perchance a man were so blind as to invent such an unprofitable exchange, as it is for a man to separate himself and content himself whilst he loses his friends and makes enemies of all, would it not be very wrong if they bore him ill will for that? But whoever has such a complexion both because the force of his duty demands it, and because of his having been born with a dislike of ceremony and dissimulation, it seems very foolish not to allow him to live. And if such a man is so moderate that he wants nothing of you, what do you want of him? And why should you wish to use him in those vanities for which his quietness is not fitted? Do you not know that there are sciences which require the whole man without ever leaving him free for your idle trivialities? When he has as little to do as you have, let him be killed if he does not observe your rules of etiquette and compliment even better than you. You seek his company and praise him only in order to obtain honor through him for yourselves, nor do you really mind what sort of man he is, so long as a pope or an emperor converse with him. And I dare affirm that he cannot be a great man who tries to satisfy idle persons rather than the men of his own craft, nor can one who is in no wise singular and reserved or whatever you may be pleased to call it, be better than the ordinary and vulgar talents which are to be found without a lantern in the market places of the world. [De Hollanda] (Holroyd)

531. *The same propensity for solitude so frequently obvious from Michelangelo's behavior and spoken words shines forth in this piece rather freely translated by Southey.*

NON SEMPRE A TUTTI . . .

Ill hath he chosen his part who seeks to please
The worthless world—ill hath he chosen his part,
For often must he wear the look of ease
 When grief is at his heart;
And often in his hours of happier feeling
With sorrow must his countenance be hung,
And ever his own better thoughts concealing
Must he in stupid grandeur's praise be loud,
And to the errors of the ignorant crowd
 Assent with lying tongue.
Thus much would I conceal that none should know
What secret cause I have for silent woe;

And taught by many a melancholy proof
That those whom fortune favors it pollutes,
I from the blind and faithless world aloof,
Nor fear its envy nor desire its praise,
But choose my path through solitary ways.

(—1544) (Southey)

532. *Michelangelo advised a sculptor not to worry over the lighting of a statue, for the crowd is the final arbiter:*

Don't fret, for the important thing will be the light of the square!

[Vasari]

533. *From a letter to his nephew, 25 August, 1541:*

. . . I advise you once again, don't come down here before Lent of next year, because this September I'll not have time even to talk to you, and especially since Urbino, who's staying with me, is going this September to Urbino, and is leaving me here greatly annoyed. That's all I'd need, to have to cook for you two! . . . And learn how to write, for it seems to me that thou art getting even worse.

[1542]

534. Messer Luigi,—He who is poor and has no one to serve him makes blunders of this sort. Yesterday, I could neither come nor reply to your invitation, because my brigade came back to the house at night. I apologize to you, therefore, and to Messer Silvestro [Da Montauto], and give my best to Cecchino.

May 1525

535. My dear Sebastiano,—Yesterday Our Captain Cuio and certain other gentlemen insisted, graciously, that I go to dinner with them; I took much pleasure from this, for I issued forth for a bit from my melancholy, or rather my madness. I took pleasure not only from the dinner which was most pleasing, but I derived even more than that from the reasonings which went on there.

536. *After asking his friend Luigi del Riccio to adjudicate an argument between two artisans, Michelangelo writes out a full statement of his own grievances arising from the dispute, adding:*

July, 1542

. . . Messer Luigi, I have set down this speech in writing to your Lordship, because if I spoke it by mouth with the men present I should scatter myself as they do, and I'd not have enough breath left to speak.

21 August, 1563

537. Lionardo,—I see from thy letter that thou hast lent thine ear to certain envious and rascally persons who, finding they can neither rob nor deceive me, have written thee a pack of lies. They are a gang of greedy robbers, and thou art a fool to listen to what they tell thee about me, as though I were a baby. Drive them from thy sight, like the envious scandal-mongers and evil livers they are. As to the unsatisfactory manner in which I am being looked after and the other things of which thou writest, I tell thee I could not possibly be better cared for, nor served more faithfully nor tended more satisfactorily than I am at present. As to my being robbed—for this I suppose is what thou wouldst imply— the people I have in the house are all persons in whom I can trust, and with whom I can live tranquilly. Therefore, look to thine own way of living and do not trouble about my affairs, for I know how to look after myself if necessary, and am not a child. Take care of thy health.

538. *Michelangelo's dowering of young girls on one occasion met the opposition of a hostile brother who had perhaps listened to unsavory rumors about the artist's mode of living:*

Be it known that on the first day of January, 1554, I Michelangelo have taken into my house, intending to find her a husband, a daughter of Michele, the pork butcher of the Macello de' Corvi, her baptismal name being Vincenzia. I am taking her on the following understanding, that if during the next four years she shall behave well in all things concerning the welfare of both body and soul, I will give her a marriage portion of fifty gold crowns in gold at the end of that period; and I undertake further that the said marriage portion shall be made a charge upon good security. As a guarantee of which I, Michelangelo, have made this memorandum with my own hand . . .

. . . And to-day, the 26th day of September, 1555, there came to my house Iacopo, the brother of the said Vincenzia, and threatening to use force against Urbino, who was ill and in bed, took her out of my house and led her away. This was witnessed by Messer Roso de Rosi of Castello Durante and by Dionigio, who were employed in St. Peter's, as well as by other persons.

Florence, 1516

539. Most dear Father, . . . Now, on hearing that you are mourning about me and claiming that I chased you out of our house, I am astounded. . . .

October, 1542

540. Monsignore, . . . Among men, I don't say before God, I consider myself a man of honor; I never cheated anyone, and yet in defending myself from louts, it is necessary at times that I become crazy, as you see.

13 February, 1557

541. Lionardo, . . . As for the Vatican workshop's being closed, this isn't true, for as anyone can see, we still have working there sixty stone-cutters, masons, and laborers, and with hope of continuing.

July 1508

542. Giovan Simone,—They say that if one does good to a good man it makes him better, but if one does it to a bad man he becomes worse. I have been trying for many years with good words and deeds to make you live honestly and peacefully with your father and with the rest of us: but you are getting worse all the time. I do not say that you are a scoundrel, but you behave in such a way that neither I nor the others like you any more. I could tell you many things about your behavior, but I would only repeat what I have told you before. To put it briefly, I can tell you for a fact that you have nothing in this world; for some time I have been paying your expenses and lodging for the love of God, believing you to be a brother of mine like the others. Now I am convinced that you are not my brother, for if you were you would not threaten my father; on the contrary, you are a beast, and I will treat you as such. I want you to know that he who sees his own father threatened or struck is held to defend him with his own life. But enough of that. I tell you that you haven't a thing in the world: and if I hear the slightest report about your goings on, I will come by the post and show you how wrong you are, and I will teach you to destroy your property and set fire to the houses and farms you have not got by your own effort: you are not where you think you are. If I come there, I will open your eyes to things that will make you shed bitter tears, and I will make you see on what you base your pride.

I want to say this once more: if you will strive to do good and to honor and respect your father I will help you like the others, and presently I will have a good shop set up for all of you. If you don't, I will come and make you realize better than ever before what you really are; and you will know what you really have in this world, and will realize it wherever you may go. That is all. What I lack in words I will make up with deeds.

. . . I cannot help adding a few more lines: to say that for the last twelve years I have been drudging all over Italy; I have borne every shame; I have endured every hardship; I have lacerated my body with every sort of hard work; I have exposed my life to a thousand dangers; simply in order to help my family. And now that I have begun to improve the conditions of my family a little, that you alone should be the one to upset and ruin in one hour what I have done in so many years and with so many hardships! By Christ's body this shall not be! I will rout ten thousand like you if need be. Be wise, and do not tempt someone who has other worries. (Speroni)

543. Thou hast sent me the measure of a *braccio* in brass as though I were a mason or a carpenter and wanted to carry it about with me. I was ashamed to have the thing in the house, and have thrown it away.

(Carden)

544. *When Michelangelo fell ill in July, 1544, his nephew came all the way from Florence to see him—apparently in vain—and reaped the following harvest of anger.*

Lionardo,—I've been ill. And thou, at the instances of Ser Giovan Francesco camest to put me to death and to see if I was leaving thee anything. Why, hast thou not enough of my property there in Florence to satisfy thee! Thou canst not deny that thou resemblest thy father, who in Florence drove me out of my own home. Knowest then that I've made out my testament in such a way that thou needest no longer worry about what I have in Rome. So go thou the ways of God and don't ever come before my eyes again and write me no more, and do as the priest does.

545. *The following lines are a wonderful example of the old artist's fury at those who (as he imagines) are born with a silver spoon and presume to cling to him like sucking sponges:*

6 February, 1546

Lionardo,—Thou hast been very hasty in giving me particulars of the Corboli property: I did not even know thou hadst reached Florence. Art thou afraid I might repent, as perhaps thou hast been told I should? I tell thee I intend to go slowly, for thou who wast born with shoes to thy feet and a coat to thy back couldst never realize how much labor the money I have earned has cost me.

And as to thy having come to Rome in such hot haste, I do not know if thou wouldst have been so prompt if I had been in want and misery. It is enough for thee to throw away money thou hast not earned. How anxious thou art not to lose thine inheritance! And then to say it was thy duty to come for the love thou bearest to me—thy love is the love of the wood-consuming maggot! If thou hadst loved me in very truth thou wouldst have written to me after this manner: "Michelangelo, spend the 3,000 crowns on yourself in Rome, for you have given us so much that we already have sufficient for our needs. We have more care for your person than for your property."

Ye have been living on me for the past forty years, and I have never received from you even so much as a good word.

It is true that last year thou wert so rebuked and scolded that for very shame thou wast constrained to send me a load of Trebbiano; I wish now thou hadst not sent even that!

I do not write this because I have no desire to buy. I intend to do so for myself so as to secure an income, for I cannot do any more work. But I wish to go slowly, so that I may not buy fresh anxieties. Therefore, be not in a hurry. (Carden)

13 October, 1550

546. Dear Giorgio, dear my Lord,—As soon as Bartolommeo [Ammannati] had arrived here, I went to speak with the Pope. And since he wanted to build a new foundation at Montorio for the sepulchers, I provided him with a stonemason from St. Peter's. Old Know-it-all [Bishop Aliotti] got wind of it, and wanted to send one of his own. I, refusing to combat with people who wish to make the winds move, withdrew from the affair, and since I am a light man, I don't want to be blown into that mess. Suffice to say that there's no need to think any more about the church for the Florentines. Return soon and sound.

5 June, 1546

547. Lionardo,—I have had the note of the power of attorney copied out just as it reached me. I have authorized thee to act as my representative, and I send thee herewith the authorization. Have it examined for thyself, and if it is sufficient for thy purpose, it is sufficient for mine—I have other things to think of besides powers of attorney. Do not write to me again: every time one of thy letters arrives I get an attack of the fever because of the trouble I have to read it! I cannot think where thou has learnt to write. I believe that if thou hadst to write to the greatest donkey in the world thou wouldst write with more care than thou dost to me. Therefore, do not add another to the troubles I have already, for I have enough to content me. . . . (Carden)

August, 1548

548. Lionardo,—Since I knew not how nor could read your last letter, I threw it in the fire. I cannot therefore answer it in any way. I have written you several times that whenever I receive one of your letters I take a fever before I've learned how to read it. Therefore, from now on I tell you not to write me any more, and if there's anything you wish me to know, employ somebody who knows how to write, for I have my mind on other matters than to keep working myself into a spasm over your letters. . . .

549. *When Luigi del Riccio, the friend who intended to publish a florilegium of Michelangelo's poetry, ran off some unidentified "print" without the artist's permission, Michelangelo wrote him an angry letter and an angry sonnet. Perhaps this "print" (stampa) involved Michelangelo's fifty poems on the death of the fifteen-year-old Cecchino Bracci, Riccio's protégé and the old artist's idol.*

NEL DOLCE D'UNA IMMENSA CORTESIA . . .

Oft in the bosom of sweet courtesy
There lurks a sword, that striketh unawares
Honor and life: beside such hurt appears
Less dear the gift of health thou gavest me.
Who maketh swift the feet, and then doth spread,
Straight in the path, a net concealed from sight,
He quenches, when it fain would burn most bright,
The flame of gratitude by love that's fed.
Then, my Luigi, free from all alloy
Keep thou that love to which my life I owe,
That so the winds of wrath disturb it not,
For wrath fair kindness' image doth destroy.
If ought I know of friendship, this I know:
A thousand joys are in one grief forgot.
 (1544/46) (Elizabeth Hall)

550. *Michelangelo's ire toward Riccio is expressed in prose as well as poetry.*

[1544/46]

Messer Luigi,
 You seem to think that I shall reply according to your wishes when the case is quite the contrary. You give me what I have refused, and refuse me what I begged. And it is not ignorance which makes you send it to me through Ercole, when you are ashamed to give it to me yourself.
 One who saved my life has certainly the power to disgrace me. But I do not know which is the heavier to bear, disgrace or death. Therefore I beg and entreat you, by the true friendship which exists between us, to destroy that print and to burn the copies which are already printed. And if you choose to buy and sell me, do not do so to others. If you hack me into a thousand pieces, I will do the same, not indeed to yourself, but to what belongs to you.
 Not painter, nor sculptor, nor architect, but what you will; but not a drunkard, as I said to you at home. (Symonds)

Serravezza, August, 1518
551. Buonarroto,—Only two of the stone-cutters who came here, Meo and Ciecone, still remain: the others came and then went away. When they arrived I gave them four ducats, and I promised to keep them supplied with money for the means of subsistence so that they might be able to do all I wanted. They worked only for a few days, in a half-hearted manner, with the result that that scoundrel of a Rubechio nearly spoiled a column I have excavated. But I am still more annoyed that they should

come there [to Florence] and give both me and the quarries a bad name, in order to clear their own reputation; for if I should require workmen later on I shall not be able to get them. I wish at least, seeing they have cheated me, that they would keep their mouths shut. Therefore I ask thee to make them keep silence by holding some threat over their heads; threaten them with Iacopo Salviati, or anything that is likely to be effective, for these greedy knaves are doing great harm to the work and to me.

(Carden)

January, 1510

552. Most Revered Father, . . . I shall not have any work done until this agreement is drawn up. Please tell him [Bernardino] how the matter stands. About the boy that came—that scoundrel of a muleteer swindled me out of a ducat, and swore that he had agreed for two broad ducats of gold: and all the other boys who come here with muleteers receive no more than ten *carlini*. I was more angry about it than if I had lost twenty-five ducats, for I see that it was the father's fault, who wanted to send him on muleback in state. Oh, I never had such luck, not I! And more than that, both the father and the lad assured me that he would do anything, look after the mule and sleep on the ground if necessary; and now I have to look after him instead. As if I wanted other vexations besides those I have had since I came back! I have had the boy I left here ill ever since my return. He is getting better now, it is true, but he has been at death's door and was given up by the doctors for about a month, and during all that time I have not been to bed, to say nothing of other troubles. Then there comes this dry-turd of a boy, who says that he does not want to lose time and that he wants to learn. When he was in Florence he said that two or three hours a day would be sufficient: now the whole day is not enough and he wants to be drawing all night as well. His father has put him up to this. If I were to say anything to him he would declare that I did not wish him to learn. I wanted somebody to look after the house; and if he was not prepared to do this they ought not to have put me to this expense. But they are schemers, and working for their own ends: but enough. I beg you to have him fetched away, for he annoys me to such an extent that I can bear him no longer. The muleteer has received so much money that he can very well afford to take him back again: he is a friend of his father's. Tell the father to send for him. I shall not give him another *quattrino*, for I have no money. I will put up with him until he is sent for, but if they do not send for him I shall dismiss him although I told him to go away the second day he was with me, as well as afterward on several occasions, and he does not realize it. . . .

. . . If you should meet the boy's father, explain the matter to him gently: tell him he is a good lad but too refined, and not suited for my work, and that he must send for him. (Carden)

21 December, 1518

553. I have here ready to use a beautiful studio, where I can set up twenty figures at the same time; but I can't put a roof over it for there is no lumber in Florence and it won't come if it rains. I don't think it will ever rain again except to do me harm.

Postscripts to nephew Lionardo:

Rome, 9 May, 1545

554. I tell you again, when anything is written to you as coming from me, don't believe it unless there is a line of my handwriting.

Rome, 6 February, 1546

555. When someone up there tells you or asks you something in my name, if you don't see a line of my handwriting, don't believe anybody.

25 January, 1549

556. Lionardo,—About that cheese you sent me, I got the letter, but I never got the cheese. I think that the muleteer who brought it from there sold it to someone else, because I sent several times to the Custom house for it. Said muleteer invented many stories and said so many words, that he got off. So that I suspect that he is a scamp. Don't send me anything further, for it's more annoyance than of any use to me.

11 April, 1556

557. Lionardo,—Thou didst uncommonly well to give that cloth to such a scoundrel. I have been waiting a month for it here, and as I told others it was on its way there is the greatest disappointment at its non-arrival. I beg of thee to find out what that scoundrel of a muleteer has done with it, and if thou recoverest it send it here as quickly as possible. If it cannot be found, and if thou canst get hold of the man, have the thieving rascal beaten, make him pay back the money and send me another seven spans. As if I had not sufficient troubles without this! I have had, and still have, more worries and annoyances than I could possibly relate.

Florence, March, 1518

558. Domenico [Buoninsegni], . . . I'd never go to Carrara now, because I'd not get the marbles I need in 20 years. Since I've acquired great hostility there because of this business, if I go back to Rome, I'd just have to work with bronze, as we said together. I inform you that the Workers of Santa Maria del Fiore have made great designs on this lot of marbles, after they were leveled by me, and I think they've already set the prices and excise taxes and other steps, and that the notaries, arch-notaries, purveyors, and sub-purveyors have already thought of doubling the take of swine-fat in that district. So think about this and do whatever you can that the marbles don't bounce into their hands, for it would be more difficult to get the marbles out of them than out of Carrara.

559. *To get marbles from the quarries to his studio, Michelangelo had even to build roads for their transportation. Nothing was so exasperating as the wait for quarried marbles to arrive by river barge, as testified in a letter from Pisa to his brother Buonarroto:*

Pietrasanta, 18 April, 1518

P.S. Those barges I chartered at Pisa have never arrived. I suppose I was cheated. It is the same with everything I touch. Oh, a thousand curses on the day and the hour that I ever left Carrara! This is the cause of all my ruin. But soon I will return to you. Today it is a sin to do one's duty.

2 July, 1558

560. Lionardo.—I wrote you on receiving the Trebbiano wine and how, without sampling it first, I gave away several bottles, believing it to be of the quality of the other which you have sent me several times. As a result I have felt shame and dismay. If you buy it good up there, then the muleteer must have committed some skullduggery on the way. So from now don't send me anything more, if I don't request it, because everything upsets me.

561. *From a letter written in Rome to the artist's brother Buonarroto, 11 January, 1511:*

. . . Keep my wardrobe locked, so that my clothes don't get stolen like Gismondo's!

562. Have confidence in no one. Sleep with your eyes open.

(CLXXXVII)

563. Don't become friendly or familiar with anybody, except God!

(XCI)

564. *As if forewarned that his brother Buonarroto would die of the plague in 1528, Michelangelo ends his last letter to him (July, 1527) with the urgent postscript:*

. . . Don't touch with thy hands the letters I send thee!

565. *Michelangelo, who seldom had the leisure to get out into the countryside, views the rustic life as a primitive Golden Age, free from the vices and vexations of the cities. In such a milieu he could throw off the anguishes, irritations, fears, angers, and mistrusts so much in evidence in this section:*

NUOVO PIACERE E DI MAGGIORE . . .

And sweet it is to see in summer time
The daring goats, upon a rocky hill,
Climb here and there, still browsing as they climb,
While, far below, on rugged pipe and shrill
The master vents his pain; or homely rhyme
He chaunts; now changing place, now standing still;
While his beloved, cold of heart and stern!
Looks from the shade in sober unconcern.

Nor less another sight do I admire,
The rural family round their hut of clay,
Some spread the table, and some light the fire
Beneath the household rock, in open day;
The ass's colt with baskets some attire;
Some tend the bristly hogs with fondling play;
This with delighted heart the old man sees,
Sits out of doors, and suns himself at ease.

The outward image speaks the inner mind,
Peace without hatred, which no care can fret;
Entire contentment in their plough they find,
Nor home return until the sun be set:
No bolts they have, their houses are resign'd
To Fortune—let her take what she can get.
A hearty meal then crowns the happy day,
And sound sleep follows on a bed of hay.

In that condition Envy is unknown,
And Haughtiness was never there a guest.
They only crave some meadow overgrown
With herbage that is greener than the rest;
The plough's a sovereign treasure of their own;
The glittering share, the gem they deem the best;
A pair of panniers serves them for buffette;
Trenchers and porringers for golden plate. . . .

They in old time who drank the streamlet clear,
And fed upon the fruits which Nature sent,
They should be your example, should appear
Beacons on which your eyes should still be bent:
O listen to my voice with willing ear!
The peasant with his herds enjoys content,
While he who rules the world, himself unblest,
Still wants, and wishes, and is not at rest. . . .

Milk, herbs, and water, always at command,
The peasant recks not of superfluous stores;
He counts his gains upon his callous hand,
No other book is needed for his scores:
Troubled with no accounts of ships or land,
No usurer's guiles he suffers and deplores;
He knows not in the world that such things be,
Nor vainly strives with fortune, no, not he!

If the cow calved, and if the yearling grew,
Enough for all his wishes fortune yields:
He honors God, and fears and loves Him too;
His prayers are for his flocks and herds and fields;
The doubt, the how, the why, that fearful crew,
Disturb not him, whom his low station shields,
And favor'd for his simple truth by Heaven,
The little that he humbly asks, is given. . . .

 (1534) (William Wordsworth)

566. *A fragmentary escapism into peaceful nature:*

To the sweet murmur of a little stream
Which a limpid shadow casts into green shade. . . . (G App. 5)

567. *On his return from Spoleto in 1556, Michelangelo wrote to Vasari:*

With considerable difficulty and expense I have had during these days
a great enjoyment in the mountains of Spoleto, visiting these hermit
monks. As a result less than half of me has returned to Rome. For truly
one cannot find peace except in the woods.

THE VISIONARY

568. *Michelangelo was flight-prone—to Bologna in 1494, to Florence in
1506, and to Venice in 1529. We do not have Michelangelo's exact words
about the flight to Bologna but Condivi quotes him as believing after
hearing of two dreams of one Andrea Cardiere that "one was no longer
safe in Florence" at that date.*

 Florence, 2 May, 1506
Giuliano,—I learn from a letter sent by you that the Pope was angry at
my departure, that he is willing to place the money at my disposal and to
carry out what was agreed upon between us; also, that I am to come back
and fear nothing.
 As far as my departure is concerned, the truth is that on Holy Saturday
I heard the Pope, speaking at table with a jeweler and the Master of the
Ceremonies, say that he did not want to spend another *baiocco* on stones,

whether small or large, which surprised me very much. However, before I set out I asked him for some of the money required for the continuance of my work. His Holiness replied that I was to come back again on Monday: and I went on Monday, and on Tuesday, and on Wednesday, and on Thursday—as His Holiness was aware. At last, on the Friday morning, I was turned out, that is to say, I was driven away: and the person who turned me away said he knew who I was, but that such were his orders. Thereupon, having heard those words on the Saturday and seeing them afterwards put into execution, I lost all hope. But this alone was not the whole reason of my departure. There was also another cause, but I do not wish to write about it; enough that it made me think that, if I were to remain in Rome, my own tomb would be prepared before that of the Pope. This is the reason for my sudden departure. . . .

(Carden)

569. *Of the sudden flight from besieged Florence in 1529 he explained:*

Venice, 25 September, 1529

Batista [Della Palla], dear friend,—I left Florence, as I think you know, meaning to go to France; but when I arrived in Venice and inquired the way, I was told that to get there I should have to pass through German territory and that the way was both difficult and dangerous. Therefore I think it well to ask you, at your pleasure, whether you are still of a mind to go; and I beg of you to go. I entreat you to let me know what you have decided, and to say where you wish me to wait for you, and we shall travel together. I came away without saying a word to any of my friends and in great confusion. Although, as you know, I wanted in any case to go to France, and had frequently asked permission to go, which I never received, I had intended to remain in Florence until the end of the war, having no fears for my own safety. But on Tuesday morning, the 21st of September, a certain person came out by the Gate at San Nicolò while I was engaged in inspecting the bastions, and whispered in my ear that I must remain there no longer if I valued my life. He accompanied me to my house, dined there, brought me horses, and never left my side until he had got me out of Florence, declaring that it was for my good that he so acted. Whether it was God or the devil I cannot say. . . .

(Carden)

570. *Poetic vision:*

I am pleased to tell you why it is usual to paint that which was never seen in the world, and how right such license is, and how true it is, for some who do not understand him are accustomed to say that Horace, a lyric poet, wrote this verse in abuse of painters [Michelangelo quotes the verses in Latin]:

Painters and bards, you'll say, the world agrees,
Are free to dare whatever flights they please.

This verse does not in any way insult painters, but rather praises and honors them; for it says that poets and painters have power to dare, I mean to dare to do whatever they may approve of; and this good insight and this power they have always had, for whenever a great painter (which very seldom happens) does a work which appears to be false and lying, that falsity is very true, and if he were to put more truth into it it would be a lie, as he will never do a thing which cannot be in itself, nor make a man's hand with ten fingers, nor paint on a horse the ears of a bull or the hump of a camel, nor will he paint the foot of an elephant with the same feeling as for that of a horse, nor in the arm or face of a child will he put the senses of an old man, nor an ear nor an eye out of its place by as much as the thickness of a finger, nor is he even permitted to place a hidden vein in an arm anywhere he likes; for such things as these are very false. But should he, in order better to retain the decorum of the place and time, alter some of the limbs (as in grotesque work, which without that would indeed be without grace and therefore false) or a part of one thing into another species such as to change a griffin or a deer from the middle downwards into a dolphin, or from thence upwards into any figure he may wish, putting wings instead of arms, putting off arms if wings suit it better, that limb which he changes, whether of a lion, horse or bird, will be quite perfect of the species to which it belongs; and this although it may appear false can only be called well imagined and monstrous. The reason is that it is better decoration when, in painting, some monstrosity is introduced for variety and a relaxation of the senses and to attract the attention of mortal eyes, which at times desire to see that which they have never yet seen, nor does it appear to them that it can be more unreasonable (although very admirable) than the usual figures of men or animals. And so it is that insatiable human desire took license and neglected at times buildings with columns and windows and doors for others imitated in false grotesque, the columns of which are made of children springing from the leaves of flowers, with the architraves and summit of branches of myrtle and gates of canes and other things, which appear to be very impossible and out of reason, and yet all this is very grand if done by one who understands it.

[De Hollanda] (Holroyd)

571. *Michelangelo tries to recall to Vasari his original conception of the stairway of the Laurentian Library in Florence, but his recollection is like a distorted dream:*

28 September, 1555

Dear Messer Giorgio,—As to the stairway of the Library, about which people have spoken so much to me, believe me, that if I could remember how I had ordered it, I'd not have to be begged. A certain stair comes clearly back to mind as in a dream, but I don't believe that it is just what I thought up at that time, because it reappears as a crude thing. Yet I'll try to describe it forthwith. . . .

572. *Two visions of giants are recorded in the poetry:*

E SON GIGANTI . . .

Giants they are of such a height
that each it seems doth take delight
in mounting to the sun, to be blinded by its light.

(—1534)

573·

UN GIGANTE V'È ANCOR . . .

A giant there is of such a height
that here below his eyes do see us not. . . .
He yearns for the sun and plants his feet
on lofty towers in order heaven to attain.

(—1534)

VII. OLD AGE AND DEATH

 Michelangelo would have us believe that he was old long before his time. About 48 years before the event, he was writing in a madrigal of his "propinqua morte" (imminent death). In 1516-18 he claimed to Domenico Buoninsegni that he was an old man. One assumes that his fear of death, which swept before it every thought of "art and genius," haunted him for decades—a theme complementary to that of senescence in his writing. His letters and poems betray the anxieties which increasing age brought to him: added pressures and responsibilities, pains and maladies, weakness and failing sight, and indeed the reduction of judgment which characterizes one in his second-childhood (rimbambito). Age meant a less judicious attitude in the habits of sex and love for, as he put it, a withered log catches fire more easily than a green one. Yet the greatest anxiety occasioned by the thought and certainty of death was his unworthiness to be judged at the approaching Day of Wrath. He began to view Death as a Gothic Grim Reaper, cutting down humanity like blades of hay. He was convinced that every day which passed made a man less worthy of salvation. "He who lives least returns happiest to heaven." His own regretted longevity made him most uneasy and he saw his nineties approach with an almost anguished certainty that his redemption was unlikely. Thus, some of his poetry, like his fresco of the Last Judgment *itself, becomes most reminiscent of the medieval hymn, the* Dies Irae. *Art and fame avail naught and only Christ can grant him the power to rise like the phoenix from his ashes.*

DEFEAT, WITHDRAWAL, AND NAUSEA

574·

TORNAMI AL TEMPO . . .

Oh give me back the days when loose and free
To my blind passion were the curb and rein,
Oh give me back the angelic face again,
With which all virtue buried seems to be:
Oh give my panting footsteps back to me,
That are in age so slow and fraught with pain,
And fire and moisture in the heart and brain,
If thou wouldst have me burn and weep for thee!
If it be true thou livest alone, Amor,

168

The Boatman Charon and Damned Souls (Rome, Vatican, Sistine Chapel, Last Judgement)
As if already numbered among the dead. (*see page 174*)

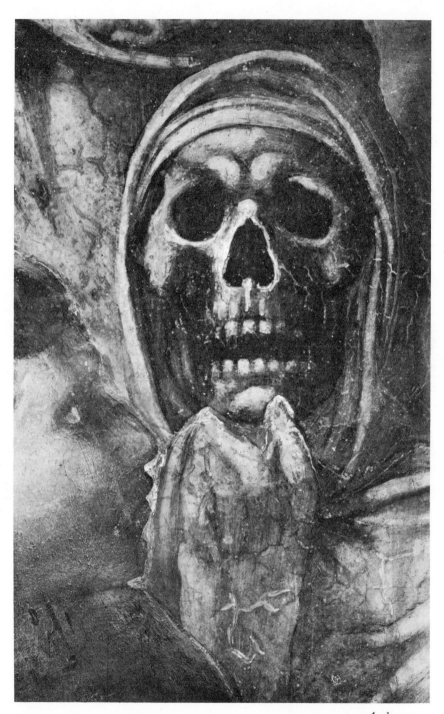

Anderson

Death's Head (Rome, Vatican, Sistine Chapel Last Judgement)

Once were our eyes whole
With pupils in their sockets;
Now they are empty, horrid and black . . . (*see pages 175–176*)

On the sweet-bitter tears of human hearts,
In an old man thou canst not wake desire;
Souls that have almost reached the other shore
If a diviner love should feel the darts,
And be as tinder to a holier fire.

(1547) (H. W. Longfellow)

Rome, [17] August, 1557

575. Messer Giorgio, . . . My memory and brain have gone off to wait for me elsewhere.

576. *One of the most pathetic sonnets of Michelangelo's old age plays with the* vanitas vanitatum *theme. The aged artist who has won all available honors and raised the dignity and prestige of his craft to its highest level comes to the late realization that even that art which he had made his "idol and monarch" was a vanity and a delusion. Of the several poets who have translated this piece, including Wordsworth, it is again Longfellow who achieves the most faithful of the Englishings in rhyme.*

GIUNTO È GIA 'L CORSO . . .

The course of my long life hath reached at last,
In fragile bark o'er a tempestuous sea,
The common harbor where must rendered be
Account of all the actions of the past.
The impassioned fantasy, that, vague and vast,
Made art an idol and a king to me,
Was an illusion, and but vanity
Were the dreams that lured me and harassed.
The dreams of love, that were so sweet of yore—
What are they now, when two deaths may be mine,
One sure, and one forecasting its alarms?
Painting and sculpture satisfy no more
The soul now turning to the Love Divine,
That oped, to embrace us, on the cross its arms.

(1552) (H. W. Longfellow)

577.

CONDOTTO DA MOLT'ANNI . . .

Borne to the utmost brink of life's dark sea,
Too late thy joys I understand, O earth!
How thou dost promise peace which cannot be,
And that repose which ever dies at birth.
The retrospect of life through many a day,

Now to its close attained by Heaven's decree,
Brings forth from memory, in sad array,
Only old errors, fain forgot by me—
Errors which e'en, in long life's erring day,
To soul-destruction would have led my way.
For this I know—the greatest bliss on high
Belongs to him called earliest to die.

<div align="right">(1536/46) (Fanny Elizabeth Bunnett)</div>

578.

LE FAVOLE DEL MONDO . . .

Earth's work and toys have occupied, amused
Years granted me on God to meditate;
Not only I forgot Him in that state,
But e'en His favors I for sinning used.
And what made others wise in me infused
But folly, making me perceive it late;
Now, though my wishes grow, my hopes abate,
That from self-love I may by Thee be loosed.
But shorten Thou, dear Lord, the road from earth
To heaven, advancing me by grace half-way;
By Thy aid only can I so far rise.
Grant me to spurn all here of greatest worth,
Those beauties that I honor most and prize;
Ere death give earnest of eternal day.

<div align="right">(1555) (Warburton Pike)</div>

579.

QUAND' IL SERVO IL SIGNIORE . . .

When some poor slave, bound by a cruel chain,
Doth many days a hopeless prisoner lie,
Use doth so mate him with his misery,
He scarce desireth to be free again.
Use doth the tiger and the snake restrain,
And quell the forest-king's ferocity:
And who in some new craft his skill would try,
Redoubled power he shall by practice gain.
But not with this the form of fire agrees:
For though the green branch it in ashes lay,
It heats the old dead wood, and nourishes;
And sets the feet of age in youth's green way,
Rekindling it with life, and joy's increase,

Till heart and soul love in his robe array.
 Whoso doth jest, and say
That this unto a hoary head were shame,
To love God's likeness, doth a lie proclaim;
 Nor is that soul to blame
Which, undeluded, nature's child doth love,
If it keep measure, and in limits move.
 (1524) (Elizabeth Hall)

580.

MENTRE M'ATTRISTA . . .

Much it afflicts, and yet it soothes my mind
To dwell upon each thought of Time gone by,
Which memory recalls; though reason mourns
Th' irreparable ill of wasted hours.
It soothes me, when the thought of death suggests
How brief, how transient, is each human joy;
It grieves me since I scarcely dare to hope
Pardon and grace, thus late, for all my sins.
Despite thy promises, O Lord, 't would seem
Too much to hope that even love like thine
Can overlook my countless wanderings;
 And yet thy blood helps us to comprehend
That if thy pangs for us were measureless,
No less beyond all measure is thy grace.
 (1555) (John S. Harford)

581.

OILMÈ, OILMÈ, PUR REITERANDO . . .

Ah, me! ah, me! when thinking of the years,
The vanished years, alas, I do not find
Among them all one day that was my own!
Fallacious hopes, desires of the unknown,
Lamenting, loving, burning, and in tears
(For human passions all have stirred my mind),
Have held me, now I feel and know, confined
Both from the true and good still far away.
I perish day by day;
The sunshine fails, the shadows grow more dreary,
And I am near to fall, infirm and weary.
 (1530) (H. W. Longfellow)

582.

IO VO LASSO, OILMÈ . . .

Tired I go, alas! but do not well know where.
Fear appalls me, for my sand is run,
And winter's frost I feel through all my limbs;
Daily I see my frame decay,
Nor would it aught avail to see it not.
On my state hereafter, Death and the soul hourly dispute;
And if I am not deceived,
One wills that I should go, one that I should stay.
Eternal punishment is mine
If aught I have perverted, or misused the truth;
But in thee, O Lord, I feel my hope is sure.
He who knows not how his will is free
Has no excuse to render, and no gifts to share.

(1530) (Duppa)

October, 1542

583. Messer Luigi, Dear Friend,—Messer Pier Giovanni has been persistently urging me to begin the painting [in the Pauline Chapel]. It may readily be seen, however, that this is impossible for the next four or six days, as the plaster is not yet sufficiently dry for me to begin operations. But there is another thing that vexes me far more than the plaster, something that prevents me from living, to say nothing of painting—I mean the delay in drawing up the release setting aside the contracts for Julius' tomb. I feel that I have been cheated, and as a result I am in a state of desperation. I have wrung from my entrails 1,400 crowns which would have enabled me to work for seven years, during which I could have made two tombs, let alone one: and I did it only so that I might obtain peace and be free to serve the Pope with my whole heart. Now I find myself deprived of the money and face to face with more troubles and anxieties than ever. I did what I did about the money because the Duke [of Urbino] agreed to it, and in order to get the ratification drawn up: now that I have paid the money I cannot obtain the ratification, so that it is easy to guess what all this means without my having to write it down. Enough; it is only what I deserve for having believed in other people for thirty years and for having placed myself freely at their services: painting, sculpture, hard work, and too much faith have ruined me, and everything goes from bad to worse. How much better it would have been if in my early days I had been set to make sulphur matches, for then I should not now be in such a passion! I write thus to Your Lordship because, as one who wishes me well and who knows all about the matter and therefore knows the truth, you can inform the Pope what is happening, and then he may perhaps understand that I cannot live, much less paint. If I promised to begin the work, it was in the expecta-

tion of receiving the said ratification, which ought to have been given to me a month ago. I will not support this burden any longer, nor will I submit to be abused and called a swindler daily by those who have robbed me of life and honor. Only death or the Pope can save me now from my troubles. (Carden)

584. *When old age prevented Michelangelo from going daily to the workshop of Saint Peter's, egregious mistakes resulted.*

17 August, 1557
[To Giorgio Vasari.] The frame on which the vault is constructed, marked in red, was carried by the workmaster right up the body of the vault. Then as they drew near the half-*tondo,* which is in the summit of the vault, he realized the mistake he had made about the frame, as is apparent here in the plan. For he was governing the vault with one frame alone whereas there were to be a number of them, as marked here on the plan in black. Mistakenly the work on the vault went so far ahead that now we have to dismantle a large number of stones, for on the aforesaid vault there is no masonry, but all is to be of limestone. And the diameter of the *tondi* exclusive of the cornice that binds them is 22 palms. This error, after I had made a model especially to guide him, as I do for everything, well, it's the result of my not being able to go there often. And whereas I thought that the vault was now completed, it will not be finished during the whole winter. If it were possible to die of shame and sorrow, I'd not be alive. . . .

585. *By 1560 the complaints of Michelangelo's mismanagement of the Vatican workshop had become so persistent that the aged master began to have doubts about himself. He wrote to Cardinal dei Carpi:*

13 September, 1560
. . . I heard yesterday in what manner Your Lordship had expressed himself as to the building of St. Peter's—that matters could not have gone worse than they have. This deeply pained me, in the first place, because Your Lordship was not informed of the true state of affairs and then because I, as becomes my office, cherish the wish beyond any man on earth, that it should all progress well. But as perhaps my self-interest or my old age deceive me, and I may be doing injury to the building, against my will, of course, I will, as soon as I am able, request His Holiness for my dismissal: indeed, that there may be no delay, I entreat Your Lordship to release me immediately from my labor, which, as you know, I have undertaken for seventeen years without any compensation; and what I have executed in this time is evident to all. I repeat, in granting this request you will be rendering me a great favor; and I tender my humble submission to Your Lordship.

THE FEAR OF DEATH

586. *Michelangelo seemed to be constantly the object of rumors, such as the unusual one he mentions to his father in June, 1508:*

Dearest Father,—I learn from your last letter that I am reported in Florence to be dead, although this is of no great importance, since I'm still alive.

January, 1545

587. I am cured, and I hope to live a few years more now, since Heaven placed my health into the hands of Maestro Baccio [Rontini] and in the Trebbian wine of the Ulivieri vintners.

588.

PER QUAL MORDACE . . .

Under what sharpest file,
O stricken soul, comes wasting and decrease
To thy tired carcass? When will time release
Thee from thy bondage, and restore to heaven,
Where thou wert pure erewhile?
Though my old slough be riven
In these last years, soon sped,
I cannot change my antique habitude
That daily plagues the more, and overpowers.
Love, may I be forgiven,
For that I bear such envy of the dead!
Confounded and subdued,
My soul is fearful for herself, and cowers:
Lord, in my latest hours,
Around me let thy pitying arms be thrown!
Teach me thy will: defend me from mine own.

(1538/41) (Ker)

589. With death nearby
I lose the present, and the future is taken from me. (G 144)

590. As if already numbered among the dead. (G 62)

591. With death at hand and at odds with myself. (G 51)

592. So near to death and so far from God. (G 66)

593. My birth is playing with death. (G 263)

594. Death is the end of a dark prison. [Copied from Petrarch]
(G App. 1)

595. I keep going, alas, alack, I know not where! (G 51)

596. Already with the plow of the other life in hand. (G 42)

597. Once dead man rearises not in the spring. (G 199)

598. Death, whereat I live and eat on credit. (G 267)

599. *Caption to a skeleton with coffin painted on the artist's wall at home:*

IO DICO A VOI . . .

I say to you who have given to the world
Your soul and body and your spirit, too,
This obscure chest is destined just for you.
(1534) (G 110)

600. For I bear envy of the dead. (G 161)

601. For I am undone if I die not soon. (G 267)

602.

Time moves on, and like a loathsome poison
Metes out the hours of our days.
Time is like a scythe and we are like hay.
(G 17)

603. Seldom did Michelangelo write a ballad, and the following Gothic verses remind us of Villon's "Ballad of the Hanged":

CHIUNCHE NASCIE A MORTE ARRIVA . . .

Whoever is born arrives at death
with the flight of time; and the sun
leaves not a single thing alive.
The sweet and painful alike pass away,
and the thoughts we have thought and the words spoken.
Our generations gone by are like shadows
in the sun or smoke on the wind.
Like you, we were men.
Like you, happy and sad.
And now we are, as you see,
lifeless earth under the sun.
Everything comes at length to death.
Once were our eyes whole
With pupils in their sockets;

Now they are empty, horrid and black,
And that is the portent of time.

(1515/30)

604.

CARICO D'ANNI . . .

Heavy with years, and vexed sore by sin,
Rooted in uses of iniquity,
The first and second death at hand I see,
Yet cherish evil thoughts my heart within.
Not mine, Oh Lord, the power that I need,
To change my life, my passions, and my fate,
Unless Thy light my path illuminate,
And Thou, not I, my steps control and lead.
'Tis not enough the deep desire to give
For that pure world where, grown divine, the soul
No more from nothingness shall be created.
Ere thou of mortal garb do her deprive,
Make short the steep path to that heavenly goal,
That brighter hope may on my footsteps wait.

(1555) (Elizabeth Hall)

MAXIMS ON SENESCENCE AND DEATH

605. Where death is, there love approacheth not. (G 127)

606. Every blooming youth makes one wince in one's latest days. (G 167)

607. One must not mourn him who dies old. (8 January, 1544)

608. For no more is he to be mourned who dies old. (September 1534)

609. He who lives least returns happiest to heaven. (G 132)

*This maxim and the two following grow from the artist's belief that
it is more difficult for an old man to obtain salvation and grace than it
is for a young man or child.*

610. He who lives least may hope more for pardon. (G 226)

611. In heaven there is no harm in being least blessed. (G 140)

612. He who feeds on death never dies. (G 74)

613. *Since the panic-thought of death blots out all concerns, it is a
remedy for love-sickness itself:*

And I remind you that in trying to find oneself again and to enjoy oneself, it is not necessary to seek such delights and pleasures, but one must think on death. That is the only thought which makes us recognize ourselves, which keeps us united within ourselves, without letting us be robbed by relatives, friends, great masters, ambition, avarice, and other vices and sins which rob a man from himself and keep him scattered and dissipated, without ever letting him find himself again or become whole. And a marvelous thing is the effect of this thought of death, which by its very nature destroys all things—preserves and maintains those who think on it, and defends them from all human passions. All this I recall having rather appropriately pointed out in a little madrigal of mine, in which, reasoning on Love, I concluded that nothing defends us from Love better than the thought of death. . . . I am happy if you wish to hear some more of my little prattle:

NON PUR LA MORTE . . .

Not death indeed, but the dread thought of death
Saveth and severeth
Me from the heartless fair who doth me slay:
And should perchance some day
The fire consuming blaze o'er measure bright,
I find for my sad plight
No help but from death's form fixed in my heart;
Since, where death reigneth, love must dwell apart.

[Giannotti] (Symonds)

614. *Another piece picks up the theme that only the destructive thought of death delivers the poet from the trials of love.*

SE'L TIMOR DELLA MORTE . . .

If he who flees it and drives it away,
that fear of death,
could but leave it there where it stirs,
Love cruel and strong
with more tenacious temper
would of a gentle heart make merciless trials.
But since through grace and death at length
the soul cherishes the hope of being happy elsewhere,
He who cannot die, holds even more dear that fear
before which every other one gives way.
Nor against lofty and unusual beauties
In a proud lady
has any other defense the strength
to withstand her disdain or her mercy.

I swear to him who does not believe it:
that against that woman who laughs at my tears
only he who kills me doth defend and free me.

(1536/46)

615.

S'A TUO NOME HO CONCETTO . . .

If in thy name I have conceived any image,
It is not without the accompaniment of death,
Whereat art and genius vanish.

(1552)

616.

OILMÈ, OILMÈ, CH' I' SON . . .

Alas, alas, that I am betrayed
By my flying days; it is then the looking-glass,
Not the mind, if self-love do not tarnish it,
Alas, that he who foolish frets in desire,
Not heeding the flying time,
Finds himself like me, at one instant old.
Nor know I how to repent, nor do I make myself ready,
Nor advise myself with death at the door.
 Enemy of myself,
Vainly I pour out plaints and sighs
Since there is no harm equal to lost time.

(1530) (Ralph Waldo Emerson)

617.

S'ALCUN SE STESSO . . .

If it were permitted to anyone in this world
To kill himself, thinking thus to gain heaven,
It would be only fair that it be he who serves love
Wretched and unhappy, and yet with such loyalty.
But since man is not like the phoenix
Who rearises and returns at the light of the sun,
I stay my hand and my foot doth tarry.

(1531)

May, 1557

618. My Lord Duke Cosimo, . . . Once this chapel has been put right I
think the remainder of the work could be finished by the end of this

summer, so that all I should have to do would be to leave them the model for the whole work, as I have been asked to do by everyone, especially by [the Cardinal Rodolfo Pio da] Carpi. Then I should be free to return to Florence with the one thought of preparing to meet death, with whom day and night I am trying to make friends so that at the end he may not treat me worse than other old folk. . . . (Carden)

619.

SE 'L DUOL FA PUR . . .

If grief o'er death makes beautiful, as they say,
Weeping and deprived of a beautiful human face,
The unwell being is made well,
My misfortune yields life and grace.

(1545)

620.

DI MORTE CERTO . . .

Of death I am sure, but not of the time;
Life is short and little remains before me;
My senses are deleted, however I am bound for
Heaven, and she prays that I go.

The world is blind, and the sad example yet
Conquers and suppresses every good custom;
The light is out, so too every bravery;
Falsehoods triumph, and truth does not come forth.

When will that for which he waits come, Lord, for
Him who believes in you? This over-long endurance
Breaks all hope, and leaves soul prone to sin.

What is the use of so much promised light,
If death burst upon us now unprepared
And gives us no chance to escape to salvation?

22 June, 1555
621. Messer Giorgio, Dear Friend, . . . Messer Giorgio, I know you are aware from the manner in which I write that I have reached the twenty-fourth hour of my day, and that no project arises in my brain which hath not the figure of death graven upon it. God grant that I may keep him waiting for a year or two more. (Carden)

622.

SOL PUR COL FOCO . . .

Not without fire can any workman mold
 The iron to his preconceived design,
 Nor can the artist without fire refine
And purify from all its dross the gold:
Nor can revive the phoenix, we are told,
 Except by fire. Hence if such death be mine
 I hope to rise again with the divine,
 Whom death augments, and time cannot make old.
O sweet, sweet death! O fortunate fire that burns
 Within me still to renovate my days,
 Though I am almost numbered with the dead!
If by its nature unto heaven returns
 This element, me, kindled by its blaze,
 Will it bear upward when my life is fled.

 (1532) (H. W. Longfellow)

FOOTNOTES TO PRIMARY SOURCES

1. Gaetano Milanesi, *Le Lettere di Michelangelo Buonarotti* (Florence, 1875), p. 522.
2. Giovan Paolo Lomazzo, *Idea del tempio della Pittura* (Milan, 1590), p. 36.
3. Anton Francesco Doni, *Disegno* (Venice, 1549), p. 44.
4. Giovan Battista Armenini, *De' veri precetti della pittura* (Ravenna, 1586), pp. 226–27.
5. Francisco de Hollanda, *Dialogos em Roma* (Porto, 1930), p. 238.
6. *Ibid.*, p. 207.
7. Enzo Noè Girardi, *Rime di Michelangelo Buonarotti* (Bari, 1960), #236.
8. *Ibid.*, #151.
9. De Hollanda, *ed. cit.*, p. 239.
10. *Il Buonarroti*, IV (April, 1866), p. 91.
11. Girardi, *ed. cit.*, #276.
12. *Ibid.*, #152.
13. *Ibid.*, #237.
14. Milanesi, *ed. cit.*, p. 554.
15. M. de Chantelou, *Journal du voyage du Cavalier Bernin* (Paris, 1885), p. 69.
16. Girardi, *ed. cit.*, #172.
17. M. de Chantelou, *ed. cit.*, p. 103.
18. De Hollanda, *ed. cit.*, p. 229.
19. Giorgio Vasari, *Le Vite de' piu eccellenti pittori, scultori, ed architettori* (Florence, 1878–85), VII, 270.
20. Giovan Paolo Lomazzo, *Trattato della pittura, scultura ed architettura* (Roma, 1844), II, 165.
21. *Ibid.*, II, 36.
22. Lomazzo, *Idea del tempio della pittura* (Milan, 1590), p. 44.
23. Lomazzo, *Trattato, ed. cit.*, II, 165.
24. *Ibid.*, I, 34–35; II, 97.
25. De Hollanda, *ed. cit.*, p. 234.
26. *Ibid.*, pp. 241–42.
27. Giraldi Cinzio, *Hecatommithi, overo Cento novelle* (Venice, 1608), II, 218.
28. Giovan Battista Gelli, *Ragionamento* (Florence, 1551), p. 29.
29. Quoted in Charles De Tolnay, *The Medici Chapel* (Princeton, 1948), p. 68.
30. Chantelou, *Journal, ed. cit.*, VII, 226.
31. Milanesi, *ed. cit.*, p. 473.
32. *Ibid.*, p. 495.
33. *Ibid.*, p. 442.
34. *Ibid.*, p. 563.
35. Ascanio Condivi, *Vita di Michelangelo Buonarroti* (Pisa, 1823), XXXVI.
36. Milanesi, *ed. cit.*, p. 17. Paola Barocchi e Renzo Ristori, *Il Carteggio di Michelangelo* (Florence, 1965–67), I, 88.
37. Girardi, *ed. cit.*, #46.
38. Milanesi, *ed. cit.*, p. 473.
39. De Hollanda, *ed. cit.*, p. 191.
40. *Ibid.*, p. 241.
41. Girardi, *ed. cit.*, #8.
42. *Ibid.*, #213.
43. Lomazzo, *Idea, ed. cit.*, p. 114.
44. Chantelou, *Journal, ed. cit.*, p. 140.
45. Milanesi, *Lettere*, p. 424.
46. *Ibid.*, p. 3. Barocchi, *ed. cit.*, I, 3.4.
47. *Ibid.*, p. 110; Barocchi, I, 142.
48. Girardi, *ed. cit.*, #267.
49. Milanesi, *Lettere*, p. 450.
50. Vasari, *ed. cit.*, VII, 232.
51. Milanesi, *Lettere*, pp. 383–84; Barocchi, *ed. cit.*, I, 277.
52. Milanesi, *Lettere*, p. 489.
53. Girardi, *ed. cit.*, #6.
54. *Ibid.*, #241.
55. *Ibid.*, Appendix, #35.
56. *Ibid.*, #239.
57. *Ibid.*, #80; Vasari, *ed. cit.*, VII,

280; Armenini, *ed. cit.*, pp. 66, 228; see Mariani, *La Poesia*, p. 100.

58. F. Baldinucci, *Vocabolario toscano dell'arte del disegno* (Florence, 1681), p. 89.
59. Armenini, *ed. cit.*, pp. 226–27.
60. *Ibid.*, p. 87.
61. Milanesi, *Lettere*, p. 119; Barocchi, *ed. cit.*, I, 170.
62. Milanesi, *Lettere*, p. 141; Barocchi, *ed. cit.*, II, 70.
63. Milanesi, *Lettere*, p. 137; Barocchi, *ed. cit.*, I, 346.
64. Milanesi, *Lettere*, p. 79; Barocchi, *ed. cit.*, I, 45.
65. Milanesi, *Lettere*, p. 29. Barocchi *ed. cit.* I. 153.
66. Milanesi, *Lettere*, p. 559.
67. *Ibid.*, p. 8; Barocchi, *ed. cit.*, I, 26.
68. Milanesi, *Lettere*, p. 555.
69. *Ibid.*, p. 403; Barocchi, *ed. cit.*, II, 185.
70. Giovanni Papini, *La Vita di Michelangelo* (Milan, 1949), pp. 469–71.
71. Milanesi, *Lettere*, p. 394; Barocchi, *ed. cit.*, II, 82.
72. Armenini, *ed. cit.*, pp. 226–27.
73. Vasari, *ed. cit.*, VII, 210.
74. Girardi, *ed. cit.*, #35.
75. Vasari, *ed. cit.*, VII, 219.
76. Written on Madonna Sketches: Berenson, 1502.
77. Chantelou, Journal, *ed. cit.*, p. 33.
78. Milanesi, *Lettere*, p. 385; Barocchi, *ed. cit.*, I, 336.
79. Milanesi, *Lettere*, p. 448.
80. *Ibid.*, p. 423.
81. Girardi, *ed. cit.*, #282.
82. Chantelou, Journal, *ed. cit.*, p. 31.
83. De Hollanda, *ed. cit.*, p. 205.
84. *Ibid.*, pp. 227–28.
85. *Ibid.*, p. 198.
86. *Ibid.*, p. 189.
87. Chantelou, Journal, *ed. cit.*, p. 26.
88. De Hollanda, *ed. cit.*, p. 241.
89. *Ibid.*, p. 230.
90. *Ibid.*, p. 90.
91. Pierre Nougaret, *Anecdotes des beaux arts* (Paris, 1176), I, 295–96.
92. Milanesi, *Lettere*, p. 458.
93. *Ibid.*, p. 446.
94. Donato Giannotti, *Dialoghi de' giorni che Dante consumò nel cercare l'Inferno e 'l Purgatorio* (Florence, 1939), p. 40.

95. Papini, *Vita*, pp. 152–53.
96. Milanesi, *Lettere*, p. 529.
97. *Ibid.*, p. 553.
98. Vasari, *ed. cit.*, VII, 280.
99. *Ibid.*, p. 278.
100. *Ibid.*, p. 281.
101. Milanesi, *Lettere*, p. 532.
102. *Ibid.*, p. 532.
103. Benvenuto Cellini, *Vita* (Florence, 1829), I, V, 27.
104. Cellini, *Due Trattati* (Milan, 1811), pp. 62–63.
105. Vasari, *ed. cit.*, V, 385–86.
106. Baccio Bandinelli, *Il Memoriale* (memoria vii).
107. Milanesi, *Lettere*, p. 553.
108. Milanesi, *Lettere*, p. 485.
109. Vasari, *ed. cit.*, VII, 284, note.
110. Milanesi, *Lettere*, p. 535.
111. Vasari, *ed. cit.*, VII, 284, note.
112. *Ibid.*, pp. 447–48.
113. Chantelou, Journal, *ed. cit.*, p. 88; also p. 222.
114. Milanesi, *Lettere*, p. 494.
115. Vasari, *ed. cit.*, V, 421–22; VII, 284.
116. De Hollanda, *ed. cit.*, pp. 228–29.
117. Vasari, *ed. cit.*, V, 584.
118. Ascanio Condivi, *Vita di Michelangelo Buonarroti* (Pisa, 1823), lxviii; see also Vasari, VII, 170.
119. *Ibid.*, lxviii and VII, 170.
120. Condivi, *ed. cit.*, p. 22.
121. *Il Codice Magliabechiano* (Berlin, 1892), p. 115.
122. Vasari, *ed. cit.*, VII, 218.
123. *Ibid.*, VII, p. 281.
124. *Ibid.*, V, 354.
125. Milanesi, *Lettere*, p. 381; Barocchi, *ed. cit.*, I, 267.
126. Milanesi, *Lettere*, p. 535.
127. De ·Hollanda, in Holroyd trans. (London, 1903), 290–1.
128. De Hollanda, *ed. cit.*, pp. 190–91.
129. Milanesi, *Lettere*, p. 500.
130. Girardi, *ed. cit.*, App. #3.
131. Heinrich Thode, *Kritische Untersuchungen*, I, 85.
132. Ascanio Condivi, trans. by Ch. Holroyd (London, 1903), p. 26.
133. Milanesi, *Lettere*, p. 78; Barocchi, *ed. cit.*, I, 44.
134. Milanesi, *Lettere*, p. 79; Barocchi, *ed. cit.*, I, 45.
135. Milanesi, *Lettere*, p. 88; Barocchi, *ed. cit.*, I, 55.

136. Milanesi, *Lettere*, p. 426.
137. *Ibid.*, p. 454.
138. Girardi, *ed. cit.*, #5.
139. *Ibid.*, #104.
140. Milanesi, *Lettere*, p. 453.
141. Girardi, *ed. cit.*, #14.
142. Carl Frey, *Die Dichtungen des Mich-elagniolo Buonarroti* (Berlin, 1897), VII, 281.
143. Girardi, *ed. cit.*, #247.
144. *Ibid.*, #102.
145. *Ibid.*, #101.
146. *Ibid.*, #103.
147. *Ibid.*, #290.
148. *Ibid.*, #161.
149. *Ibid.*, #5.
150. *Ibid.*, #94.
151. *Ibid.*, #158.
152. *Ibid.*, #267.
153. Milanesi, *Lettere*, p. 544.
154. Giannotti, *Dialoghi, ed. cit.*, p. 66.
155. Girardi, *ed. cit.*, #84.
156. Milanesi, *Lettere*, p. 478.
157. Girardi, *ed. cit.*, #60, note.
158. *Ibid.*, #85.
159. *Ibid.*, #145, note.
160. Milanesi, *Lettere*, p. 534.
161. *Ibid.*, p. 473.
162. *Ibid.*, p. 504.
163. Girardi, *ed. cit.*, #253, note.
164. Milanesi, *Lettere*, p. 524.
165. *Ibid.*, p. 527.
166. *Ibid.*, p. 425.
167. *Ibid.*, pp. 479–80.
168. *Ibid.*, p. 466.
169. Girardi, *ed. cit.*, #277.
170. Giannotti, *Dialoghi, ed. cit.*, p. 65.
171. Milanesi, *Lettere*, p. 254.
172. Girardi, *ed. cit.*, #250.
173. Giannotti, *Dialoghi, ed. cit.*, pp. 77–79.
174. *Ibid.*, p. 87.
175. Girardi, *ed. cit.*, #248.
176. Milanesi, *Lettere*, p. 462.
177. *Ibid.*, p. 230; see also, p. 208.
178. *Ibid.*, p. 287.
179. Giannotti, *Dialoghi, ed. cit.*, pp. 71–72.
180. Girardi, *ed. cit.*, #10.
181. Milanesi, *Lettere*, p. 59.
182. De Hollanda, *ed. cit.*, p. 235.
183. Quoted in Cesare Guasti, *Le Rime di Michelangelo Buonarroti* (Florence, 1863), p. xl.
184. Vasari, *Vita di M.*, crit. edit. of Paola Barocchi (Naples, 1962) I, 116.
185. Quoted in Cesare Guasti, *Le rime di Michelangelo Buonarroti* (Florence, 1863), p. xl.
186. Girardi, *ed. cit.*, Appendix, #15.
187. Girardi, *ed. cit.*, #292.
188. *Ibid.*, #87.
189. *Ibid.*, #289.
190. *Ibid.*, #32.
191. Milanesi, *Lettere*, p. 238.
192. *Ibid.*, p. 47; Barocchi, *ed. cit.*, I, 140.
193. Girardi, *ed. cit.*, #298.
194. *Ibid.*, #274.
195. Milanesi, *Lettere*, p. 517.
196. *Ibid.*, p. 330.
197. Vasari, *ed. cit.*, VII, 279.
198. Milanesi, *Lettere*, p. 243.
199. *Ibid.*, p. 248.
200. *Ibid.*, p. 253.
201. *Ibid.*, p. 217.
202. *Ibid.*, p. 313.
203. *Ibid.*, p. 47; Barocchi, *ed. cit.*, I, 140.
204. Milanesi, *Lettere*, p. 30.
205. *Ibid.*, p. 282.
206. Girardi, *ed. cit.*, #132.
207. Milanesi, *Lettere*, p. 433.
208. *Ibid.*, p. 436.
209. *Ibid.*, p. 327.
210. *Ibid.*, p. 47; Barocchi, *ed. cit.*, I, 140.
211. Milanesi, *Lettere*, p. 442.
212. Girardi, *ed. cit.*, #106.
213. *Ibid.*, #34.
214. *Ibid.*, #42.
215. *Ibid.*, #44.
216. *Ibid.*, #68.
217. Girardi, *ed. cit.*, #67.
218. *Ibid.*, #67.
219. *Ibid.*, #67.
220. *Ibid.*, Appendix, #7.
221. *Ibid.*, #269.
222. *Ibid.*, #124.
223. *Ibid.*, #120.
224. *Ibid.*, #296.
225. *Ibid.*, #60.
226. Milanesi, *Lettere*, p. 79; Barocchi, *ed. cit.*, I, 45.
227. Girardi, *ed. cit.*, #248.
228. *Ibid.*, #68.
229. *Ibid.*, #250.
230. Milanesi, *Lettere*, p. 241.

231. *Ibid.,* p. 138; Barocchi, *ed. cit.,* I, 346.
232. Girardi, *ed. cit.,* #6.
233. *Ibid.,* #85.
234. *Ibid.,* #208.
235. *Ibid.,* #267.
236. *Ibid.,* #165.
237. *Ibid.,* #135.
238. Milanesi, *Lettere,* p. 287.
239. *Ibid.,* p. 524.
240. *Ibid.,* p. 533.
241. *Ibid.,* p. 462.
242. Girardi, *ed. cit.,* #15.
243. *Ibid.,* #123.
244. *Ibid.,* #116.
245. *Ibid.,* #137.
246. *Ibid.,* #163.
247. Frey, *ed. cit.,* p. 13.
248. Girardi, *ed. cit.,* #244.
249. Girardi, *ed. cit.,* #117.
250. *Ibid.,* #145.
251. *Ibid.,* #53.
252. *Ibid.,* #141.
253. Milanesi, *Lettere,* p. 150.
254. *Ibid.,* p. 39.
255. Girardi, *ed. cit.,* #54.
256. *Ibid.,* #148, note.
257. *Ibid.,* #301.
258. *Ibid.,* #295.
259. *Ibid.,* #109.
260. Giannotti, *Dialoghi, ed. cit.,* p. 87.
261. Milanesi, *Lettere,* p. 166.
262. Girardi, *ed. cit.,* #38.
263. *Ibid.,* #204.
264. *Ibid.,* #150.
265. *Ibid.,* #258.
266. *Ibid.,* #256.
267. *Ibid.,* #134.
268. *Ibid.,* #131.
269. *Ibid.,* #130.
270. *Ibid.,* #54.
271. *Ibid.,* #157.
272. *Ibid.,* #218.
273. *Ibid.,* #272.
274. *Ibid.,* #255.
275. Milanesi, *Lettere,* p. 515.
276. *Ibid.,* p. 515.
277. Girardi, *ed. cit.,* #105.
278. *Ibid.,* #166.
279. *Ibid.,* #59.
280. *Ibid.,* #55.
281. *Ibid.,* #27.
282. *Ibid.,* #17.
283. *Ibid.,* #8.
284. *Ibid.,* #112.

285. *Ibid.,* #95.
286. *Ibid.,* #142.
287. Milanesi, *Lettere,* p. 237.
288. Condivi, *Vita,* xvi.
289. Milanesi, *Lettere,* p. 293.
290. *Ibid.,* p. 271.
291. *Ibid.,* p. 208.
292. *Ibid.,* p. 264.
293. Girardi, *ed. cit.,* #4.
294. *Ibid.,* #54.
295. *Ibid.,* #20.
296. Milanesi, *Lettere,* p. 515.
297. Girardi, *ed. cit.,* #162.
298. *Ibid.,* #150.
299. *Ibid.,* #265.
300. *Ibid.,* #47.
301. *Ibid.,* #279.
302. Milanesi, *Lettere,* p. 528.
303. Girardi, *ed. cit.,* #89.
304. Milanesi, *Lettere,* p. 462.
305. Girardi, *ed. cit.,* #76.
306. Milanesi, *Lettere,* p. 466.
307. *Ibid.,* p. 467.
308. *Ibid.,* p. 469.
309. Girardi, *ed. cit.,* #83.
310. *Ibid.,* #164.
311. *Ibid.,* #107.
312. *Ibid.,* #97.
313. Milanesi, *Lettere,* p. 471.
314. Girardi, *ed. cit.,* #100.
315. *Ibid.,* #99.
316. Milanesi, *Lettere,* p. 474.
317. Girardi, *ed. cit.,* #197, note.
318. Milanesi, *Lettere,* p. 477.
319. Girardi, *ed. cit.,* #180.
320. *Ibid.,* #182.
321. *Ibid.,* #185.
322. *Ibid.,* #187.
323. *Ibid.,* #190.
324. *Ibid.,* #194.
325. *Ibid.,* #195.
326. *Ibid.,* #196.
327. *Ibid.,* #198.
328. *Ibid.,* #200.
329. *Ibid.,* #203.
330. *Ibid.,* #215.
331. *Ibid.,* #223.
332. Girardi, *ed. cit.,* #190.
333. *Ibid.,* #194.
334. *Ibid.,* #196.
335. *Ibid.,* #198.
336. *Ibid.,* #199.
337. *Ibid.,* #201.
338. *Ibid.,* #206.
339. *Ibid.,* #207.

340. *Ibid.*, #211.
341. *Ibid.*, #214.
342. *Ibid.*, #218.
343. *Ibid.*, #233.
344. *Ibid.*, #228.
345. Vasari, *ed. cit.*, VII, 281.
346. Milanesi, *Lettere*, p. 151.
347. Milanesi, *Lettere*, p. 197.
348. *Ibid.*, p. 198.
349. *Ibid.*, p. 216.
350. *Ibid.*, p. 299.
351. *Ibid.*, p. 271.
352. *Ibid.*, p. 15; Barocchi, *ed. cit.*, I, 80.
353. Milanesi, *Lettere*, p. 49.
354. *Ibid.*, pp. 55–56; Barocchi, *ed. cit.*, II, 373.
355. Girardi, *ed. cit.*, #86.
356. Milanesi, *Lettere*, p. 97; Barocchi, *ed. cit.*, I, 101.
357. Milanesi, *Lettere*, p. 30; Barocchi, *ed. cit.*, I, 107.
358. Milanesi, *Lettere*, p. 102; Barocchi, *ed. cit.*, I, 123.
359. Milanesi, *Lettere*, p. 182.
360. *Ibid.*, p. 230.
361. *Ibid.*, p. 237.
362. *Ibid.*, p. 241.
363. *Ibid.*, p. 249.
364. *Ibid.*, p. 256.
365. *Ibid.*, p. 270.
366. *Ibid.*, p. 285.
367. *Ibid.*, p. 293.
368. *Ibid.*, p. 297.
369. *Ibid.*, p. 533.
370. *Ibid.*, p. 305.
371. *Ibid.*, p. 343.
372. *Ibid.*, p. 372.
373. *Ibid.*, p. 542.
374. *Ibid.*, p. 290.
375. *Ibid.*, p. 97; Barocchi, *ed. cit.*, I, 101.
376. *Ibid.*, p. 179.
377. *Ibid.*, p. 221.
378. Gianotti, *Dialoghi, ed. cit.*, p. 68.
379. Milanesi, *Lettere*, p. 129; Barocchi, *ed. cit.*, I, 182.
380. Milanesi, *Lettere*, p. 447.
381. *Ibid.*, p. 375; Barocchi, *ed. cit.*, I, 1.
382. Milanesi, *Lettere*, p. 519.
383. *Ibid.*, p. 472.
384. Girardi, *ed. cit.*, #300.
385. Milanesi, *Lettere*, p. 314.
386. *Ibid.*, p. 539.

387. Girardi, *ed. cit.*, #299.
388. *Ibid.*, #71.
389. Milanesi, *Lettere*, p. 598.
390. *Ibid.*, p. 324.
391. *Ibid.*, p. 552.
392. *Ibid.*, p. 210.
393. *Ibid.*, p. 524.
394. Girardi, *ed. cit.*, #175.
395. Papini, *Vita*, p. 283.
396. Girardi, *ed. cit.*, #160.
397. Giannotti, *Dialoghi, ed. cit.*, p. 93.
398. Milanesi, *Lettere*, p. 149; Barocchi, *ed. cit.*, I, 41.
399. Milanesi, *Lettere*, p. 107; Barocchi, *ed. cit.*, I, 135.
400. Milanesi, *Lettere*, p. 108; Barocchi, *ed. cit.*, I, 136.
401. Milanesi, *Lettere*, p. 46; Barocchi, *ed. cit.*, I, 139.
402. Milanesi, *Lettere*, p. 221.
403. Girardi, *ed. cit.*, #249.
404. Giannotti, *ed. cit.*, pp. 39–40.
405. Milanesi, *Lettere*, p. 47; Barocchi, *ed. cit.*, I, 140–41.
406. Milanesi, *Lettere*, p. 84; Barocchi, *ed. cit.*, I, 51.
407. Milanesi, *Lettere*, p. 147; Barocchi, *ed. cit.*, I, 39.
408. Milanesi, *Lettere*, p. 23.
409. De Hollanda, *ed. cit.*, p. 227.
410. *Ibid.*, p. 221.
411. Milanesi, *Lettere*, p. 107; Barocchi, *ed. cit.*, I, 135.
412. Vasari, *ed. cit.*, VII, 240.
413. Milanesi, *Lettere*, p. 108; Barocchi, *ed. cit.*, I, 136.
414. Milanesi, *Lettere*, p. 451.
415. *Ibid.*, p. 61; Barocchi, *ed. cit.*, I, 18.
416. Girardi, *ed. cit.*, #238.
417. Milanesi, *Lettere*, p. 555.
418. *Ibid.*, p. 191.
419. *Ibid.*, p. 206.
420. *Ibid.*, pp. 482–83.
421. *Ibid.*, p. 241.
422. *Ibid.*, p. 319.
423. *Ibid.*, p. 4; Barocchi, *ed. cit.*, I, 4.
424. Milanesi, *Lettere*, p. 180.
425. *Ibid.*, p. 250.
426. *Ibid.*, p. 200.
427. *Ibid.*, p. 130; Barocchi, *ed. cit.*, I, 183.
428. Milanesi, *Lettere*, p. 11; Barocchi, *ed. cit.*, I, 91.
429. Milanesi, *Lettere*, p. 109; Barocchi, *ed. cit.*, I, 142.

430. Milanesi, *Lettere*, p. 436.
431. *Ibid.*, p. 489.
432. *Ibid.*, p. 102; Barocchi, *ed. cit.*, I, 123.
433. Girardi, *ed. cit.*, #67.
434. Milanesi, *Lettere*, p. 517.
435. *Ibid.*, p. 391; Barocchi, *ed. cit.*, II, 7.
436. Milanesi, *Lettere*, p. 225.
437. *Ibid.*, p. 209.
438. *Ibid.*, p. 326.
439. *Ibid.*, p. 461.
440. *Ibid.*, p. 510.
441. *Ibid.*, p. 558.
442. *Ibid.*, p. 220.
443. *Ibid.*, p. 32; Barocchi, *ed. cit.*, I, 97.
444. Milanesi, *Lettere*, p. 224.
445. *Ibid.*, p. 314.
446. *Ibid.*, p. 599.
447. *Ibid.*, p. 321.
448. *Ibid.*, p. 12; Barocchi, *ed. cit.*, I, 92.
449. Girardi, *ed. cit.*, #267.
450. Milanesi, *Lettere*, p. 104; Barocchi, *ed. cit.*, I, 133.
451. Milanesi, *Lettere*, p. 386; Barocchi, *ed. cit.*, II, 9.
452. Milanesi, *Lettere*, p. 420; Barocchi, *ed. cit.*, II, 384.
453. Milanesi, *Lettere*, p. 173.
454. *Ibid.*, p. 500.
455. *Ibid.*, p. 550.
456. Girardi, *ed. cit.*, App. 16.
457. Milanesi, *Lettere*, p. 335.
458. *Ibid.*, p. 366.
459. *Ibid.*, p. 310.
460. *Ibid.*, p. 213.
461. *Ibid.*, p. 242.
462. *Ibid.*, p. 270.
463. *Ibid.*, p. 279.
464. *Ibid.*, p. 162.
465. *Ibid.*, p. 489.
466. *Ibid.*, p. 126; Barocchi, *ed. cit.*, I, 177.
467. Milanesi, *Lettere*, p. 97; Barocchi, *ed. cit.*, I, 101.
468. Giannotti, *Dialoghi*, *ed. cit.*, p. 60.
469. *Ibid.*, p. 88.
470. *Ibid.*, p. 91.
471. *Ibid.*, p. 96.
472. Milanesi, *Lettere*, p. 537.
473. Vasari, *ed. cit.*, VII, 188; 496.
474. Milanesi, *Lettere*, p. 383; Barocchi, *ed. cit.*, I, 277.
475. Milanesi, *Lettere*, p. 394; Barocchi, *ed. cit.*, II, 82.
476. Milanesi, *Lettere*, p. 172.
477. *Ibid.*, p. 327.
478. Giannotti, *Dialoghi*, *ed. cit.*, pp. 45–46.
479. Ibid., p. 43.
480. Milanesi, *Lettere*, p. 23.
481. Giannotti, *Dialoghi*, *ed. cit.*, p. 86.
482. Milanesi, *Lettere*, p. 17; Barocchi, *ed. cit.*, I, 88; Milanesi, p. 61, Barocchi, I, 18; Milanesi, p. 544; Milanesi, p. 209; Milanesi, p. 221; Girardi, #85.
483. Milanesi, *Lettere*, p. 116; Barocchi, *ed. cit.*, I, 167.
484. "Un Dialogo tra Niccolò Franco e il Buonarroti," *Il Buonarroti IV* (April, 1866), p. 91.
485. Milanesi, *Lettere*, p. 284.
486. *Ibid.*, p. 104; Barocchi, *ed. cit.*, I, 133.
487. See Ludwig Goldscheider, *Michelangelo Drawings* (London, 1951), p. 54.
488. Chantelou, *Journal*, *ed. cit.*, p. 174.
489. Girardi, *ed. cit.*, #172.
490. *Ibid.*, #136.
491. *Ibid.*, #48.
492. *Ibid.*, #62.
493. *Ibid.*, #278.
494. Milanesi, *Lettere*, p. 393; Barocchi, *ed. cit.*, II, 36.
495. Vasari, *ed. cit.* VII, 280.
496. Vasari, *ed. cit.*, VII, 279.
497. Cinzio, *ed. cit.*, p. 221.
498. Justi was apparently the first to advance this interpretation later.
499. Giovanni Baglione, *Le Vite de' Pittori* (Naples, 1733), p. 143.
500. Vasari, *ed. cit.*, VII, 156.
501. *Ibid.*, p. 281.
502. *Ibid.*, p. 284.
503. Anton Francesco Doni, *I Marmi* (Bari, 1928), p. 101.
504. Chantelou, *Journal*, *ed. cit.*, p. 119.
505. Armenini, *ed. cit.*, p. 288; also Vasari, *ed. cit.*, VII, 171.
506. Vasari, *Vita di Mich*, ed. by Paola Barocchi (Milan, 1962) I, 83.
507. M. Herrero García, *Contribución de la literatura a la historia del arte* (Madrid, 1943), p. 93.
508. *Ibid.*, pp. 77–78.
509. Francisco de Hollanda, *Three Dialogues* (London, 1903) p. 285.
510. Lomazzo, *Idea*, *ed. cit.*, p. 56.
511. Milanesi, *Lettere*, p. 87; Barocchi, *ed. cit.*, I, 54; Milanesi, p. 418,

Barocchi, II, 343. Milanesi, p. 216.
512. Vasari, *Vita di M,* critical edition of Barocchi (Milan, 1962) I, 117, supports Varchi by another assertion by Mich.: "Si conosce che quando e' voleva cavar Minerva dalla testa di Giove, ci bisognava il martello di vulcano."
513. Vasari, *ed. cit.,* VII, 280 f.
514. *Ibid.,* p. 278.
515. See R. J. Clements, *Michelangelo's Theory of Art* (N. Y., 1961) pp. 206–7.
516. Milanesi, *Lettere,* p. 413; Barocchi, *ed. cit.,* II, 232.
517. Girardi, *ed. cit.,* #98.
518. *Ibid.,* #100.
519. *Ibid.,* #99.
520. *Ibid.,* #85.
521. *Ibid.,* #85.
522. *Ibid.,* #177.
523. *Ibid.,* #222.
524. *Ibid.,* #184.
525. *Ibid.,* #6.
526. Giannotti, *ed. cit.,* p. 45.
527. Milanesi, *Lettere,* p. 351.
528. *Ibid.,* p. 498.
529. Giannotti, *Dialoghi, ed. cit.,* p. 68.
530. Francisco de Hollanda, *Three Dialogues* (London, 1903), p. 276.
531. Girardi, *ed. cit.,* #109.
532. Vasari, *ed. cit.,* VII, 280.
533. Milanesi, *Lettere,* p. 167.
534. *Ibid.,* p. 481.
535. *Ibid.,* p. 446.
536. *Ibid.,* p. 484.
537. *Ibid.,* p. 371.
538. *Ibid.,* p. 607.
539. *Ibid.,* p. 49.
540. *Ibid.,* p. 492.
541. *Ibid.,* p. 333.
542. *Ibid.,* p. 150; Barocchi, *ed. cit.,* I, 95.
543. *Ibid.,* p. 213.
544. Milanesi, *Lettere,* p. 174.
545. *Ibid.,* p. 187.
546. *Ibid.,* p. 531.
547. *Ibid.,* p. 194.
548. *Ibid.,* p. 230.
549. Girardi, *ed. cit.,* #251.
550. Milanesi, *Lettere,* p. 520.
551. *Ibid.,* p. 140; Barocchi, *ed. cit.,* II, 59.
552. Milanesi, *Lettere,* p. 27.
553. *Ibid.,* p. 398; Barocchi, *ed. cit.,* II, 129.
554. Milanesi, *Lettere,* p. 180.
555. *Ibid.,* p. 187.
556. *Ibid.,* p. 236.
557. *Ibid.,* p. 318.
558. *Ibid.,* p. 386; Barocchi, *ed. cit.,* II, 9–10.
559. Milanesi, *Lettere,* p. 137; Barocchi, *ed. cit.,* I, 346.
560. Milanesi, *Lettere,* p. 341.
561. *Ibid.,* p. 101; Barocchi, *ed. cit.,* I, 113.
562. Milanesi, *Lettere,* p. 213.
563. *Ibid.,* p. 108; Barocchi, *ed. cit.,* I, 136.
564. Milanesi, *Lettere,* p. 145.
565. Girardi, *ed. cit.,* #67.
566. *Ibid.,* App. 5.
567. Milanesi, *Lettere,* p. 541.
568. *Ibid.,* p. 377; Barocchi, *ed. cit.,* I, 113.
569. Milanesi, *Lettere,* p. 457.
570. Francisco de Hollanda, *Three Dialogues* (London, 1903), pp. 316–7.
571. Milanesi, *Lettere,* p. 548.
572. Girardi, *ed. cit.,* #67.
573. Girardi, *ed. cit.,* #68.
574. *Ibid.,* #272.
575. Milanesi, *Lettere,* p. 547.
576. Girardi, *ed. cit.,* #285.
577. *Ibid.,* #133.
578. *Ibid.,* #288.
579. *Ibid.,* #25.
580. *Ibid.,* #294.
581. *Ibid.,* #51.
582. *Ibid.*
583. Milanesi, *Lettere,* p. 488.
584. *Ibid.,* p. 546.
585. *Ibid.,* p. 558.
586. *Ibid.,* p. 11; Barocchi, *ed. cit.,* I, 91.
587. Milanesi, *Lettere,* p. 502.
588. Girardi, *ed. cit.,* #161.
589. *Ibid.,* #144.
590. *Ibid.,* #62.
591. *Ibid.,* #51.
592. *Ibid.,* #66.
593. *Ibid.,* #263.
594. *Ibid.,* App. 1.
595. *Ibid.,* #51.
596. *Ibid.,* #42.
597. *Ibid.,* #199.
598. *Ibid.,* #267.
599. *Ibid.,* #110.
600. *Ibid.,* #161.
601. *Ibid.,* #267.
602. *Ibid.,* #17.

603. *Ibid.*, #21.
604. *Ibid.*, #293.
605. *Ibid.*, #127.
606. *Ibid.*, #167.
607. *Ibid.*, #205.
608. Girardi, *ed. cit.*, #86. On death of father Lodovico Buonarroti.
609. Girardi, *ed. cit.*, #132.
610. *Ibid.*, #226.
611. *Ibid.*, #140.
612. *Ibid.*, #74.

613. *Ibid.*, #127; Giannotti, *Dialoghi, ed. cit.*, p. 69.
614. Girardi, *ed. cit.*, #128.
615. *Ibid.*, #284.
616. *Ibid.*, #51.
617. *Ibid.*, #52.
618. Milanesi, *Lettere*, p. 543.
619. Girardi, *ed. cit.*, #244.
620. *Ibid.*, #295.
621. Milanesi, *Lettere*, p. 538.
622. Girardi, *ed. cit.*, #62.

PROPOSED REVISIONS OF DATES
FOR THE LETTERS OF MICHELANGELO

Since the appearance of the earlier version of this idearium of the artist in 1963, two collections of Michelangelo's letters have appeared revising or correcting dates established by Milanesi. These two works are *The Letters of Michelangelo translated from the Original Tuscan,* edited by E. H. Ramsden in two volumes (Stanford University Press, 1963) and *Il Carteggo di Michelangelo,* the projected edition of Giovanni Poggi carried on by Paola Barocchi and Renzo Ristori (Florence, Sansoni, 1965, 1967). The first two volumes of the latter project presently available carry the correspondence up to August, 1523. Wherever either one or both of these two editions proposes a date at variance with or more precise than the Milanesi date utilised in the preceding pages, the revised date is offered below:

RAMSDEN DATES THAT DIFFER FROM MILANESI

1. (March) 1547
14. (December 1550)
45. (January) 1524
52. October/November 1542
61. July 28, 1515
65. (February) 1513
68. 1548/49
78. April 2, 1518
79. (December) 1525
92. November (25) 1531
101. (1550)
110. (January 1547)
114. October/November 1542
126. January 1547
136. December 1523
140. June 17, 1526
153. (August) 1525
156. (August/September 1542)
162. February 1544
164. (March) 1547
165. February (16), 1550
166. (December 1526)
167. (May/June 1542)
168. August 1533
191. (September 25) 1557
195. (November) 1545
238. November (19) 1552
239. (March) 1547

275. (Spring 1539)
291. November 12, 1547
296. (Spring 1539)
306. August 1533
308. July 28, 1533
313. September 1534
316. (May 1542)
318. (September) 1542
348. December 3, 1547
350. April 21, 1554
352. August 1499
353. September/October 1521
358. January 10, 1512
359. June 21, 1550
360. March (2), 1549
373. April 28, 1557
377. October 22, 1547
392. November 5, 1547
393. (March) 1547
402. October 22, 1547
408. October 1512
417. 1548/49
418. April 29, 1547
419. October 1547
428. June 1509
431. October/November 1542
432. January 10, 1512
434. (November) 1545

189

437. November 19, 1547
440. (Autumn 1545)
442. February 18, 1548
448. (June) 1509
455. January 14, 1559
460. September 3, 1547
464. July (10/17) , 1540
465. October/November 1542
482. c.) (August) 1525
 e.) October 22, 1547
485. October 22, 1552
527. March (17) , 1560
533. August 20, 1541
534. August 30, 1542

536. May 1542
540. October/November 1542
542. (June) 1509
548. March (2) , 1549
550. (January 1545)
552. (February) 1513
562. September 3, 1547
564. September 4, 1527
567. December 18, 1556
571. September 28, 1555
583. October/November 1542
584. July 1, 1557
586. June 1509
587. (March 1541)

BAROCCHI-RISTORI DATES THAT DIFFER FROM MILANESI

61. July 28, 1515
62. (August 30/31) 1518
65. October 28, 1514
71. (September 13/14, 1518)
78. (April 2, 1518)
203. (October/November 1512)
210. (October/November 1512)
352. August 19/26, 1508
354. Second half of June 1523
356. November 17, (1509)
358. January 10, (1512)
375. November 17, (1509)
401. (October/November 1512)
405. (October/November 1512)
428. May or the first half of June 1509

432. January 10, (1512)
435. (The first half of May 1518)
443. September 15, 1509
448. (Second half of May or first half of June 1509)
451. (First half of May 1518)
452. After the 11th of July, maybe the 18th, 1523
467. November 17, (1509)
475. (September 13/14, 1518)
511. b.) (First of) February 1522
542. (July/August 1509)
551. Toward the middle of August 1518
558. First half of May 1518
586. May or first half of June 1509

SELECTIVE INDEXES

Note: Themes and subject matter may be located through the analytical table of contents on pages v, vi, and vii. Translators are not included in the following glossary.

INDEX OF NAMES

INDEX OF MICHELANGELO'S WORKS OF ART